The
TROMPE L'OEIL
HOME

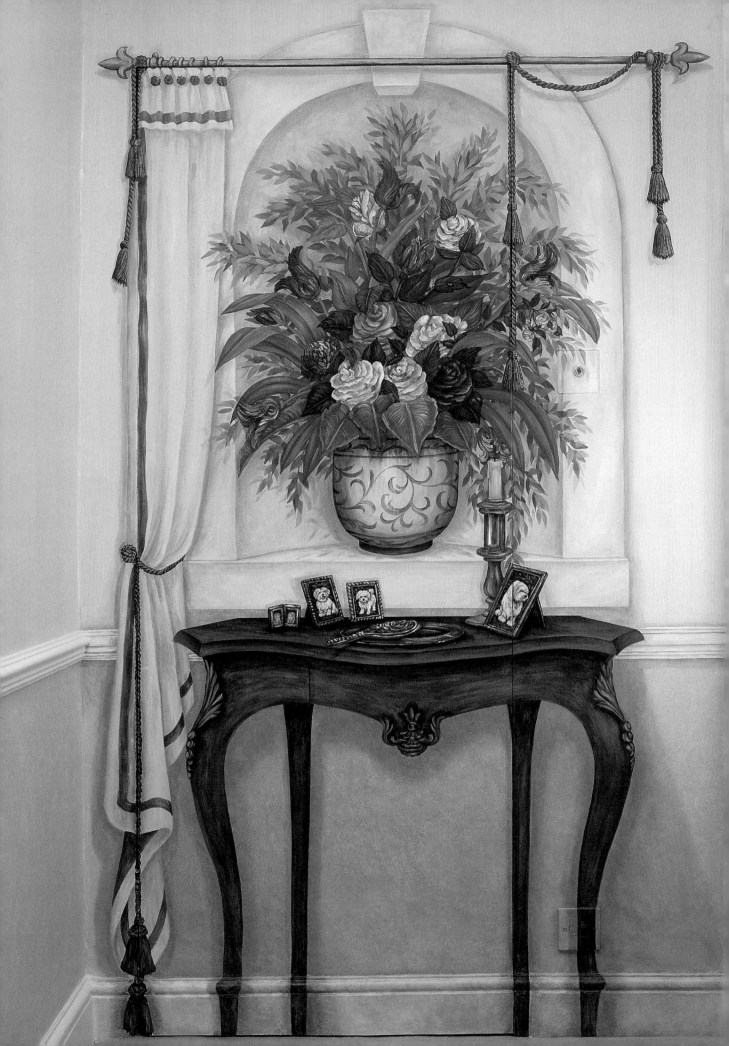

The
TROMPE L'OEIL
HOME

ROBERTA
GORDON-SMITH

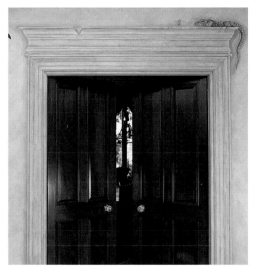

Watson-Guptill Publications/New York

A David & Charles Book
First published in the UK in 2000 by David & Charles,
Brunel House, Newton Abbot, Devon TQ12 4PU England
Editorial staff: Lindsay Porter, Alison Wormleighton, Valerie Streak
Art and design staff: Ali Myer, Robin Whitecross
Assistant to Ms. Gordon-Smith: Bubble Englefield
Photography by Shona Wood
Text set in 11/16 Weiss

First published in the United States in 2001 by
Watson-Guptill Publications,
a division of BPI Communications, Inc.,
770 Broadway, New York, N.Y. 10003

Library of Congress Catalog Number: 00-105525
ISBN 0-8230-5446-2

First printing, 2001

1 2 3 4 5 6 7 8 9 / 09 08 07 06 05 04 03 02 01

Contents

INTRODUCTION

Trompe l'oeil – a French term meaning to 'trick the eye' – utilizes painting techniques to create the illusion that a two-dimensional painting is three-dimensional reality. The wonderful thing about trompe l'oeil is that it can be used in any style of home, in any room and on any scale. Whether you want to create a spectacular view from a fake window, an impressive pediment for a boring door, or a visual joke in a tiny powder room, trompe l'oeil is ideal. What's more, it doesn't require any painting experience.

Above, below and opposite: Murals, faux finishes and still lifes are all possible using trompe l'oeil techniques.

The art of trompe l'oeil goes back to ancient times, when the Romans decorated their villas with wall paintings simulating columns, niches and open windows with dramatic views. Ever since then, Neoclassical styles of decor have always included this element. Many examples can be seen in châteaux and elegant homes that can be adapted to create atmosphere in your own home.

The technique actually includes a variety of types of painting. There are architectural features – pediments, windows, doors, archways, columns and pilasters, niches, low-relief sculptures – which are painted with a monochromatic technique known as grisaille. In addition, there are landscapes and seascapes, often painted within one of these windows or archways. Still lifes are another category, comprising realistic

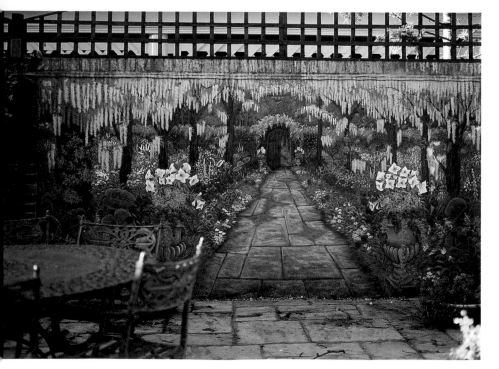

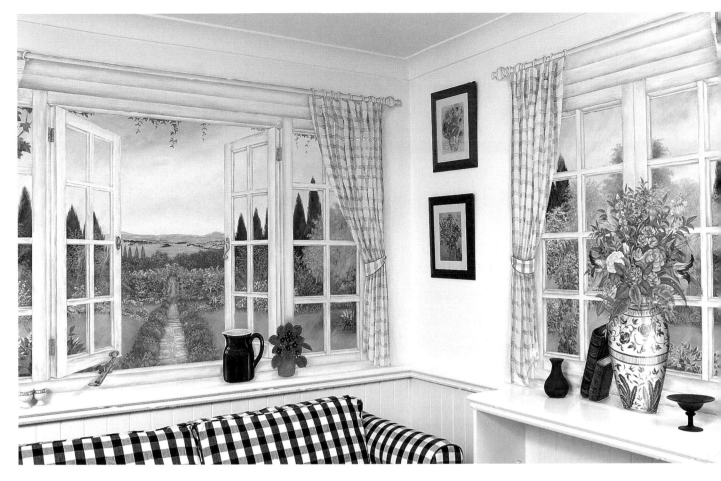

paintings of ornaments, books, fruit and flower studies. And there are the faux finishes ('faux' meaning 'false' or 'fake' in French) such as faux fabric, stone, tiles and wood. All of these categories are included in this book.

Whether you prefer just one of these types of trompe l'oeil or are longing to introduce the whole range into your home, you can be certain that it will add character and interest, particularly to a room that lacks a focal point or architectural features. In rooms with no windows, such as a powder room or hall, a trompe l'oeil window complete with lovely view transforms the whole space. A 'tented' effect painted onto walls and ceiling helps to camouflage unattractive elements such as ductwork or boxed-in pipes. Trompe l'oeil can even be used to improve the apparent proportions of a room. For instance faux fabric in vertical stripes, as in the

project on page 90, makes a ceiling look higher, while false perspective makes a small room seem larger.

Because trompe l'oeil has different uses throughout the home, this book is organized room by room. The projects in each chapter teach you the techniques required, and there is an introductory section on pages 8–19 covering the basics of trompe l'oeil.

Most people are nervous about trying trompe l'oeil because they don't think they are artistic enough, which is why I've planned this book so that you don't have to be even the slightest bit artistic to make a success of the projects. (In fact, an artistic flair often emerges, once confidence is built up.) The designs for the projects can be copied from the photos or traced from templates at the back of the book, and every aspect is explained and demonstrated in step-by-step detail.

It's best to start with the simplest projects until you have gained experience, and then the more ambitious projects will be well within your capabilities. Some of these are quite complex, but they can all be broken down into simple elements. You can therefore tackle a whole project, or just some aspects of it.

The book will also enable you to devise your own trompe l'oeil. Start building up a reference file of images to copy. Magazines, books and postcards are all good sources, and you could also take your own photographs.

You will find that your work – and your confidence – improves with practice, so try to experiment with different effects as much as possible. I hope you enjoy yourself as much as I have in devising the projects for you.

Roberta Gordon-Smith

Materials and Equipment

The beauty of trompe l'oeil painting is that the materials are not expensive and you need very little special equipment. In addition, everything that you do need is widely available.

Paints

I prefer to use water-based paints because they are quick-drying and do not give off fumes. When I need large amounts, I use flat or eggshell finish latex paint. This also comes in sample cans, which are useful if you need only a little of particular shades, but for small amounts I generally use artist's acrylic. Because both are water-based, they can be mixed together, so you will find that many projects call for both and they are freely interchanged. Acrylic titanium white does provide better cover than latex white, so occasionally you will need both for one project.

Some of the projects, particularly the faux panelling projects, require very few paints. Also, you will find that the same shades keep reappearing in the projects. Not only does this prevent you from having to buy too many cans or tubes of paint, but also these shades are the colours that I find most effective.

> **TIP** Before storing paints, shake the can to create an airtight seal. To keep some unused paint on a palette overnight, cover it with plastic wrap. To keep it for a few days, cover it with water first and then with plastic wrap; drain the water off when you want to reuse it.

Varnishes

Varnish protects a surface and also brings out the paint colours. With water-based paints you can use either acrylic or polyurethane varnish, but polyurethane yellows with age, so I always use acrylic. These days there are many good acrylic varnishes available which are strong enough even for floors, and they dry within an hour or two. Using water-based products means, therefore, that you can often complete a project in one day, enabling you to use the room right away.

On walls you need only one coat, unless it is in an area that will need frequent cleaning, such as a kitchen, bathroom, powder room or children's room, where two coats are preferable. On furniture, floors or other heavily used flat surfaces, and also outdoors, three coats are advisable.

I nearly always use dead-flat (matt) varnish, as, despite the name, it does have a slight sheen. Sometimes, however, the shinier look of satin finish looks better, particularly on doors and other woodwork.

> **TIP** Apply varnish thinly, and always allow it to dry between coats.

Right: Although the paints are water-based, with the correct preparation beforehand and adequate varnishing afterwards, they can be used outdoors as well as inside.

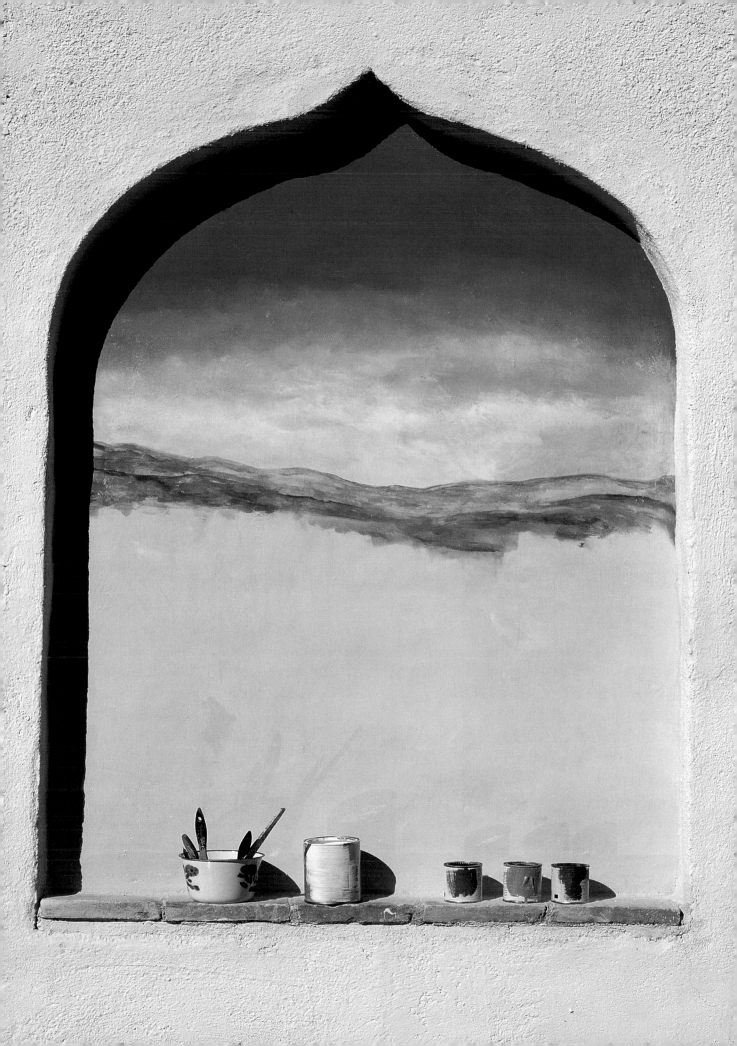

Left: Always use the low-tack variety of masking tape, because it is less likely to pull away paint when it is removed.

Masking tape

Masking tape is used to allow you to paint right up to an edge without getting paint on the other side, and to paint crisp, straight lines. Be sure to choose the low-tack type, which is less sticky and therefore less likely to pull off paint when you remove it. If masking a surface that has already been painted, make sure the paint is completely dry.

To remove tape, pull it back on itself very carefully. You can then reuse it elsewhere if you wish. On large areas with a lot of tape, don't wait until all the painting is completed before removing the tape. Just as soon as you have completed painting the area next to a portion of the tape, remove that portion. This allows you to wipe off any paint that has bled underneath using a damp cloth before it has dried. If the tape does pull off any of the background paint, retouch it with the appropriate colour of paint.

Brushes

For nearly all the projects in this book you need only five brushes. First, there is a 5cm (2in) *decorator's brush*, which is a flat, thin, soft bristle brush that is used for painting relatively large areas. It enables you to pick up the paint and

cut in edges easily. For projects involving very large areas you could use a 7.5cm (3in) decorator's brush, but don't use one any larger or you will not have control over it. You also will need a *varnishing brush*, which is very similar; once it has been used for varnishing, it shouldn't be used for painting. A 5–7.5cm (2–3in) one will normally be adequate, but on very large areas you could use a 12.5–15cm (5–6in) one if you prefer. (I actually use another varnishing brush in place of a decorator's brush, because it gives even more control, but to avoid confusion a decorator's brush is specified in the projects in this book. Use whichever you find works better for you.)

> **TIP** Your brushes should last a long time if you look after them. Because the paints and varnishes are water-based, warm, soapy water is used to clean them. For an artist's brush, roll the head in the palm of your hand as you clean it, dry it on a cloth and then roll it to a point in your palm and store with the head pointing upward in a jar. For the other brushes, clean with a nail brush at the shaft, stroking down to the end of the brush, then allow to dry flat on newspaper. Don't leave brushes soaking overnight in water. When you use a varnishing brush for the first time, 'stab' the wall with it before putting it in the varnish, in order to get rid of any loose bristles.

The 2.5cm (1in) *fitch* is another brush that is good for cutting in edges. Thin, flat and slightly angled, it is used for shading smaller areas and blending colours together. From time to time you might also need a 12mm (½in) fitch.

Finally, you need two *artist's brushes*. The projects in this book call for a No. 8 (for larger details) and a No. 5 (for finer details). You could substitute a No. 7 or 9 for the No. 8, and a No. 4 or 6 for the No. 5. A No. 3 brush is also occasionally used for very fine detail. Artist's brushes are not as tough as fitches and decorator's brushes, so you have to avoid being too rough with them.

Other materials and equipment

Other items you'll need are a carpenter's level, tape measure, metre ruler (yardstick), smaller ruler, 6B and HB pencils, tracing paper (or thin layout paper, which is slightly more durable), lining paper for making templates, and an eraser (or use a damp cloth for erasing pencil lines). Reusable adhesive such as Blu-Tack is handy for positioning designs or holding tracings on the wall. You'll also need some cleaning cloths – I use mutton cloth (scrim). A plastic paint bucket or can with a lid is useful for mixing paints. An old plate or the lid of an empty can of latex paint is ideal for a palette. If you wish to paint any of the projects on canvas, use the ready-primed type.

Planning

Any trompe l'oeil project starts with the planning stage, when you think about what you want to do and how it will look in the room. Start with simple ideas until you are experienced enough to tackle a large-scale project such as a mural on one whole wall, or faux panelling all around a room.

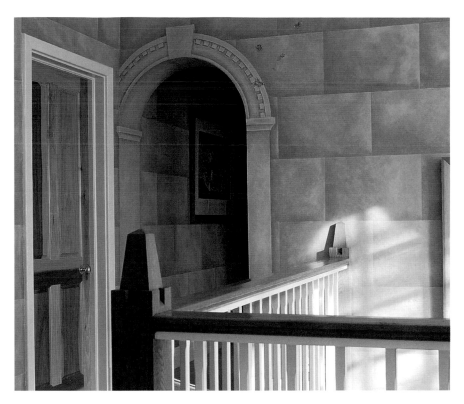

Reality checks

The project should, of course, take into account the style of the room – not just the colour scheme but also any architectural features. You could, for example, take designs for a faux pediment over a door from a cornice or the moulding on a mantelpiece.

One of the fun ways to tie in a trompe l'oeil project with the rest of the room is to merge the real and the faux. In the mural on pages 72–73, for instance, the painted floor tiles are a continuation of the real ones. In the design on pages 30–31, the small vase on the right is real while the books near it are trompe l'oeil.

Visual aids

If you are planning an overall theme in a room, it helps to prepare a simple floor plan so that you can work out the positions of everything and record any relevant measurements. The walls do not need to be accurately measured

or scaled down for the drawing (unless you are doing a slab-stone effect, for which you need to divide the width and height into equal sections). For small projects, simply sketch the part of the room where the trompe l'oeil will go, photocopy the sketch and then plan out your design on the photocopies. The sketch should only be rough, as the detail will emerge in the paintwork.

As for colours, buy sample cans, if necessary, and try all the colours on a piece of paper that is at least 11 x 17 inches. Ideally, apply each colour in the same proportion and using the same technique as in the project. To

Top: A slab-stone effect on walls requires careful planning.

Above: For trompe l'oeil all around a room, sketching a floor plan helps.

get the same texture as the wall you will be working on, paint a piece of cardboard with latex paint using a roller, and practise the brush strokes on this. Finally, to get an idea of how the project will look once it's in place, you can draw it on lining paper and fix it temporarily with Blu-Tack. Or you can just 'go for it' and experiment on the actual surface you'll be painting.

Preparation

Like any painting project, adequate preparation beforehand is essential for an attractive, long-lasting result. Fortunately, the amount of preparation most surfaces require is minimal, which means that you can get on with the more enjoyable part — the trompe l'oeil work — sooner.

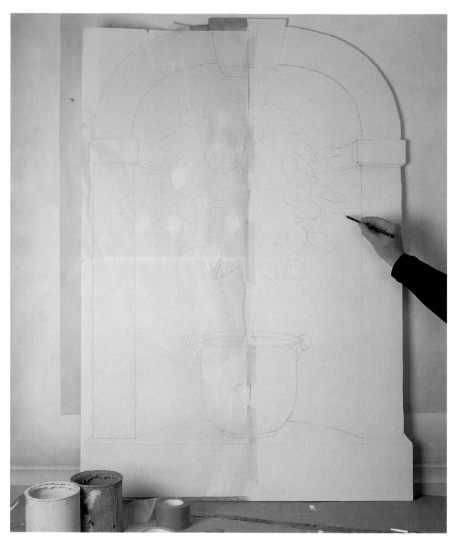

Each of the projects in this book mentions briefly what preparation was done beforehand, but the materials are not included in those listed for the trompe l'oeil work because it is the same as for ordinary decorating.

Base-coating walls

Remove any old paper from walls, fill cracks, and sand down the surface. Apply a base coat of flat latex paint in trade white or brilliant white (or, for a softer effect, cream or ivory) using a fluffy paint roller.

> TIP When painting the base coat on a wall, use a small radiator roller at the corners and edges, so that the stippled texture will continue over the whole wall.

Colourwashing walls

A colourwash makes an attractive background for trompe l'oeil. After painting a white base coat and allowing it to dry, dilute a coloured latex paint — for example, peach —

with the same amount of water in a paint can. Apply it to about 1 square metre (yard) of the wall at a time, using a 5cm (2in) decorator's brush and criss-crossing the brush strokes. Pick up some of the same colour, but undiluted this time, and add it in patches, softening the edges in the wash. Now pick up on the brush a little of a deeper but toning colour — for example, pale coral looks good with the peach — and add patches of it at random, again softening the edges.

Preparing portions of a wall

If you are not redecorating but are simply painting a design on a portion of wall, you can paint over the existing colour if it is white or a light earth colour. If it isn't, you'll need to outline the design on the wall and then paint

Above: For symmetrical designs, a tracing of half of it is turned over and used for the other half.

within the outline using white latex paint. Keep some of the paint that you used for the rest of the wall, to mix with raw umber if a subtle shadow is needed around the trompe l'oeil project. (If the rest of the wall is very dark, you may have to add a little black or deep blue-black to achieve the necessary depth of colour.)

Preparing other surfaces

Sand woodwork and paint it with a white acrylic primer. To paint melamine or previously painted furniture, sand it down or use a paint remover, then apply acrylic primer.

For metal surfaces, apply an acrylic metal primer and then acrylic primer; if it has been previously painted, apply paint remover beforehand. For plastic surfaces, sand lightly, then apply paint remover followed by acrylic undercoat.

Some of the projects can be painted on plywood or MDF (medium-density fibreboard), which is fixed to the wall or simply leaned against it. To prepare the board, make a template for it (see below), transfer the outline to the board, and cut around it with a jigsaw. Sand down the edges of the board, then undercoat with two or three coats of white acrylic primer.

Enlarging a design

For many of the projects, there are templates at the back of the book, and in some cases you will be able simply to trace the photograph illustrating the project or perhaps a photograph from

another reference source. Whichever you use, the design will probably have to be enlarged. Once you have worked out the appropriate dimensions for your room, either enlarge the design on a photocopier or, for very large designs, use the grid method:

1 Trace the design and draw a grid over the tracing.

2 Measure out the desired finished size on a piece of paper, and draw a grid on it with the same number of squares as your trace.

3 Copy the design square by square onto the paper.

> TIP When enlarging a design using the grid method, don't have too many squares in the grid, or it will make the drawing too detailed, which in turn results in the overall composition being too tight. At any rate, applying the paint will obscure many of these details, making it wasted effort.

Transferring a design

You can use special graphite paper, similar to carbon paper, to transfer a design, but I prefer to use the traditional 'pencil' method:

1 Trace the design onto tracing paper using a medium (HB) pencil. Then, with a very soft (6B) pencil, apply a thick line of pencil to the back

2 Tape the tracing to the surface you will be painting. Using a hard (H) or medium (HB) pencil, draw over the lines you traced. You'll have to press

Above left and above: When painting a small portion of a wall, the base coat can be applied just within the outline.

Below left: To enlarge large designs, use the grid method.

hard with the pencil. Before you remove the tracing, lift it to check you have transferred all the design.

3 Remove the tracing paper. The lines should have transferred to the surface, but you may need to strengthen them with pencil.

Symmetrical designs

With some designs, such as pots, urns and pediments, it's important that they are completely symmetrical, but it is easy to achieve this:

1 Using a very soft pencil, trace only half of the shape, marking the centre. Now turn the tracing over and transfer it to the wall as in steps 2 and 3 of Transferring a Design. Go over the hard/medium pencil lines on the paper using the very soft pencil. (Alternatively, if you are not using a template but are simply drawing the design straight onto the wall, draw only half of it then trace that onto tracing paper using a very soft pencil.)

2 Turn the tracing paper over again, line up the centre marks and transfer the other half of the design.

Perspective

There are two ways that trompe l'oeil tricks the eye into believing that a two-dimensional painting is a real three-dimensional object or view: one way is through the use of light and shade (see pages 17–18) and the other is through the use of perspective.

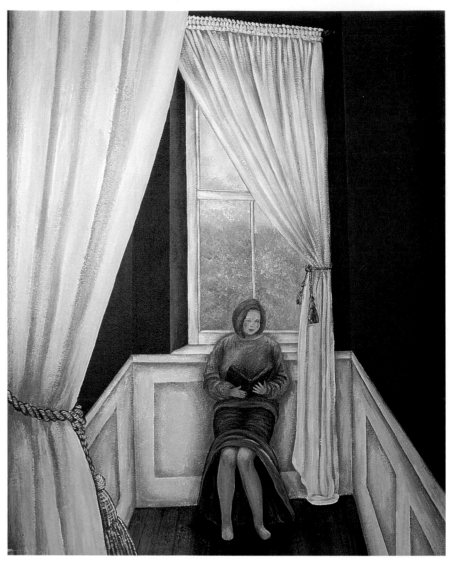

The observation point

In perspective drawing, the observation point or viewpoint – the point from which the observer sees the picture – always remains the same. Trompe l'oeil works best if it is a full-face view: in other words, with the picture viewed square on. This means that with something like a vase or pediment, the outline of each side is the mirror image of the other, which makes the work much easier. All the projects in this book use this central viewpoint.

The eye-level line

The starting point for all perspective drawing is the eye-level of the observer. This is an imaginary horizontal line at the level of their eyes when they are looking straight ahead at the picture. In a seascape or landscape it is the horizon line, and it is sometimes called the horizon line even in scenes that don't have a horizon. Anything above the eye-level line is drawn as though it is seen from below, and anything below the line is drawn as though seen from above, as shown in the diagram opposite.

To decide on the height of the eye-level in a trompe l'oeil, think about the room in which it will appear. In a kitchen or hallway, an eye-level corresponding to the viewer's eye when standing is generally used. In a sitting room or dining room, where the trompe l'oeil is more often viewed while sitting down, a lower eye-level is appropriate.

Vanishing points

Perspective utilizes the fact that two parallel lines (such as a railway track) eventually seem to converge in the distance, at a point on the eye-level

Above: The central viewpoint for perspective gives a mirror image of angles to follow when you are drawing the design.

line known as the vanishing point. Every pair of lines depicting parallel lines in a picture has a different vanishing point, all on the eye-level line. Usually the lines stop far short of the vanishing point, but they should be drawn at an angle that would cause them to meet at the vanishing point if they were extended that far. The farther that pairs of lines extend into a picture, the more noticeable the use of perspective will be and the more important it is to get it right.

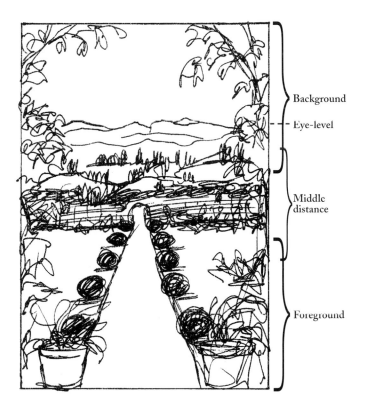

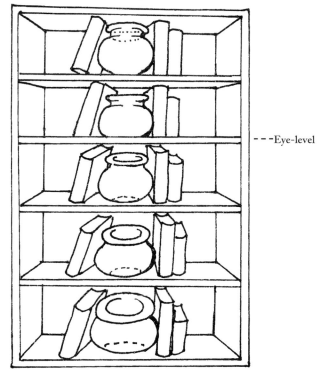

Background

Eye-level

Middle
distance

Foreground

Eye-level

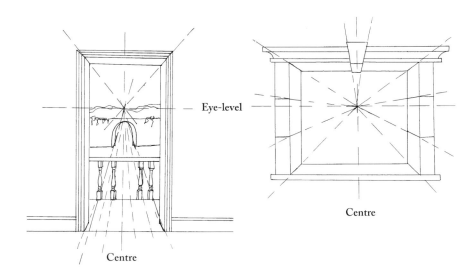

Eye-level

Centre

Centre

Above left: Start with the background then work through the middle distance to the foregound to the foreground, always overlapping the previous area.

Above right: Objects above eye-level are drawn as though seen from below; below eye-level as though from above.

Far left and near left: Parallel lines should be drawn as though they will meet at the vanishing point.

Background, middle distance and foreground

Perspective also exploits the fact that the farther away things are, the smaller they look. Landscape murals, in particular, utilize this, as they often comprise a background of sky, mountains, trees, etc., all roughly at eye-level; a middle distance of larger trees, garden walls and so on, roughly 1 metre (1 yard) from the floor; and a foreground, with large bushes, flowers,

objects, paths and suchlike, at the bottom of the mural (and sometimes also at the sides and top). To emphasize the effect, the background is indistinct and the foreground sharp.

TIP It is always advisable to draw the project where it will be hung, even if you are doing it on a piece of board or canvas. Remember, though, that detailed perspective drawing is mainly done with your paintbrush, so the only pencil lines you need are to define broad areas.

Of course, the transition between the three areas should be gradual rather than abrupt. Always paint the background first, then do the middle distance so that it overlaps onto the background. Finally, paint the foreground, overlapping the middle distance. Any trees, climbing vines or other foliage in the foreground at the top of the picture will help to emphasize the contrast between foreground and background.

Basic
Techniques

*You've chosen your project,
collected together the paint
colours and equipment, drawn
the design onto the surface —
now you are ready to paint.*

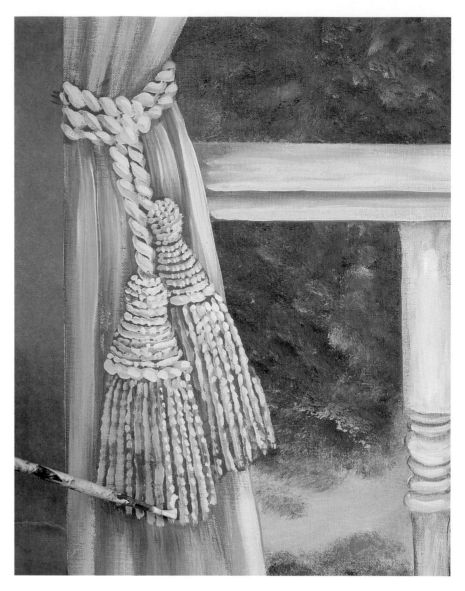

Using a palette

If you are using latex paint, start by
putting large puddles of the various
colours on the palette, using a fitch.
You can take latex paint straight from
the can, but the palette is handy
for removing excess paint from the
brush before starting to paint. (Also,
using a palette prevents the paint in
the can from getting dirty if there is
paint of a different colour already on
the brush.) If you are using acrylics,
squeeze no more than 2.5cm (1in) of
the tube onto the palette, as acrylics
dry out quickly.

Keep the colours separate, and leave
some room for blending them. Mixing
the colours on the palette allows you
to create whatever shade you want,
from subtle tonal variations to
completely different colours. Always
use a fitch for this, as it prevents wear
on the artist's brushes.

When to add water

Sometimes the paint needs to be
'loosened' slightly with water to help it
flow easily. Either add a little water to

the paint on the palette, or dip the
brush in water and then into the paint.

Diluting the latex or acrylic with
more water makes it suitable for
watercolour effects. Adding still more
water to latex creates a wash, while
adding it to acrylic produces a glaze; a
wash is cloudier than a glaze because
the pigment of the latex is not as fine
as that of acrylic. If you are using a
watercolour effect and wish to
strengthen the colour in places, simply
pick up undiluted paint on the brush.

> **TIP** Hold your brush towards the end of
> the handle, rather than close to the bristles.
> This allows greater movement and freer
> brush strokes.

**Above: Use different-shaped brush
strokes to create a variety of realistic
effects in your designs.**

Even when you are not painting with a
watercolour effect, you can strengthen
colour by applying paint more thickly
in some places – pick up undiluted
paint with no water on the brush.

Brushwork

Don't dip more than 6mm (¼in) of an
artist's brush, or 12mm (½in) of a fitch
or decorator's brush, into the paint.
Take off the excess on the palette or a
cloth – to control the paint, it's
important not to overload the brush.
When changing from one colour to a

very different, paler colour, dip the brush in water, rinse and dry with a cloth; when changing to a very different, darker colour, just clean the brush with a cloth. However, it's not always necessary to clean your brush between colours, as you will achieve more subtle colour changes without doing so, particularly when applying different tones of the same colour to an object. Leave the colour you have been using on the brush, and then start picking up another colour – as the old colour runs out and the new one slowly predominates, it creates a gradual transition between the two.

A similar way of creating tonal variations is to dip the brush into two or more separate colours on the palette and then apply them to the painting, allowing them to blend slightly as you apply each brush stroke. This creates a more interesting, uneven effect than if they are mixed together first. The steps for each project specify the method to use.

Blending colour

To blend adjacent areas of colour together imperceptibly, the edge of the first should be 'softened' over the background, which means the colour gradually fades away, and the edge of the new colour is softened over that.

For subtle blending in some projects, the instructions may say to keep a wet edge. To do this, dip the brush in water and paint it over the edge you wish to keep wet; you can do this for up to 30 minutes after painting it (less on a hot day). However, keeping a wet edge is not essential for subtle blending; if the paint has dried, you can soften the new colour back over the dry edge – start on the unpainted portion and

then begin softening over the painted edge as the brush empties of paint.

When painting one colour over another, if you want to keep them distinct and separate, leave the first one to dry before applying the next.

Backgrounds and large areas

Backgrounds and large areas are generally painted with a 5cm (2in) decorator's brush or a 2.5cm (1in) fitch, depending on the scale of the subject matter. When you want a smooth effect, with no individual brush marks visible, use horizontal strokes about 15–20cm (6–8in) long. For treetops and other foliage, use a stippling (dabbing) action to create a mottled effect. To shade and blend skies and to soften the edges of trees, use a loose, or 'slipping' stipple action, which is done by letting the brush slip a little as you stipple. To paint a section of wood panelling, use long, sweeping brush strokes in the direction of the grain, with the brush flat and using it to pull the paint out.

Foreground and detailing

The foreground, which is very detailed, is usually painted with artist's brushes. Although stippling can still be used for, say, flower heads, or fluffy tassel tops, the strokes are gentler. Not only does this create a more subtle effect, but it is less hard on the brush. Flower heads may also be 'printed' by pressing the brush down, dragging it slightly, then lifting it off.

Other basic brush strokes for painting detail using an artist's brush include C-shaped strokes, which are useful for rose petals and palm tree

TIP Save old brushes that have lost their shape to use for stippling trees, so that you won't wear out your new ones too quickly.

tops; and S-shaped strokes, which can be used to depict cording and rope. A similar but slightly less detailed technique utilizes a line of dots that just touch, rather like a chain; this is good for fringing in tassels, soft stripes in fabric, or even sailboat rigging!

When you are painting with simple, straight or gently curved brush strokes – for example, for faux fabric, books, jugs, fruit or individual leaves – these usually should follow the shape of the item being painted.

Shadows, midtones and highlights

Apart from perspective drawing, the main means of creating a three-dimensional effect in trompe l'oeil painting is through the use of shading and highlighting. Shading, in the form of a dark shade, is added where shadows would appear on the item. Highlighting, in the form of a very light tint of the hue (or cream or white), is added where the item would catch the light. The tones in between these are known as the midtones.

In landscapes, the trees, mountains, etc., in the distance are too small for this treatment, so it is only done to the middle distance and foreground. In other types of trompe l'oeil, a shadow is painted around the item onto the actual background; if you have some of the background colour, it can be mixed with raw umber acrylic paint to create a very realistic-looking shadow.

To know where the shadows and highlights will appear, you have to decide where the light source is. This should be the same as the real light source (such as a window) if there is one, but make sure it is a little to one side or the other (not directly behind you, which would look too flat). If, for

example, the window is above and to the left, then the highlights will be concentrated on the top and left, and the shadows mainly on the bottom and right edges (and in any grooves or other crevices). Don't exaggerate the effects of the light source, however, as the light is always changing in a room.

As an example of the use of these tones for 'modelling' a shape, think of a sphere lit by a light from top left. The shadow would be a crescent-moon shape extending from top right to bottom left, the midtone would cover the rest of the sphere, and the highlight would be a circle near top left.

Objects, plants and still lifes

Here is the sequence that is generally followed for painting objects, plants and still lifes either as a study or placed in a mural.

1 If the subject is painted without a mural background, a shadow is painted around it onto the background. Use raw umber on its own, and soften the outer edges into the background. If raw umber is too dark, add some of the background colour. Outline the composition with the dark tones. (You can add a touch of raw umber if necessary, but usually the colours are deep enough already.)

2 With the deep shade you used for outlining, 'block in' (i.e., fill in) the colour within the outline.

3 Next, paint the midtones on top of the blocked-in colour, leaving parts of the dark shade unpainted to create the shadows, particularly on the side away from the light source. (If you added raw umber to a colour to create the deepest shade in step 1, you can simply omit the raw umber for the midtone colour; alternatively, add white or cream to lighten a colour a little, or use a different paint colour that looks like a lighter version of the darkest shade.)

4 Finally, add highlights on top of the midtones using the lightest tint of the colour. (The simplest way to create this colour is to add white or cream to the midtone colour; sometimes white or cream is used on its own to highlight.) Build up extra highlights on the side near the light source.

Grisaille

This trompe l'oeil technique of monochrome painting to simulate architectural features has been used in Neoclassical decoration for centuries. Traditionally, the paints used were dark grey, light grey and white, but I like to use either dark grey-brown, cream and white, or dark grey-brown, tan and cream. For a more dramatic look, you could choose darker colours, such as dark red-brown, dark tan and sand, or perhaps black, dark green and mid-green. Grisaille is used for the architectural projects in this book – pediments, archways, doors and windows and faux panelling. It is done as shown opposite.

> **TIP** Work on only one portion of the pediment (or other moulding) at a time, so that you can adjust the effect before it dries, if necessary.

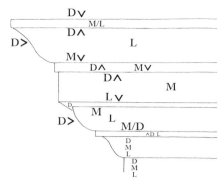

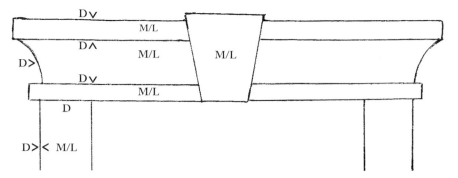

Above and above right: Draw your moulding design and mark the grisaille shading as dark (D), mid (M) and light (L) tones.

Grisaille techniques

1 After drawing the pediment (or other moulding) on the wall in pencil, use a fitch and the darkest shade – dark grey-brown is shown here – to paint a shadow on the wall around it. Rub it with a cloth and/or a dry fitch to soften the shadow, so it is dark at the inner edges and fades away subtly.

2 With the same colour and an artist's brush (No. 5 for thin lines, or No. 8 for thicker lines), paint along each of the lines using long strokes. Keep the edge alongside each line crisp and sharp, and soften the other edge by thinning the colour with a touch of water on the brush. Allow to dry.

3 Using the midtone – sand is shown here – loosened with a little water, paint the remainder of the pediment (or other moulding) with an artist's brush. Again, take up a touch more water on the brush, and soften the edges into the softened edges of the darker shade. You can also use the cloth for this, lightly rubbing horizontally. Allow to dry.

4 Using the No. 5 brush and the lightest tone – cream in this case – with no water added, 'dust' the light tones over the midtones, referring to your moulding design sketch.

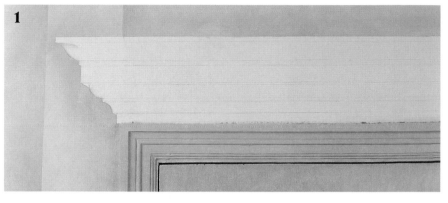

1

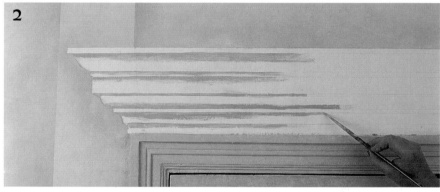

2

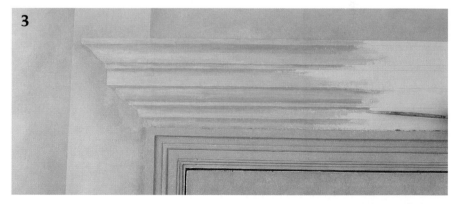

3

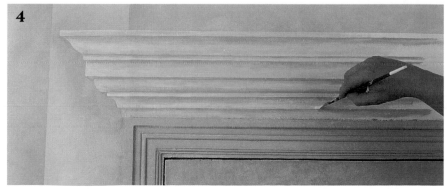

4

PROJECTS

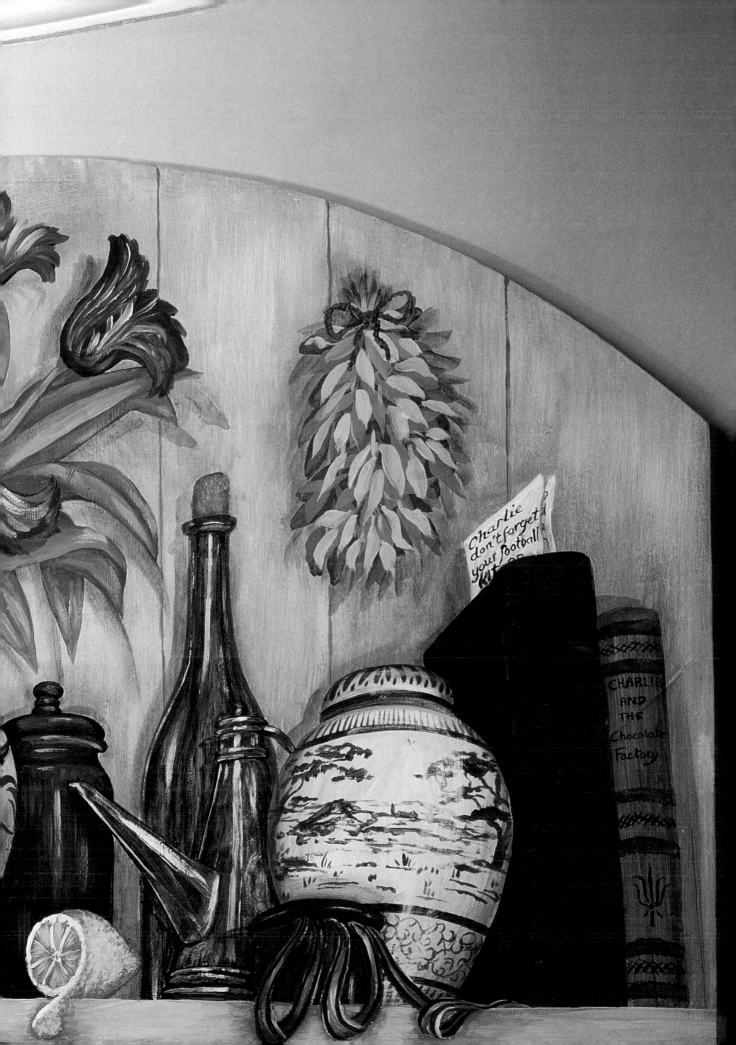

Charlie
don't forget
your football
kit...

CHARLIE
AND
THE
Chocolate
Factory

HALLWAYS

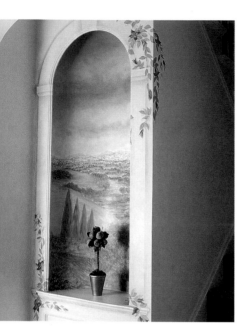

Left: A real niche in a hall or on a landing creates great visual impact with a subtly painted distant landscape. The clematis in the foreground and the faux stone surround complete the picture.

Right: This trompe l'oeil table and vase of flowers in a niche are hiding a door leading from the hall into a powder room. The rope, tassels and table legs are all judiciously placed to hide the outline of the door, and the recessed brass door handle is camouflaged by the brass candlestick and framed pictures on the table.

Trompe l'oeil can be very useful in the hallway. As the first part of the home that family and visitors see, the hall needs to be welcoming, yet it's often too small and filled with nothing but doors. You can make it look a lot more impressive with faux pediments over the doorways or trompe l'oeil paintings on one or more doors to make them virtually disappear. Furniture and vases of flowers can be painted on the doors and walls whether there's room for the real thing or not. Faux stone slabs provide an elegant wall finish, and the neutral tones help make a small area seem more spacious.

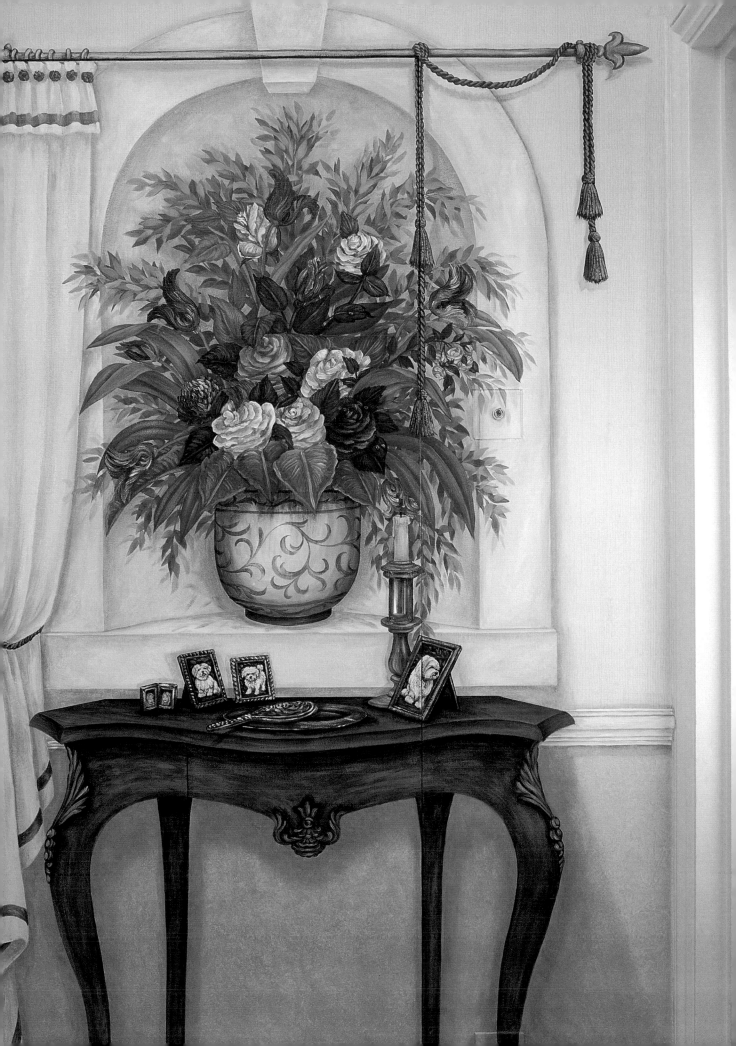

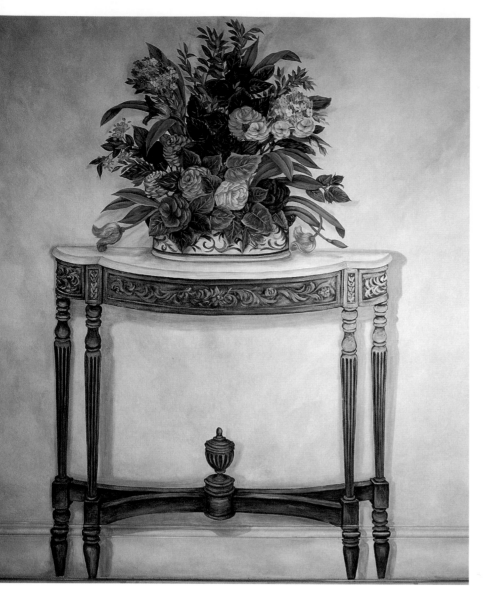

YOU WILL NEED

Template of table (page 134)

Tracing paper and pencils

Acrylic paints in raw umber, titanium white, ultramarine, black, raw sienna, yellow ochre, crimson and metallic gold

Flat latex paints in wall colour, dark green, cream and light green

2.5cm (1in) fitch

No. 5 and No. 8 artist's brushes

Matt varnish and varnishing brush

Preparation

This wall was painted with a colourwash of light Etruscan pink over a white base coat, but other colours or a flat finish would also be suitable (though colours that are not light would have to be overpainted with white within the outline of the trompe l'oeil).

Enlarge the table template and transfer it to the wall using tracing paper and pencils (see page 13). Draw one half of the vase, trace it, and transfer the other half of the vase to the wall (see page 13). Lightly pencil onto the wall the rough shapes of the flowers and foliage.

Table with Vase of Flowers

This elegant table with its faux limestone top and splendid flower arrangement will add colour and wit to any hall, and it has the added benefit of taking up no floor space. Nor will these flowers ever die! If you wish, adapt the flower colours to match your decor.

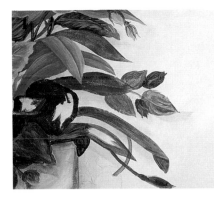

Shadows and blocking in

1 Mix a little raw umber with the wall colour, and using the fitch, paint the shadows outside the outline of the table, tabletop, vase and floral arrangement. Mix white, ultramarine and black, and with the No. 8 brush, block in the vase; concentrate the darkest colour around the edge and under the foliage as shadows, and take up more and more white on the brush as you work towards the centre. Block in the foliage in dark green. Block in the flowers in raw sienna, yellow ochre and crimson, adding a little raw umber for the dark tones. Block in the wooden part of the table in raw umber.

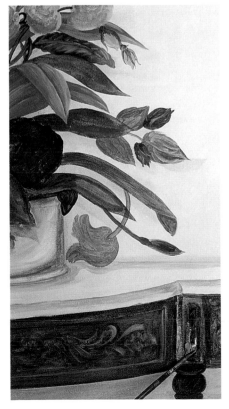

Tabletop and all midtones

2 Mix cream, raw umber and white, and with the No. 8 brush paint the tabletop, including shadows under the vase, as for grisaille (see pages 18–19). Mix raw umber with raw sienna and gold, then paint the midtones of the wood to bring out the carving. Mix light and dark green, and add foliage midtones with C-shaped brush strokes, working from the edges of the arrangement into the middle. Mix white with the flower colours and use the No. 5 brush to apply these as midtones to the flowers.

> **TIP** If you prefer, you can complete each flower – painting its dark, mid- and light tones – before starting the next.

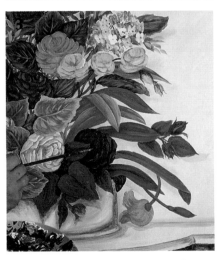

Flower highlights and detailing

3 Mix more white into the flower colours, and use this to add highlights to them with the No. 5 brush. Pick up black and yellow ochre paint on the brush without mixing them, and add the centres to the flowers.

Table highlights

4 Mix a little white or cream into the gold, and using the No. 5 brush, subtly highlight the table.

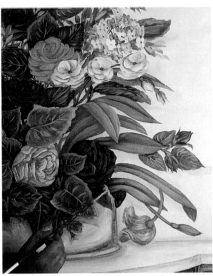

Foliage highlights

5 Add some more light green to the green used for the leaf midtones, and with the No. 5 brush, paint highlights onto the leaves. Add cream to this mixture, and apply some paler highlights. When the flowers painted in step 3 are completely dry, add some further leaves, overlapping the flowers.

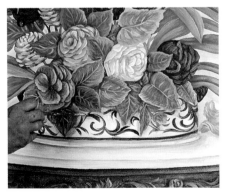

Vase pattern

6 Lightly pencil a design on the vase. Take up some crimson, raw umber and light green on the No. 5 brush without mixing them, and paint in the pattern. Check the whole design, and add any extra flowers, leaves or detailing that you feel are necessary. When the paint is completely dry, apply a coat of varnish.

Stone Pediment

A faux stone pediment above a doorway makes the door look more important, which is particularly useful in a hallway, where you may want to accentuate the door leading into the sitting room. The extra height can also improve the proportions of double doors. Here, the wall is painted in the same tones as part of the project.

YOU WILL NEED

Straightedge, pencils, tracing paper and carpenter's level
No. 8 artist's brush
Flat latex paints in dark grey, mid-grey and pale silver-grey
2.5cm (1in) fitch
5cm (2in) decorator's brush
Low-tack masking tape

Preparation

The wall was painted first with a white latex base coat.

With the straightedge and a soft pencil, draw half the pediment on tracing paper, using the photo as a guide. With a hard pencil, transfer it to the wall above one half of the door (see page 13), using the carpenter's level to make it level, then transfer the reversed tracing to the wall above the other half. Add the horizontal lines, using the carpenter's level.

Measure and mark the centre of the door with a light vertical line, and draw the keystone centred on this, with a width of about 15cm (6in) at the bottom and 23cm (9in) at the top. A keystone would normally project about 12mm–2.5cm (½–1in) above the pediment, but the ceiling was too low for that here.

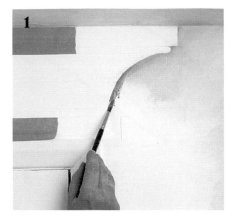

Shadow and wall

1 With the No. 8 brush, paint a dark grey shadow on the wall alongside each end of the pediment, using long brush strokes. Soften the edges of the shadow into the wall using a fitch. Now mix the mid-grey and pale silver-grey, and paint the surrounding wall with this, using the decorator's brush in a swishing motion; vary the tones by adding water and extra pale silver-grey, and at the edges of the wall add extra mid-grey to make it a bit darker.

Concave section

2 On one side of the pediment, mask outside the top and bottom edges of the section that is to be painted to look concave (curving inwards) and also outside the edge where this section meets the keystone. With the fitch, paint alongside the tape with dark grey, softening the edges towards the centre. Pick up some mid-grey on the fitch, and paint the remainder of the masked area.

3 Still using the fitch, pick up some of the pale silver-grey, and apply this to the most central part of the section, softening it out towards the edges. Use the No. 8 brush to apply the pale silver-grey to the pediment along the curved edge next to the wall. Remove the tape. While this side dries, repeat step 2 and this step for the other side of the pediment and leave to dry.

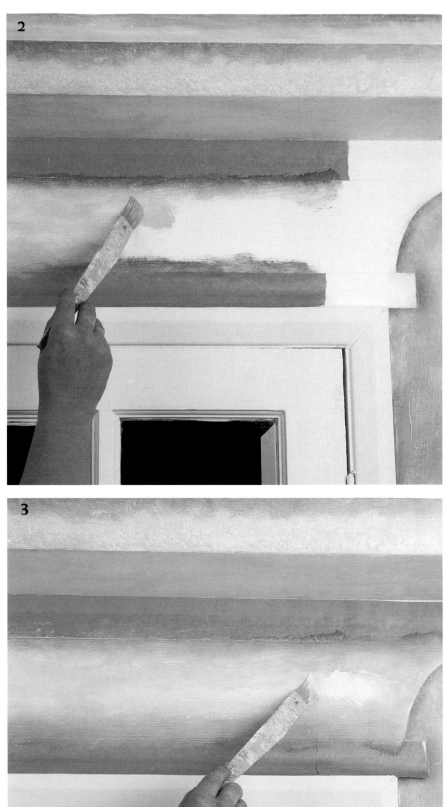

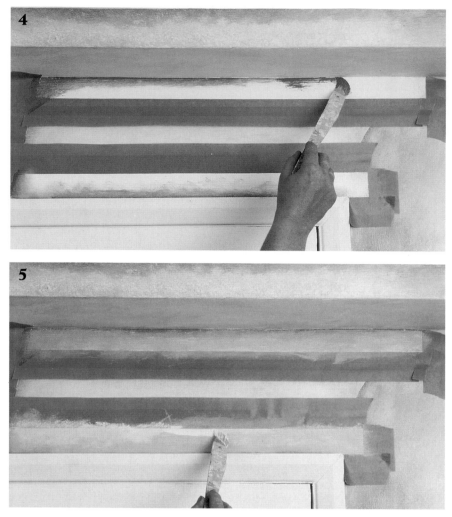

5 Using the fitch and mid-grey, fill in the remaining parts of both the top flat section and the bottom one, softening into the dark grey shadows. Pick up pale silver-grey and use this to highlight the edges that don't have shadows, again softening the edges. Remove the tape, and leave to dry while you repeat step 4 and this step for the other side of the pediment.

Convex section

6 Mask outside the top and bottom edges of the narrow strip that is still unpainted; also mask outside the end next to the keystone, as shown. This section is to be painted to look convex (curving outwards). With the No. 8 brush, paint the upper edge dark grey, softening it into the centre. Now pick up mid-grey on the brush, which should still have a little dark grey on it, and paint along the lower edge. Pick up a touch of water, and soften the mid-grey edge into the dark grey

Top and bottom flat sections

4 Mask below the lower edge of the flat section at the top of the pediment, and above the upper edge of the flat section at the bottom of the pediment; also mask outside both ends of these two sections, as shown. Using the fitch, paint a heavy dark grey shadow along the lower edge of the bottom flat section, extending along the end next to the keystone; soften the edges towards the centre. Because this room has a cornice around the ceiling, the upper edge of the top flat portion has to be in shadow, so it is shaded with dark grey (which, once again, extends along the end next to the keystone). If there were no cornice, the shadow would be on the wall above the pediment, and the top flat section would be painted without a shadow.

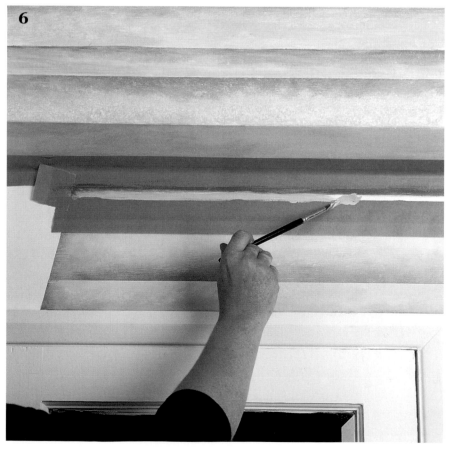

previously painted. Pick up a little pale silver-grey and paint the rounded end next to the wall, then soften back along the lower edge. Remove the tape and leave to dry while you paint the strip on the other side.

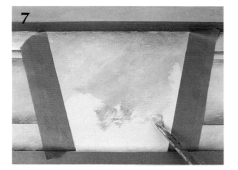

Keystone

7 Mask outside all four edges of the keystone, which is to be painted as though it were a flat piece of stone. Use the fitch to stipple mid-grey and pale silver-grey over the whole area.

8 While the paint is still wet, pick up a touch of dark grey on the uncleaned brush and use it to add a little shadow to the lower edge of the keystone, and a very small amount to the centre. Also blend a thin shadow along the top edge because of the cornice mentioned in step 4. Remove the tape and leave to dry.

TIP If there is no cornice, the shadow along the top edge of the keystone should be left light.

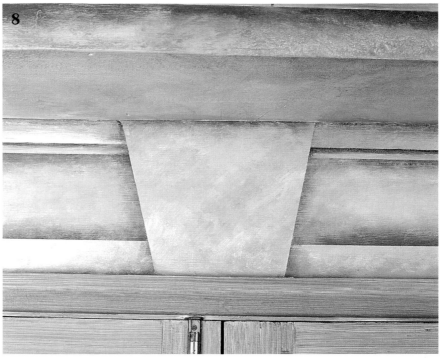

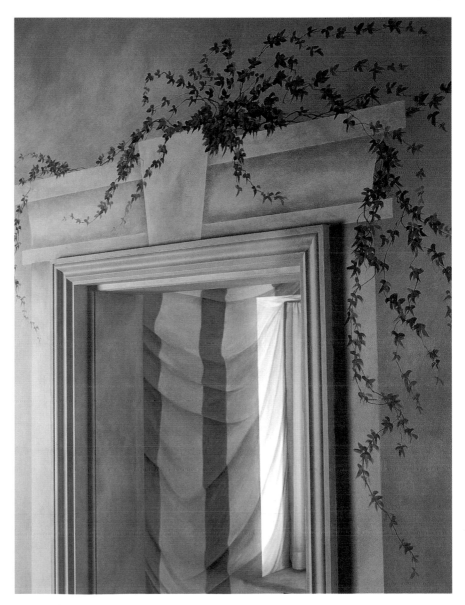

Right: Here, a similar pediment is decorated with ivy. There is more room above this one, allowing the keystone to project above the rest of the pediment.

LIVING ROOMS

Left: Faux Italianate panelling looks good in an opulent decor. The colourwashed outer and inner panels are separated by scroll-effect faux mouldings highlighted with gold paint to reflect the candlelight and add to the rich atmosphere.

Right: These painted windows combine almost every type of trompe l'oeil: landscape, faux fabric, architecture and still life. Whether a room lacks windows or not, a painted one will add character and interest, provided it matches the real windows in style.

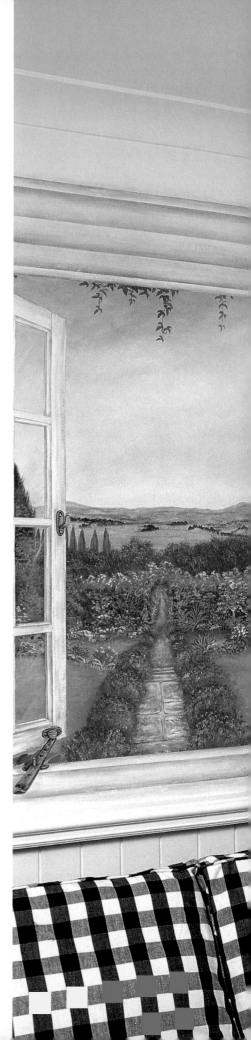

Trompe l'oeil can be adapted to any style of decor, and a living room provides the perfect site. Because most of the furniture tends to be placed against the walls, any elaborate wall treatments should be concentrated on the upper walls. Faux panelling works well here because it not only looks elegant but also provides a good background for pictures and mirrors. If the living room lacks windows, views or a focal point, a trompe l'oeil window is the answer, and it doesn't involve redecorating the whole room. Smaller opportunities for clever paintwork also abound, from mirror frames to firescreens to TV cabinets.

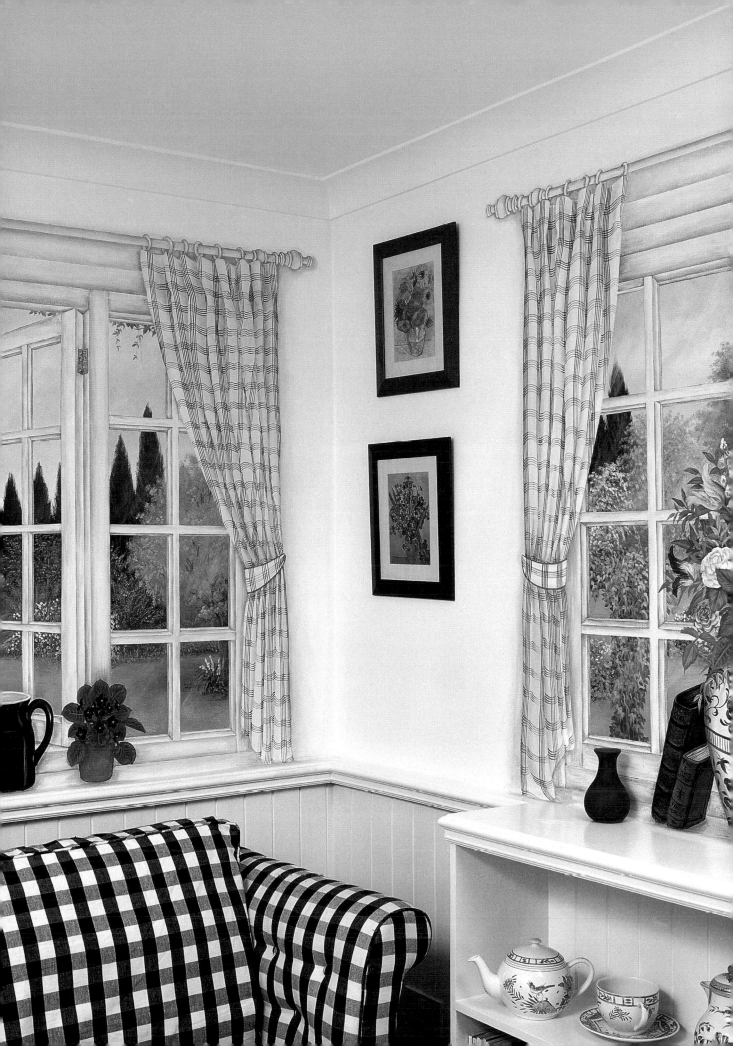

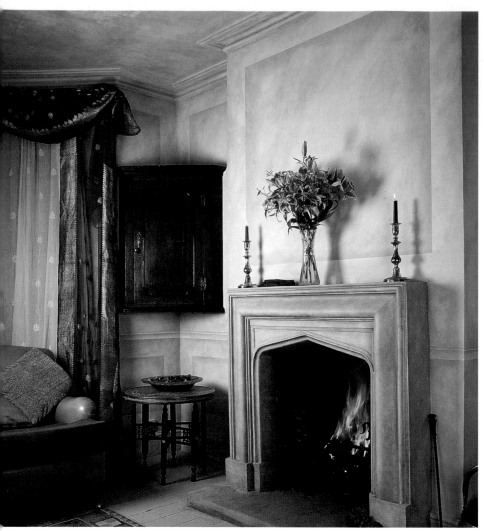

Stone Panelling, Ceiling and Fireplace

A faux stone fireplace, either on its own or combined with matching panelling, looks remarkably realistic and makes an effective background for furniture, pictures, mirrors and perhaps trompe l'oeil niches. If you wish, stipple the woodwork in the same three tones to blend with the faux panelling.

Pencil, tape measure, carpenter's
 level and straightedge
Low-tack masking tape
 (for panelling)
Two 5cm (2in) decorator's brushes
Flat latex paints in dark grey-brown,
 honey-sand and cream
No. 8 artist's brush (for panelling)
2.5cm (1in) fitch
Acrylic paint in black and raw umber
 (for fireplace)
2 small jam jars with lids
 (for fireplace)
Matt acrylic varnish and varnishing
 brush (for fireplace)

Preparation

A base coat of white latex was applied to the surfaces that were to be painted, after the fireplace and woodwork had been primed with acrylic primer.

The panelling can cover the walls either to chair-rail height or to the ceiling. Here, each wall has two panels, one above the other; the bottom one extends from the baseboard to a trompe l'oeil chair rail, while the top one extends from there to the ceiling or cornice. The panels stretch from one corner of the wall to the other, so as not to break up the wall areas. Each window has a panel beneath it, and each door has a panel above it. Chimney breasts and niches have separate panels.

With a pencil, tape measure, carpenter's level and straightedge, mark the edges of the 6cm (2½in) wide chair rail, the panels and a 12.5–20cm (5–8in) wide surround framing each panel.

TIP For a marginally warmer look, you could use cream latex paint rather than white as the base coat, and slightly darker midtones and shadows.

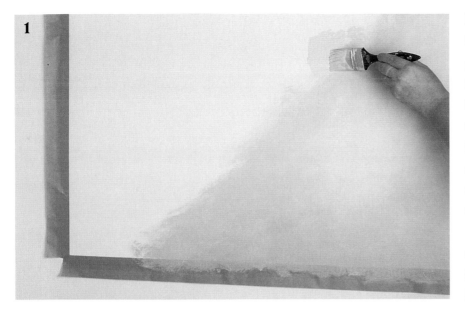

1

Panelling

1 This technique, in which three neutral tones are used together, is similar to grisaille (see pages 18–19) but the colours are blended together and diffused across the wall more than in the harder-edged technique of classic grisaille. Start by masking around the outside of a panel. Dip a decorator's brush first in dark grey-brown and then in honey-sand latex paint, and apply the colour around the edges of the panel using sweeping brush strokes and working into the centre. Reserve this brush for these colours, and use the other one for the cream paint.

2 Add a little water to the other decorator's brush, and work the cream paint into the centre of the panel, softening back into the darker tones, so that the panel almost imperceptibly becomes lighter towards the centre. For extra interest, add small areas of the dark tone to the light centre. As soon as you have finished the panel, remove the tape. Allow to dry. This procedure is repeated for each panel; you can either do all the panels and then all the surrounds (see step 3), or each panel followed by its surround.

Panelling: surrounds

3 For the surround framing an *upper* panel, mask below the lower edge of the bottom section of surround; there is no need to mask the other three sections. Once again, start painting from the outside, applying a blend of dark grey-brown and honey-sand with the decorator's brush already used for these tones.

Now, with the cream brush, paint cream into the inner edges, softening back into the darker edges. As the brush empties of paint, soften the light tones into the dark edges of the panel (the panel needs to be dry). Work around the surround in lengths of 60–90cm (2–3ft) at a time so that the paint is still damp as you blend. As before, remove any tape once you have finished with it.

For the surround framing a *lower* panel, repeat the process, but mask along the upper edge of the top section of surround, and shade below this line, to create a shadow underneath the faux chair rail.

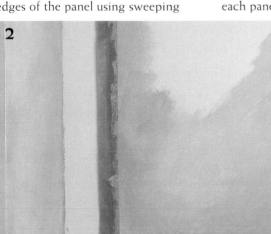

2

3

Panelling: chair rail

4 For the chair rail, mask above the upper edge of the unpainted strip. Draw a line 15mm (⅝in) below this. Using the No. 8 brush, paint along this edge with the dark grey-brown. Pick up some cream and apply this, softening it into the dark grey-brown and working away from the taped edge towards the pencil line. Remove the tape and leave the paint to dry.

5 Mask above the pencil line, and with the fitch apply the dark grey-brown along the taped edge. Pick up cream on the brush, and soften into the dark tones, working towards the lower edge. As the brush empties, soften over the edges onto the surround underneath (which needs to be dry). Remove the tape.

Ceiling, cornice and ceiling rose

6 The dark grey-brown isn't used for the ceiling. With the decorator's brush already used for the darker tones, stipple honey-sand latex paint around the edges, covering an area no more than a metre (yard) wide at a time. Work in circles around the ceiling, painting in towards the centre.

7 As you approach the centre of the ceiling, change to the cream decorator's brush and start taking up more and more cream and less of the honey-sand; soften it into the honey-sand. It's easiest to paint the cornice at the same time as you move around the edge of the ceiling, but don't cover more than a metre (yard) at once. Dip the fitch into water then into the dark grey-brown and honey-sand. Paint the grooves of the cornice with this. Now paint the remainder of the cornice using the decorator's brush and the cream paint, blending it into the dark tones and softening with long strokes. If there is a ceiling rose, stipple it in the same way, using circular strokes.

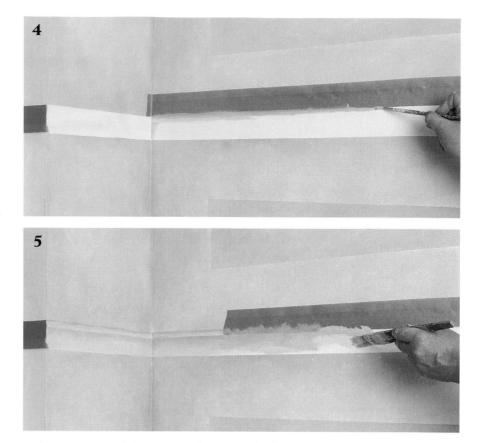

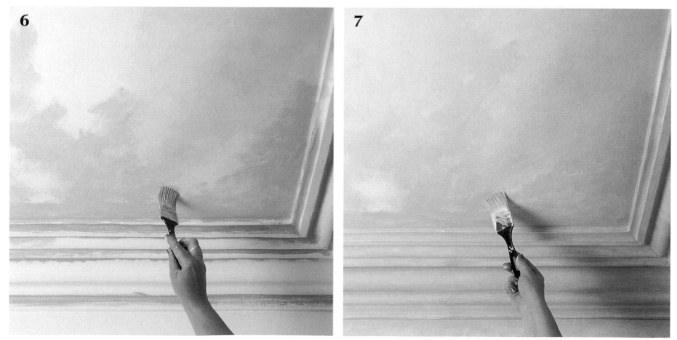

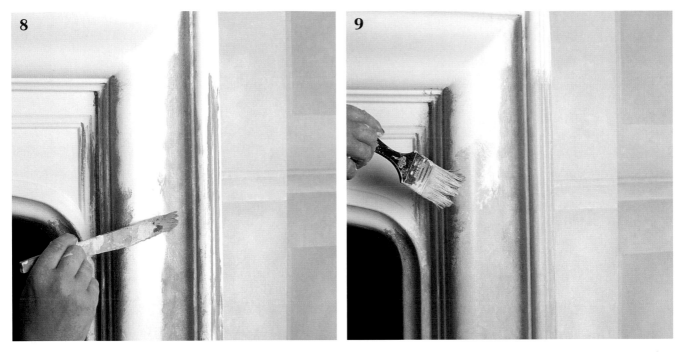

8

9

Fireplace

8 In one jar, mix a little black acrylic into the dark grey-brown. Squeeze about 4cm (1½in) from the tube of raw umber into the second jar; using the fitch, stir in a little water to make the raw umber a consistency slightly thinner than latex paint, then mix in some honey-sand paint until the jar is about three-quarters full. With the fitch, paint the darkest tone (dark grey-brown/black) into the recesses of the mantelpiece, working on a 30cm (1ft) length at a time. For ease of blending, let this dry only partially, so that the edges are damp as you paint the next step.

9 Now apply the medium tone (honey-sand/raw umber), working away from the recesses and using a stippling action to blend the tones. You can pick up a little of the darkest tone on the brush if needed. For the smaller moulded areas use the fitch, and for the larger mouldings use a decorator's brush.

10 Start picking up cream paint with the cream decorator's brush, still using a stippling action, and apply this on areas that would catch the light.

11 When the paint is dry, any areas that seem too strong can be softened. Do this by removing excess paint from the decorator's brush so that there is almost none left on it, and then 'dusting' undiluted honey-sand or cream paint on softly. Leave for 24 hours, then apply two coats of varnish, allowing it to dry between coats.

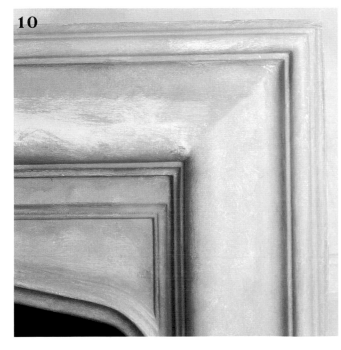

10

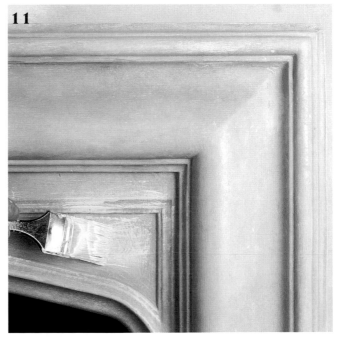

11

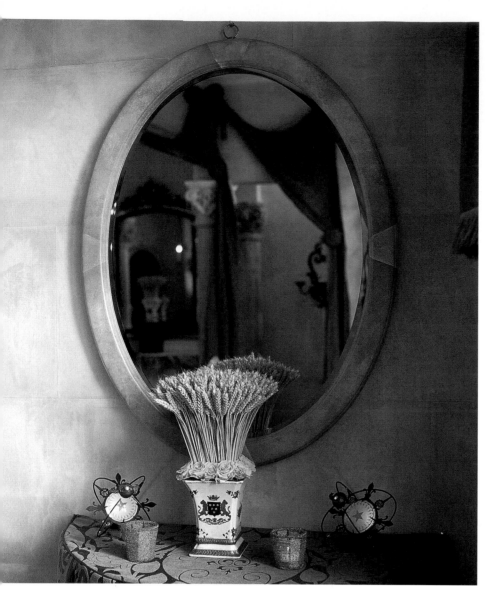

Stone Mirror Frame

This faux stone mirror frame is extremely versatile – any frame can be used as long as it doesn't have too much moulding detail. The stone effect looks good on all types of wall, including matching faux stone, as here. It looks good in virtually any room of the home, but its elegance makes it especially well suited to the living room.

YOU WILL NEED
Pencil and ruler
Low-tack masking tape
2.5cm (1in) fitch
Flat latex paints in dark grey-brown, tan and cream

Preparation

The mirror frame was sanded down and undercoated with two thick coats of white acrylic primer and then allowed to dry.

If possible, remove the mirror from the frame to make it easier to paint the edge. Otherwise, wait until the frame has been varnished and has dried before wiping off any paint that gets on the mirror.

With a pencil, mark the centre of the top, the bottom and both sides. Draw the four wedge-shaped keystones so that each is centred on one of these lines; they should be 5cm (2in) wide on the inner edge and 7.5cm (3in) wide on the outer edge. (If the frame is rectangular, they could go at the corners.)

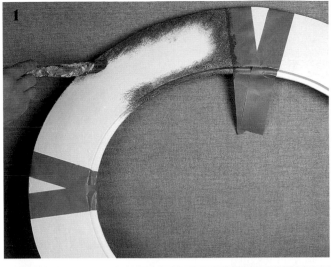

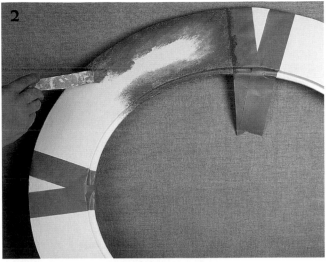

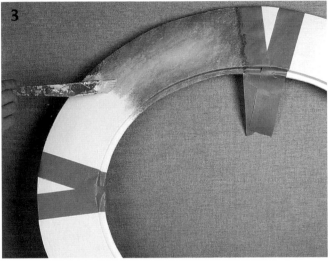

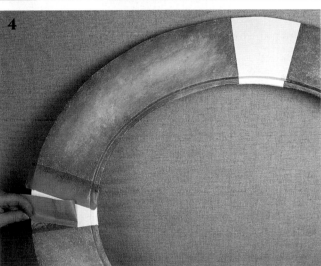

First section

1 Mask inside the straight edges of the keystones. Take up a little water on the fitch, and then some dark grey-brown paint, and stipple both the inner and outer edges of part of the frame, as well as along the masked edges. Work on no more than 15–20cm (6–8in) at once, to keep the paint wet for blending.

2 Clean the fitch lightly with a cloth, and then stipple tan paint around the inside of the dark grey-brown, blending the two colours together where they meet.

3 Clean the fitch once more and, using cream paint, stipple the centre between the two areas of tan, blending the two colours together where they meet.

Remainder of frame

4 Repeat steps 1, 2 and 3 for the next section, and continue in this way until the whole frame has been painted, apart from the keystones. Remove the tape, and leave the frame to dry.

Keystones

5 Mask outside the straight edges of the keystones, then stipple dark grey-brown paint along both curved edges of one keystone. Do not clean the fitch – just pick up tan and cream on it without mixing them, and stipple the centre of the keystone, blending the paint into the edges of the dark grey-brown. Add extra cream on the masked edges to make the keystone appear to be above of the rest of the frame. Remove the tape. Repeat for the remaining keystones.

TIP After removing the masking tape from the edges of the keystone, you can always reapply tape if you need to touch up the paint along any of the edges.

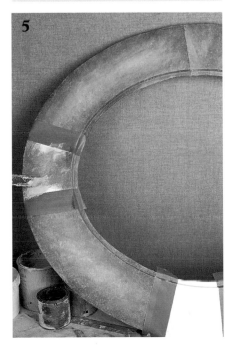

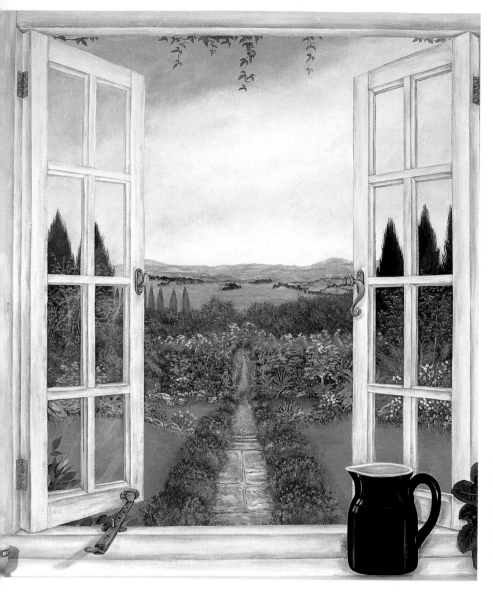

Window with View

For the ultimate trompe l'oeil, paint a window that matches your real windows and has a fabulous view. This window has small panes but the technique can be adapted to other styles. Add faux curtains to match your decor and, on the window sill, whatever ornaments you wish, all taken from other projects in the book.

Tracing paper, pencils, carpenter's level and straightedge

Templates of fastener, hook and stay (page 135) and jug (page 136)

Low-tack masking tape, 5cm (2in) wide and 2.5cm (1in) wide

Flat latex paints in sky blue, white, deep purple, pale lime green, pine green, cream, dark olive green, dark grey-brown, tan and terracotta

5cm (2in) decorator's brush

No. 5 and No. 8 artist's brushes

2.5cm (1in) and 12mm (½in) fitch

Acrylic paints in black, crimson, cadmium yellow, ultramarine and metallic silver

Matt varnish and varnishing brush

Preparation

This wall was painted in white latex paint, but the project could be painted on a coloured wall if the window area is painted white first.

Enlarge the window shown here and on pages 30–31, and transfer it to the wall using tracing paper and pencils (see page 13), or use a pencil, carpenter's level and straightedge to draw it on the wall. For convenience, make the muntins the width of the narrower tape and the remainder of the wood the width of the wider tape. For the hardware, enlarge the templates and transfer them to the wall. If you are painting a jug on the window sill, enlarge and transfer it to the wall.

TIP To get the angles of the top and bottom edges of the open windows right, either trace and enlarge the ones shown in the photos, or stick strips of low-tack masking tape in position on the wall, adjusting them until they look right.

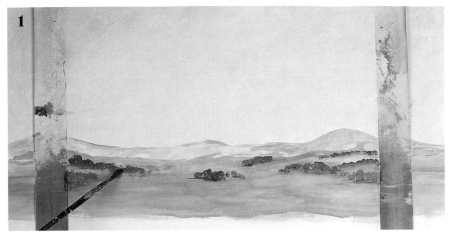

Landscape background

1 Cover the window with masking tape, using the 5cm (2in) tape for the stiles and rails and the 2.5cm (1in) tape for the muntins.

Using sky blue and white, paint the sky with a decorator's brush, and using deep purple thinned with water, paint the mountains with a No. 8 brush, as for the sky and mountains in Balcony View, step 1 (see page 49).

Mix pale lime green with water, pick it up along with touches of white and pine green on the No. 8 brush, and paint the distant hills in the same way.

Mix pale lime green with a touch of cream and some water, and using the decorator's brush, paint the grass in the distance. For the grass next to the hills, pick up a little dark olive green on the brush without mixing it.

Add some distant clumps of trees using the No. 8 brush and dark olive green. Remove the tape as soon as the area next to it is painted.

Landscape middle distance

2 Using the 2.5cm (1in) fitch and dark olive green, begin painting the middle distance, stippling the rounded, leafy trees and using long brush strokes for the poplars. Pick up pine green and black on the fitch, and paint the larger pine trees on each side, using long strokes. Remove the adjacent tape.

3 Clean the fitch, pick up dark grey-brown and tan, and paint the edges of the path. Pick up some cream on the fitch and use long horizontal strokes to fill in the path; continue it through the archway while leaving some white at the sides. Pick up some tan and dark grey-brown on the fitch, and add shadows suggesting one or two steps.

Clean the fitch, mix terracotta with dark grey-brown, and paint the brick wall in the middle distance, leaving an archway in the centre. Pick up more terracotta and a little cream, and add horizontal brush strokes to the wall.

Still using the fitch, stipple the copper beech tree on the right in terracotta. Clean the fitch.

4 Mix pale lime green with water, and using the decorator's brush, paint grass in the middle distance. Use a loose stipple with the 2.5cm (1in) fitch to add dark olive green foliage along the path. In front of the wall, paint flower borders in pine green; pick up some water and soften the lower edge onto the grass. Mix dark olive green with pale lime green, and stipple the vine above the wall, feathering the edges.

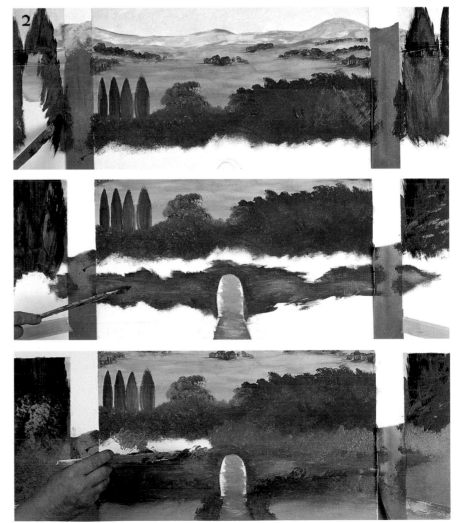

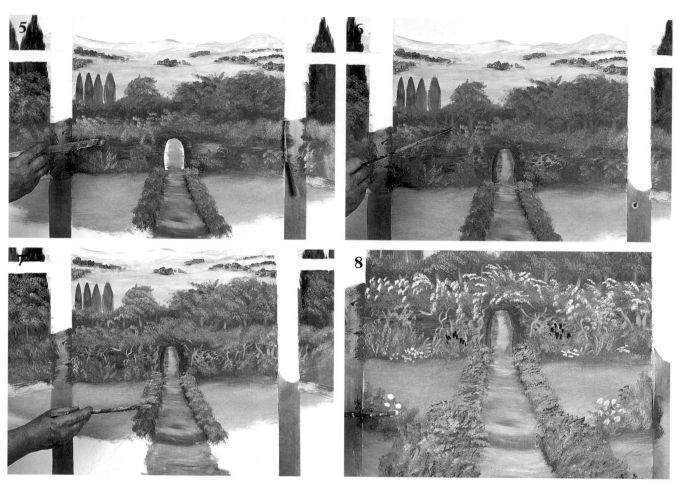

5 Mix some white with dark olive green, and use the same fitch to stipple midtones onto the foliage lining the path; also add midtones to the poplars and pine trees in this colour, using longer brush strokes. Clean the fitch, mix pale lime green and dark olive, and stipple midtones onto the rounded treetops in the centre, giving them 'frothy' edges. Use some of the same colour to stipple midtones onto the flower border at the base of the wall. Vary the amount and shape of the stippling to suggest different plants. Mix pale lime green with white, and stipple midtones onto the Russian vine.

TIP The midtones and highlights can be applied while the foliage is still wet, which helps to vary the tones, but if the foliage is already dry, it doesn't matter. Here, the mixing of the different shades on the palette is the most important element.

6 Using the No. 5 brush, stipple some dark olive green foliage edging the path inside the archway, then mix white with the green and stipple the midtones. Clean the brush, and use it with dark grey-brown to outline the inside of the archway (also picking up a little black on the brush when doing this), to paint some bricks in the wall and to add tree trunks and branches to the trees behind the wall and to the copper beech.

7 Using the 2.5cm (1in) fitch, pick up terracotta and tan on the brush, and use it to stipple highlights onto the copper beech foliage.

Mix a little white into the dark grey-brown, and with the No. 5 brush, add a few highlights to the tree trunks (they don't need midtones here). With the same colour paint some squiggly lines representing Russian vine stems growing against the brick wall.

Add some white to the mixture of pale lime green and dark olive green used in step 5 for the midtones of the treetops and flower border at the base of the wall, and stipple highlights onto them using the 2.5cm (1in) fitch.

Add more white to the pale lime green and white mixture used for the midtones of the Russian vine in step 5, and stipple some highlights onto the vine with the fitch.

Now mix a lot of white with dark olive green, and use the fitch to stipple highlights on the foliage edging the path (including along the path inside the archway). Remove the tape next to the painted area.

Landscape foreground

8 Using the decorator's brush, fill in the foreground grass as in step 4. With the 2.5cm (1in) fitch, stipple dark olive green foliage edging the path in the foreground, then add midtones

and highlights to this foliage as in steps 5 and 7.

'Print' flower heads of different shapes by dotting the No. 5 brush in various ways. For the flowers in the border below the wall, use black mixed with crimson for deep red flowers. Add white to this mix for pink flowers.

Clean the brush, and add the white flowers at the top of the Russian vine – using a 12mm (½in) fitch for these; also paint any other white flowers.

Paint yellow flowers using the No. 5 brush and cadmium yellow, mixing yellow with crimson, tan or white for variation.

Clean the No. 5 brush, and paint any blue flowers with ultramarine, adding white to vary the tones.

Still using the No. 5 brush, add deep purple flowers to the lavender foliage edging the path; pick up a touch of white as you go to add midtones to the lavender, and pick up more white for highlights.

The foreground paint should now be dry enough for you to paint flowers in the foreground. Use the No. 8 brush to create bigger flowers, in the same colours as those you have already painted. Remove the remaining tape.

> **TIP** Don't get too involved in painting detailed flower heads – a subtle, varied stipple of colours is best for this type of work.

Wooden window

9 The window is painted using the grisaille technique (see pages 18–19), but only with dark grey-brown and white. Add enough water to the dark grey-brown to make it flow; this will also keep it wet for longer, to make shading easier. Using the No. 8 brush, paint the edges and mouldings that will be in shadow. The brush strokes

should follow the grain of the wood. Also paint the shadow created by the stay; the shadow stretches to the left because the light source is from the right, and this adds to the illusion.

10 Rinse the No. 8 brush, and without drying it, paint the remainder of the window in white, picking up a little more water and softening the white over the shadows as the brush empties. It's easier if the dark grey-brown is still damp, but it's not essential. To add a few extra tones, dip into the dark grey-brown occasionally and mix it with some white on the palette.

Iron hardware and finishing

11 Clean the No. 8 brush. Mix black with a touch of metallic silver to create a very dark pewter shade. Thickly outline the stay, and add the holes, then add a little more silver to the mix and fill in the stay.

12 Mix more silver with the pewter shade from step 11, and, using the No. 5 brush, add midtones and details such as the peg, screw heads and hinge details.

13 Clean the No. 5 brush. Mix white with silver, and add a few highlights, positioning them slightly to the right, to emphasize the light source.

Repeat the procedures in steps 11–13 for the fastener and hook and the hinges elsewhere on the window.

To add curtains, see the instructions for the Bed Canopy (pages 94–97) or the curtain in Balcony View, steps 7–8 (page 50).

If you are including a jug, paint it using ultramarine, black and white, following the techniques for the jar in the Secret-Cabinet Bookcase, steps 2 and 6 (pages 55–56), and the pot in the Lemon Tree, step 6 (page 84).

Allow it all to dry, then varnish it.

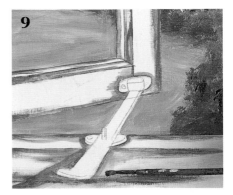

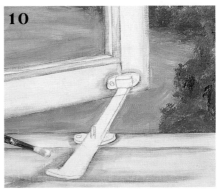

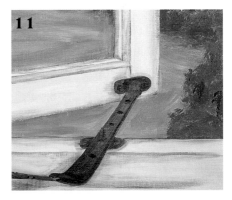

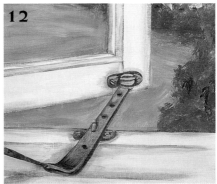

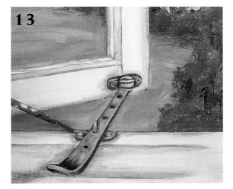

DINING ROOMS

Left: An exotic gold 'ugly-fish' draped over the doorway of this dining room adds a Chinese element to the decor and ties in with Oriental artefacts displayed around the room.

Right: Serve dinner on your own private balcony with a view over spectacular countryside. The dining room is the ideal place for such dramatic effects.

The dining room is the place, perhaps more than anywhere else in the home, where you can indulge yourself and create real atmosphere using trompe l'oeil. Because dining rooms tend to be used more at night, projects can be as fanciful, exotic or extravagant as you wish. Floor-to-ceiling murals can look wonderful, or you may prefer something more subtle, such as faux panelling on the walls. Sky ceilings work well here, too. Or, for a less ambitious project, a hatch or door to the kitchen could be disguised, a sideboard could be given trompe l'oeil ornaments or a screen could be painted with virtually anything.

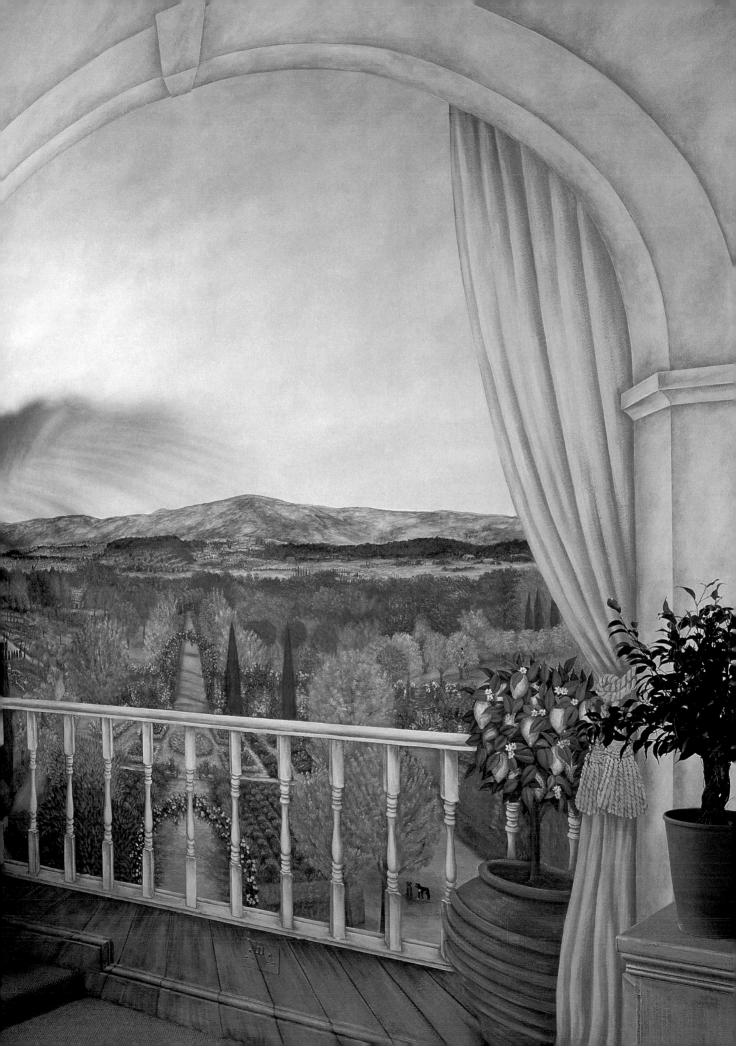

Wood Panelling

Faux wood panelling is an elegant accompaniment to richly colourwashed walls, enabling strong colours to be used to maximum effect without dominating the scheme. A dining room is a good place for low-level detail, since most of the furniture is usually away from the walls. The technique can also be used for faux panelled doors.

YOU WILL NEED

Pencil, straightedge, tape measure and carpenter's level
Low-tack masking tape, preferably 5cm (2in) wide
5cm (2in) decorator's brush
Flat latex paints in dark grey-brown, cream and off-white
No. 5 and No. 8 artist's brushes
Matt varnish and varnishing brush

Preparation

The walls were painted first with a white latex base coat, and the woodwork with white acrylic primer. The upper walls were colourwashed using a 7.5cm (3in) decorator's brush, first in deep Chinese yellow, then with deep rust red over that, and finally with a wine red containing a touch of deep red-brown. They were then varnished.

> **TIP** The colourwashing was done before the faux wood panelling, as it is important always to work from top to bottom on a wall, to avoid splashing your work.

The (real) baseboard was painted with dark tones in the mouldings, softened with cream overall and then highlighted with off-white, working on lengths of about 90cm (3ft) at a time.

Using the pencil, straightedge, tape measure and carpenter's level, mark out the horizontals and verticals for the panelling. The panelling should extend all the way around the room, but the width of the panels is up to you. Each window should have a panel beneath it, and each door should have one above it. Chimney breasts and niches should have

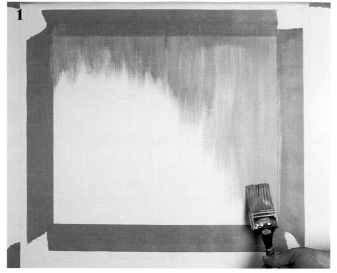

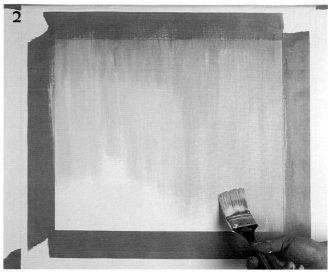

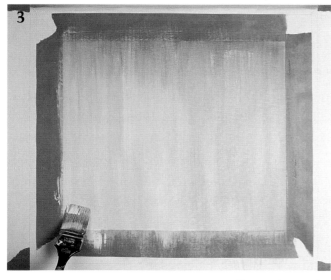

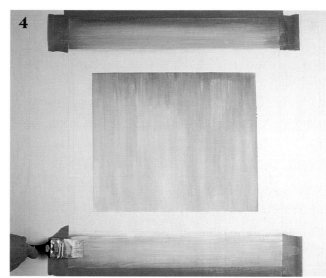

separate panels; the sides can be painted with vertical brush strokes using the same three colours as the central panels. Every panel consists of a central panel framed by a surround, each side of which is 10–15cm (4–6in) wide. Between the central panel and the surround is a 5cm (2in) wide moulding, which includes a narrow beading around the outside of it.

The trompe l'oeil chair rail on the wall immediately above the panelling is 5cm (2in) deep. The top of the chair rail should be about 85–90cm (33–36in) from the floor. Draw a horizontal line 2.5cm (1in) beneath this top edge, and another one halfway between that line and the lower edge of the rail.

Central panels

1 Mask around the outside of the central panel. Using the decorator's brush and the dark grey-brown mixed with a little water, paint across the top and down the right side of the panel with vertical strokes. With water on the brush, pull the paint out with each stroke, leaving visible brush marks on the panel.

2 Mix water with cream paint. Without cleaning the brush, paint this midtone over the rest of the panel, softening the edges over the dark grey-brown while it is still damp. Pick up more cream and paint this along the bottom and left side of the panel, softening it back with vertical brush strokes.

3 Pick up off-white, and paint it at the bottom of the central panel, with vertical strokes softening towards the centre, over the cream while it's damp. Remove the tape and leave to dry while you paint other panels.

Stiles and rails

4 Mask the outer edges of the rails. With the same brush, paint dark grey-brown next to the taped edges of one section. Clean the brush. Paint the rest of the section with cream, drawing the brush horizontally and into the dark tones while damp. Clean the brush, and with off-white and horizontal strokes, soften into the midtones, leaving the edges darker. Remove the tape and allow to dry. Repeat for the other section.

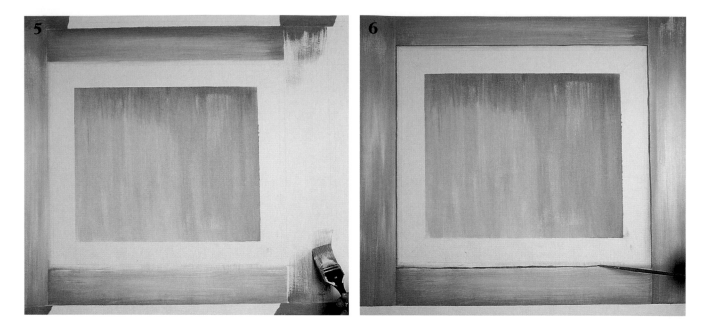

5 Mask outside the ends of the stiles or vertical sections. Because there are no dark sides here, you don't have to mask the sides. Clean the decorator's brush on a cloth, and paint dark grey-brown at the top and bottom of one section. Clean the brush on a cloth again, pick up a touch of water if necessary, and paint the cream over the remainder of the section, using vertical strokes. Clean the brush on

TIP It's preferable for the paint to be damp when you are doing this type of work, but as long as you keep any edges soft that are to be blended together, you can soften back onto dry paint if necessary.

the cloth, pick up off-white on the brush and soften it into the cream, again using vertical brush strokes. Remove the tape and allow to dry while you do the other stile in the same way.

6 With the No. 5 brush, paint a thin line of dark grey-brown paint around the inner edges of the stiles and rails. Allow to dry.

Moulding

7 Using the No. 8 brush, paint a 1.2cm (½in) wide band of cream paint around the outer edge of the moulding, to represent beading. (This should be painted just inside the dark

grey-brown line applied in the previous step.)

With the same brush, paint dark grey-brown shadows just inside this beading on the top and right-hand sections of moulding, leaving the inner half of these sections unpainted. Soften the inner edges of the shadows by adding water to the brush, but leave the outer edges sharp.

8 Still using the No. 8 brush, paint the remainder of the top and right-hand sections of moulding with cream paint, softening over the damp shadows by adding a little water to the brush.

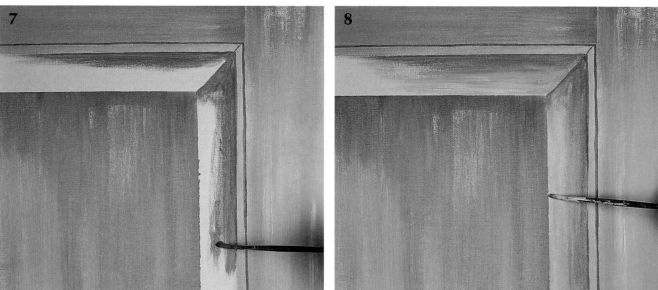

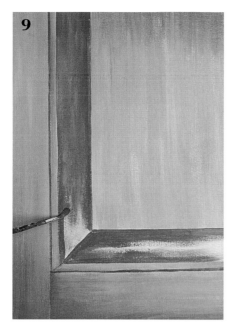

9 Thin the dark grey-brown paint with a little water, and add a touch of cream to it. With the same brush, paint this shade over the whole of the bottom and left-hand sections of moulding, inside the cream beading.

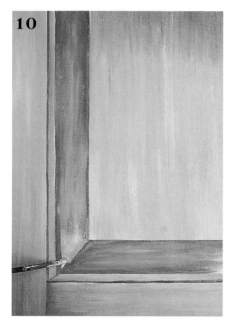

10 With the No. 8 brush, paint a cream highlight along the bottom of the left-hand section of moulding. Use a little water to blend it into the dark tones, then, without cleaning the brush, add a little off-white and apply highlights about 15cm (6in) long to the edges of the moulding, including the beading, all the way around.

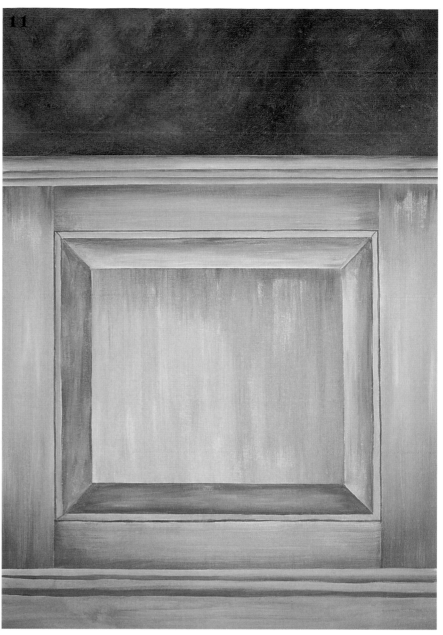

TIP To emphasize the trompe l'oeil effect, the inner edge of beading should always contrast with the adjoining edge of the central panel. In our project, the panel is light on the left and dark on the right, so the inner edge of the left-hand section of beading is dark, and the inner edge of the right-hand section of beading is light. The outer edge of the beading (just inside the surrounding light-coloured band) is always dark all the way around.

Chair rail

11 The chair rail is painted using the grisaille technique (see pages 18–19), masking the edges, and using dark grey-brown at the upper edge, cream at the bottom of the top band, with off-white between them; dark grey-brown at the upper edge of each of the two narrower bands beneath that, and off-white at the lower edge of each of those two bands. Work on lengths of up to 30cm (12in) at a time, removing the tape as you go. When dry, varnish, along with the panelling.

TIP The panel has been shaded in this way because on this particular panel in this room the light comes slightly from the left. If you want to suggest light coming from the right, reverse the arrangement.

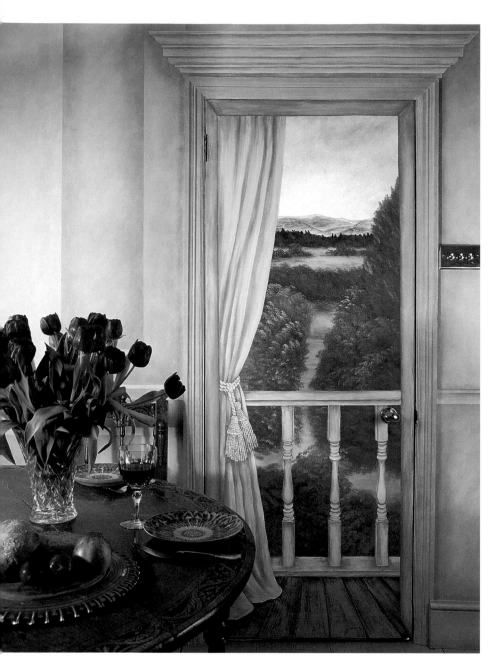

Balcony View

Add another dimension to your dinner parties by painting the dining room door so that it appears to lead out onto a balcony overlooking a wonderful view. A mural like this would also look effective at the end of a corridor or on wardrobe doors.

YOU WILL NEED

Carpenter's level, straightedge, pencils, tracing paper and tape measure

Template of baluster (page 134)

Low-tack masking tape

2.5cm (1in) and 5cm (2in) decorator's brushes

Flat latex paints in sky blue, white, deep purple, dark grey-brown, tan, cream, pine green, sage-lime green, dark olive green, dark brown and black

No. 5 and No. 8 artist's brushes

2.5cm (1in) fitch

Double-sided tape, heavy-duty fabric spray glue, thumbtacks or super-strong adhesive (all optional)

Matt varnish and varnishing brush

Preparation

If the door is flat, the mural can be painted either straight onto it or onto a piece of canvas which is fixed to the door upon completion. If canvas is used, it should be cut 2.5cm (1in) bigger than the door all around, and then left unpainted in this margin, so that the canvas can be fixed to the sides of the door. If the door is panelled, the mural can be painted onto a thin panel cut to fit the door. A door or board should be painted first with primer and then with white latex paint; for canvas, use the pre-primed type.

Using a carpenter's level and straightedge, pencil the design on the door or canvas; enlarge the template and carefully transfer it using pencils and tracing paper (see page 13 for how to do this). The balustrade (handrail) is 94cm (37in) from the floor, while the mountains are just below eye-level (when standing). The trompe l'oeil reveal around the top and sides of the door is 10cm (4in) wide; if the door is recessed rather than flush, do not include it. (Instructions for painting the pediment above the door in the photo are on page 19.)

Sky and mountains

1 Mask along the inner edge of the top and right-hand reveal. Take up a little water on the 5cm (2in) decorator's brush and dab off the excess on a cloth. Take up some sky blue on the brush and start painting the sky from the top, using a stippling action and working from side to side. Add a little white to the blue on the brush, then gradually pick up more and more white as you work downwards. Remove the tape by the painted area. Put some deep purple, dark grey-brown, tan and cream on the palette. Add a little water to the No. 8 brush, then take up these colours on the brush without mixing them and paint the mountains as a soft wash. While this is still wet, use the damp but not wet No. 5 brush and the same colours without water to add a few mountain tops within the wash, as shown.

Background greenery

2 Add a little water to the fitch, dip it into the pine green and stipple the forest line in the background. Some of the treetops in the outline should be pointed and others rounded. While

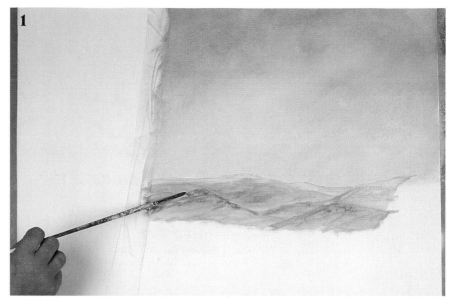

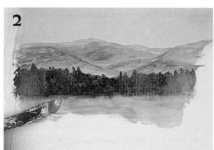

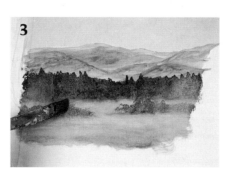

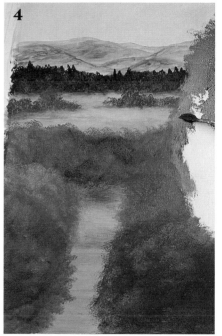

this is still wet, clean the fitch, pick up sage-lime green and a touch of cream without mixing them, and paint the grass using horizontal strokes. Blend it into the base of the trees with irregular horizontal strokes, to create the effect of shadows of the trees.

Middle distance and foreground greenery

3 Paint the grass in the middle distance, and while it is still wet, use the fitch to stipple dark olive green bushes in the middle distance. Blend the base of the bushes into the grass using irregular horizontal strokes.

4 Mask beneath the upper edge of the balustrade. The inner edge of the right-hand reveal should still be masked. Unevenly mix tan with dark brown, and cream with pine green on the palette. Also add pine green and dark olive green to the palette (keeping them separate rather than mixing them together). Use one of these four colours to stipple each bush in the middle distance and foreground with the fitch. Clean the brush with a cloth each time you change colour. Remove the tape adjacent to the painted area. Allow to dry.

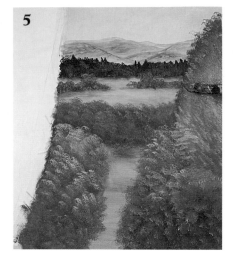

5 Mix cream with each of the colours used in step 4, and stipple midtones onto this foliage using the fitch. Pick up more cream on the fitch and stipple some highlights, mainly at the top of the foliage. Soften the edges of the foliage into the background.

Between the balusters

6 Mask above the lower edge of the balustrade and beneath the upper edge of the base rail. Complete the foreground foliage and grass in the same way as for the middle distance. Remove the tape. Leave the balusters white, trying to keep a neat edge. When the foliage and grass are dry, touch up the edges of the balusters with white using the No. 8 brush.

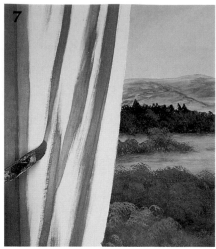

Curtain

7 Mask along the inner edge of the trompe l'oeil reveal at the left. Paint the shadows between the folds of fabric using the fitch and dark grey-brown paint, softening the edges into the white background. You can complete the whole curtain now or stop at the tieback, as you wish.

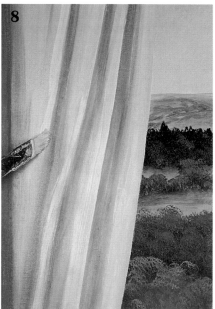

8 Clean the fitch, and paint cream midtones between the shadows, softening the cream over the softened edges of the shadows. Clean the fitch again and paint white highlights along the edges of the folds towards the landscape, which is the light source in this mural. Keep the shadows darker on the door side.

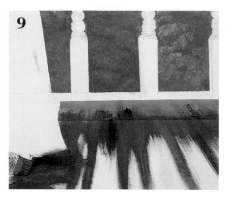

Balcony floor and bottom rail

9 Mask above the lower edge of the base rail. Dip the 5cm (2in) decorator's brush in water and then in dark brown, and paint short, almost vertical strokes interspersed with longer ones fanning out down to the bottom. Pick up a little black, and strengthen the shadows, particularly on the floor beneath the fabric.

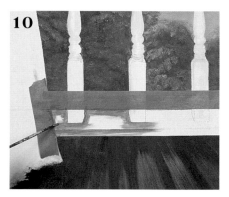

10 Take up a little water on the same brush and some more dark brown, and paint midtones between the shadows, completely covering the white. Remove the tape and mask above the top edge of the base rail, and also along the curtain edge. Using a wet No. 5 brush and dark grey-brown, paint along the edges of the base rail as shown. With the No. 8 brush and cream paint, paint the midtones of the base rail between the shadows, covering all the white background. Then, with the white paint, highlight the edges that would catch the light coming from the background. Finally, remove the tape.

TIP Making the floorboards of the balcony look wider in the foreground (i.e., at the bottom of the door) than at the far edge of the balcony utilizes perspective to create a feeling of depth.

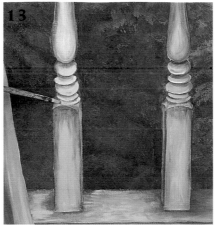

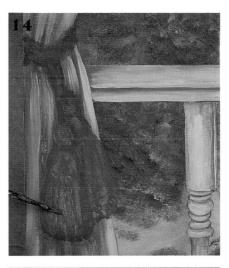

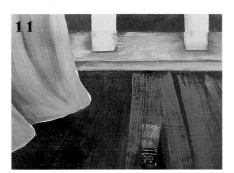

11 If you haven't already done so, complete the bottom of the curtain in the same way as in steps 7–8. Very lightly load the 2.5cm (1in) decorator's brush with the dark grey-brown, then use it to 'dust' the floor of the balcony.

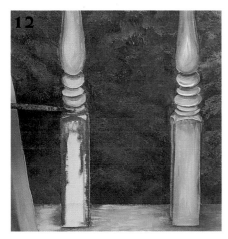

Balusters and balustrade

12 Using the No. 8 brush and dark grey-brown, paint shadows around the outline of the balusters. Work on lengths of about 15–20cm (6–8in) at a time so that the paint will still be wet as you do the next step. Clean the brush and fill in between the shadows with cream midtones.

13 Clean the brush again and add a few white highlights to the cream area, along the edges that would catch the light. Repeat step 12 and this step for the rest of this baluster, the other balusters and the balustrade.

Tieback

14 Using the No. 8 brush and dark grey-brown, fill in the cord and tassels. Add water to the brush for some of the brush strokes in order to vary the tones a little. Allow to dry.

15 Clean the No. 8 brush and use it to add cream midtones to the cord and tassel. Use brush strokes resembling a chain of linked dots for the tassel, and S-shaped brush strokes for the cord (including the cord just above the tassel fringing). Allow to dry.

16 Use the No. 5 brush to add white highlights to the cord and tassels, mainly on the right side.

Reveal

17 If you are painting on canvas, fix it to the door using either heavy-duty double-sided tape in a lattice on the front plus solid strips on the sides, or heavy-duty fabric spray glue. If you are using a board, fix it to the door with thumbtacks or strong adhesive.

Now paint the trompe l'oeil reveal using the fitch, applying tan paint along the edges and at the corner mitres, with cream paint blended in. The top part should be a bit darker than the sides overall. Work on lengths of only 30–45cm (12–18in) at a time in order to keep a damp edge for blending. Leave to dry, then apply a coat of varnish.

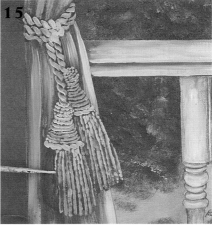

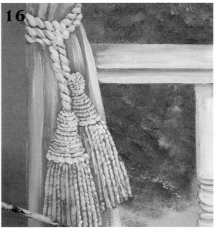

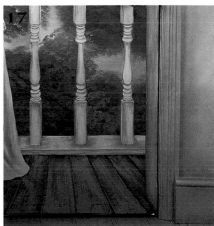

STUDIES

Left: Panelled doors, including those on cabinets, can be transformed into a trompe l'oeil display case, whose painted contents are much more interesting than the paperwork concealed within.

Right: An elegant study with a fireplace flanked by alcoves for books looks wonderful with faux wood panelling. Here, the detailing at the top of the panel echoes that of the stone fireplace.

Studies are usually cramped areas overflowing with paperwork and cumbersome equipment and files, so trompe l'oeil works best here if it is not too intrusive. However, wit and irony are at the heart of this style of painting, and certainly do not have to be abandoned just for the sake of practicality. There is always room for projects that enliven dull office paraphernalia – whether ring binders or cabinets – and if some form of labelling is included in the design, they can be functional as well as fun. In a more formal study, faux wood panelling or trompe l'oeil bookshelves add to the cosy library atmosphere.

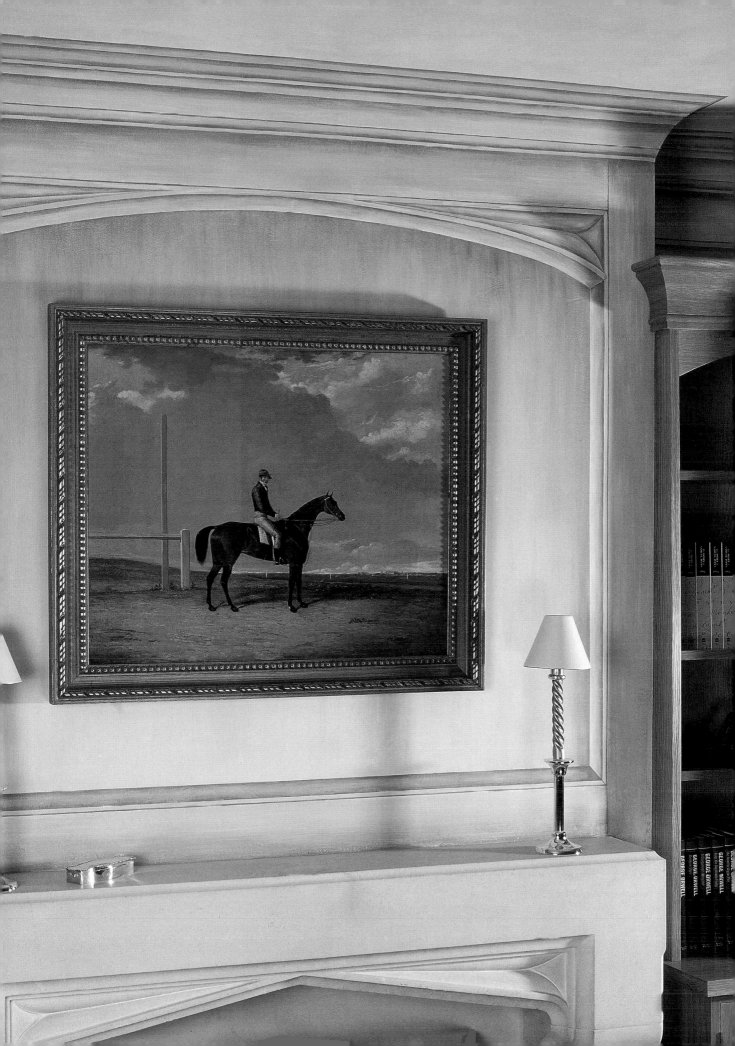

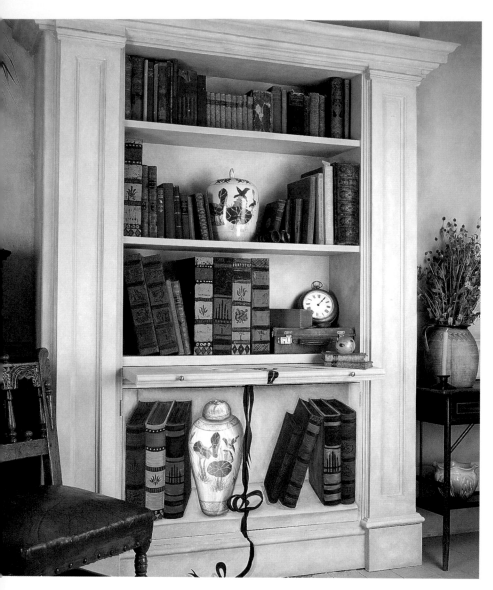

Secret-Cabinet Bookcase

A bookcase presents an excellent opportunity for trompe l'oeil. Here, a cabinet at the bottom is painted to look like the bookcase's real shelves, with books and a china jar, and plain ring binders have been disguised as leather-bound books. The pull-out desk is also a project (see pages 58–59).

YOU WILL NEED

Straightedge and pencil
No. 5 and No. 8 artist's brushes
Flat latex paints in grey, tan, cream, black, rust, sand and pine green
Acrylic paints in raw umber, crimson, ultramarine, titanium white and metallic gold
2.5cm (1in) fitch
Matt varnish and varnishing brush
Spackling compound and wide putty knife (for ring binders)
5cm (2in) decorator's brush (for ring binders)

Preparation

The bookcase was primed with white acrylic primer and then given a faux stone finish by stippling with grey, honey and cream paint using a 5cm (2in) brush; the grey was applied in the moulding details and the honey and cream on the flat sections. The cabinet was left white for painting.

Using the straightedge, pencil the design on the cabinet. The perspective should be from a central viewpoint looking down.

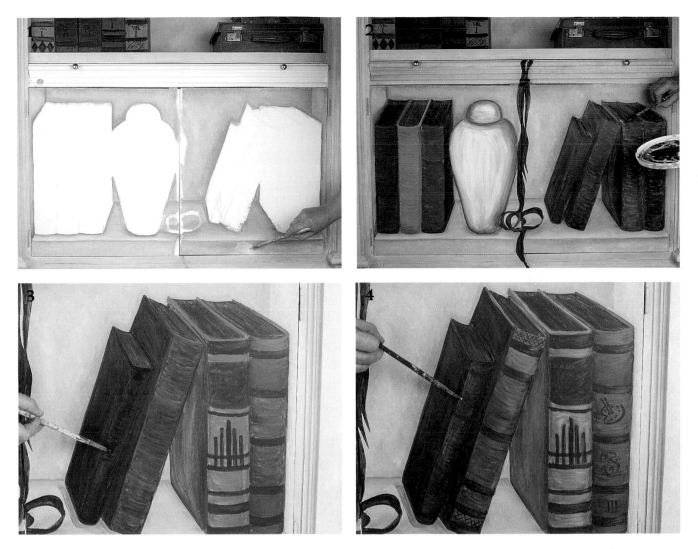

Shadows and background

1 Use the No. 8 brush and grey paint mixed with a little raw umber to paint the shadows around the objects you've pencilled in, and also the shadows along the edges of the shelf and the area just above the shelf. Use the fitch to fill in the midtones of this area with horizontal strokes, picking up varying amounts of tan and cream with the grey on the fitch without mixing them, and softening the shadows into this background. The No. 8 brush is useful for getting the shadows right into the corners. Allow to dry.

Blocking in the books and jar

2 With the No. 8 brush, paint black pages at the top of each book, using long, sweeping strokes. Also paint the black ribbon, which camouflages the gap between the cabinet doors. Now put the book colours on the palette: rust mixed with tan and sand; rust mixed with raw umber; pine green; crimson mixed with black; and ultramarine mixed with cream and black. With the No. 8 brush, paint the top edges of the books and the spines in these shades, using very shallow U-shaped strokes for the spines. Add a little water to vary the tones, and black or raw umber to define the sides. Mix black with ultramarine and white, and with the No. 8 brush, paint around the edges of the jar and its lid. Start painting towards the centre of the jar, picking up more white and a touch more ultramarine on the brush. As this paint dries, mix white, a touch of blue and some water on the palette and apply the midtones to the jar and lid with the No. 8 brush, keeping the centre of the lid white. Allow to dry.

Book midtones

3 Use the No. 5 brush to add black designs to the spines. Next, create midtone colours for each book either by adding a little cream to the colour used for blocking in or by mixing up some more of the original colour but leaving out the black or raw umber.

Book highlights and detailing

4 Add more cream to the various book colours, and with the No. 8 brush, add highlights to the tops and spines. Now paint some black symbols or lettering on the spines. Paint a few details on the spines of the books in metallic gold using the No. 5 brush.

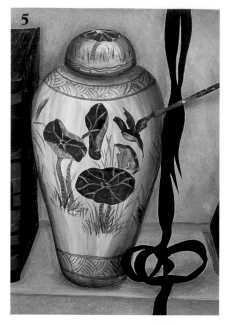

Jar pattern

5 Pencil in the pattern on the jar and lid, using the photograph as a guide. Mix ultramarine with a touch of black, and paint the darker areas of the pattern with the No. 5 brush. Pick up white on the brush, and paint in the lighter parts of the pattern. Clean the brush, and paint the bird and the veins on the mushrooms. Allow to dry.

6 Add water to white acrylic to make a thin white glaze, and highlight the jar and lid with this, softening the edges. The glaze should be strongest in the centre, then gradually fade until it disappears about 2.5cm (1in) from the edges. Pick up undiluted white on the brush, and add some stronger highlights to the jar and the lid.

Ribbon highlights

7 Mix black with a touch of white to make a dark grey shade, and use the No. 5 brush to add subtle dark grey highlights to the ribbon where it crosses and folds. Allow to dry. Apply two coats of varnish.

Binders spackling

8 Remove plastic rings or rivets from the spines, and peel off or lightly sand off tabs and labels (don't use water). With the putty knife, apply spackling compound to the spines, cleaning the edges so the binders will still open easily.

9 Use the putty knife to make horizontal grooves in the compound; these will represent strips of leather tooling when finished. If you are creating matching binders, make sure these will line up. Allow the spackling compound to dry, preferably overnight.

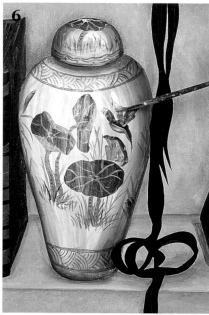

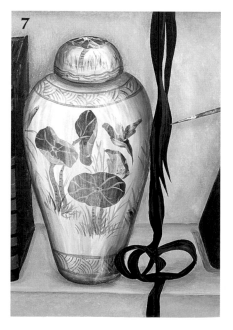

> **TIP** Allow time for the spackling compound to dry naturally – trying to speed up the process with a hairdryer would only cause it to crack or chip.

Binders background painting

10 Paint the dry compound on each binder with a thick coat of black paint using the fitch, carefully working it into the dents and cracks so that no white shows through. Allow to dry thoroughly.

Binders decoration

11 Dip the decorator's brush into the sand paint and then into the tan, without mixing them. Take off excess paint on the palette, then apply to the large flat areas of the spine, using a light pressure and leaving some of the black showing through. Allow the paint to dry a little, to prevent smudging. Paint any other binders in the same way, varying the colours as desired.

12 Mix a little rust with the tan and sand on the palette, and paint the bottom section of the spine with the decorator's brush. Clean the brush with a cloth, not with water, and then pick up rust from the can. Take off the excess on the palette, and then paint the title section of the spine and also some of the thin bands. Repeat for the other binders. Leave to dry.

With the No. 5 brush and black paint, neaten the tooling lines and add some motifs to the spine of each binder. You can personalize the motifs, perhaps according to what will be stored in the binder, and possibly add wording as well. Allow to dry.

13 With the No. 5 brush, paint rust diamond shapes on the bottom section, and outline them in black. Add rust dots to the thin black band above it. Allow to dry. Paint gold circles around the rust dots, and gold dots on the other two black bands. Decorate the other binders in the same way. Leave to dry, then varnish.

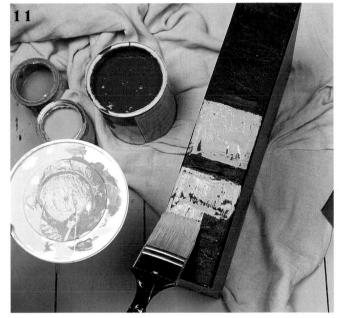

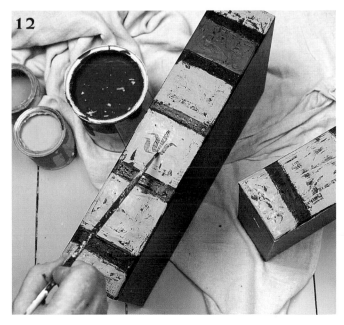

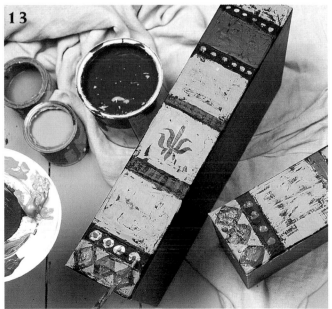

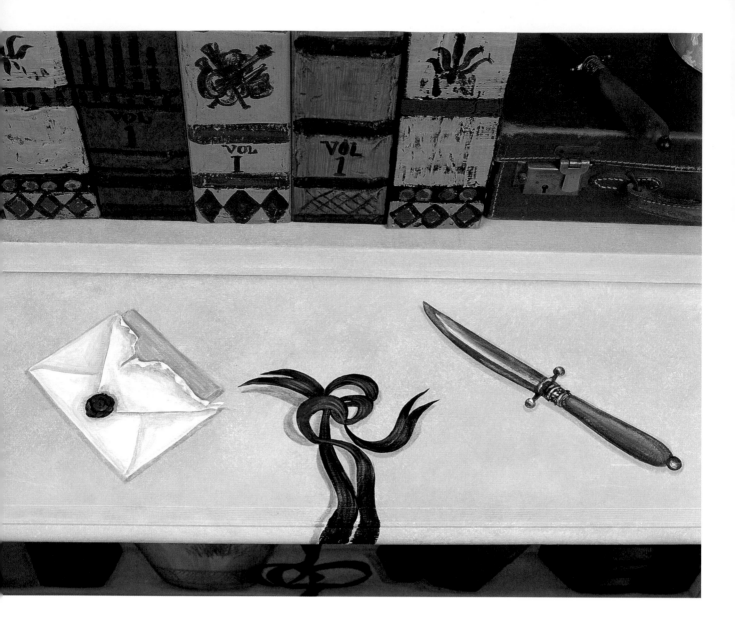

Decorated Desktop

Liven up your working hours with amusing trompe l'oeil desk paraphernalia painted onto your desk- or tabletop. This drop-down desk is part of the bookcase on page 54, but any desk- or tabletop would do — or you could decorate the top of a radiator shelf or a filing cabinet.

YOU WILL NEED

Templates of envelope
 and letter opener (page 136)
Tracing paper and pencils
Flat latex or acrylic paints in white
 and black
No. 5 and No. 8 artist's brushes
Acrylic paints in raw umber,
 ultramarine, crimson, raw sienna
 and metallic silver
Matt or satin varnish and
 varnishing brush

Preparation

The desktop was cleaned with a plastic kitchen scouring pad and detergent, dried well and lightly sanded with 000-grade fine steel wool. It was then painted with acrylic primer and given a stippled faux stone finish like the rest of the bookcase (see page 54).

Enlarge the templates and transfer them to the desktop using tracing paper and pencils (see page 13). Draw the ribbon if you are also doing the bookcase project on page 54.

Basic shapes and shadows behind them

1 Paint the shapes within the outlines white using a No. 5 brush. Then, with the same brush, paint soft shadows around the objects in raw umber.

> **TIP** The lighting should be as though it were coming from above, so don't accentuate the shadows too much.

Shading

2 Mix ultramarine with white, and paint the notepaper inside the envelope using the No. 5 brush. Very lightly pencil in the folds of the envelope and the detail on the letter opener.

Clean the brush, and paint the ribbon in black. Pick up black and crimson (unmixed) on the brush, and paint the seal on the envelope.

Clean the brush. Mix black and raw umber, loosening it with a little water on the palette, and paint the letter-opener blade and metal decoration.

Without cleaning the brush, pick up a touch of white and begin painting the folds on the envelope; the colour should be a dark grey-brown. Pick up more white on the brush and soften the edges of the shadows.

Clean the brush, then pick up raw sienna and a touch of raw umber, and

paint the letter-opener handle without mixing the two colours on the brush.

Midtones and highlights

3 Mix black with a touch of white, and using the No. 5 brush, add subtle grey midtones to the ribbon where it folds and crosses. Clean the brush, and outline the letter-opener handle with raw umber. Clean the brush again and fill in the handle with raw sienna. Allow to dry.

Clean the No. 5 brush, and paint crimson midtones on the seal. Pick up

a little white on the brush and add a very light highlight in the wet paint. Clean the brush again. Mix a little metallic silver with black and a touch of white, and paint midtones on the blade, handle and end of the letter opener. Pick up more white on the brush and add very light highlights to the blade and metal decoration. Also add a little subtle highlighting to the ribbon with this. When dry, apply three coats of varnish, allowing it to dry between coats.

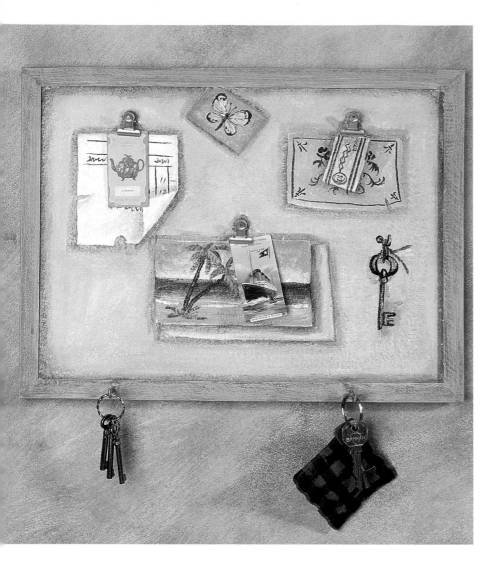

YOU WILL NEED

Pencil

No. 3, No. 5 and No. 8 artist's
 brushes

Flat latex paints in dark grey-brown,
 sand and cream

2.5cm (1in) fitch

Acrylic paints in crimson,
 titanium white, ultramarine, black,
 chromium oxide green, cadmium
 yellow, raw umber and
 metallic silver

Matt varnish and varnishing brush

Noticeboard

*Create a visual filing system
with a noticeboard covered in
trompe l'oeil postcards, bills,
tickets, invitations, even keys —
whatever suits your own storage
needs. The images are painted
straight onto the undercoated
cork and serve as the ideal
reminder of where to keep all
your paperwork.*

Preparation

The wood frame of the cork
noticeboard was lightly sanded, then
the frame and the cork were painted
with several coats of white acrylic
primer. Chrome binder clips were
attached to the noticeboard with
pushpins (but thumbtacks could be
used instead) and two small L-shaped
hooks were screwed into the wooden
frame to hold keys.

Draw the outlines of the objects
onto the painted cork. You can draw
around or copy real letters, envelopes
and tickets, or copy what is shown in
the photograph.

Shadows

1 With a wet No. 8 brush and dark grey-brown paint, paint the shadows around the pencilled shapes and also a shadow just inside the frame, on the cork.

Frame and background

2 Pick up a little water and dark grey-brown paint with a fitch, and paint the frame with this thick wash. Rinse the fitch and dab it on a cloth. Pick up sand paint on the fitch, and paint the cork between the shapes. Allow to dry.

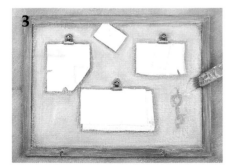

3 With a dry fitch, dust cream highlights here and there on the frame and on the central part of the sand-coloured background of the cork. The contrast this creates accentuates the shadows, so don't soften over them.

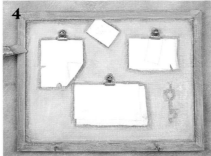

4 With the cream still on the fitch, pick up sand paint and dust it along the frame, leaving the dark grey-brown showing through.

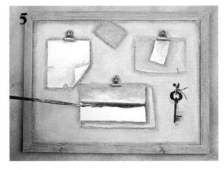

Blocking in

5 Put some of each acrylic colour on the palette. Mix crimson with white, and with the No. 5 brush, paint the pink paper at the bottom and the pink ticket; add more white for the edges.

Using the brush with pink on it, pick up ultramarine and use this light lavender for the card at the top. Add more ultramarine and white to this, and paint the sky of the postcard.

Clean the brush. Add a touch of black to the ultramarine, and paint the shadows of the fold and of the tear on the white paper.

Mix green with white for the green card, adding extra green for the shadow under the pale pink ticket.

Clean the brush, mix ultramarine and green, and paint the sea on the postcard; add a little yellow to it for the shallow, turquoise part of the sea.

Clean the brush again. Paint the key and hook in black and the string in raw umber.

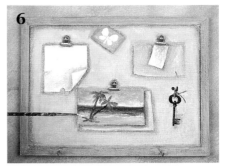

Beach scene and butterfly shape

6 Clean the No. 5 brush, pick up sand and cream paint with it, and paint the sand on the postcard. For the palm trees, use raw umber for the trunks and green for the fronds and the foliage under the trees. Mix yellow and white with these colours for the midtones and more yellow and white for the highlights of the palms. Clean the brush and add the white waves and the white butterfly shape.

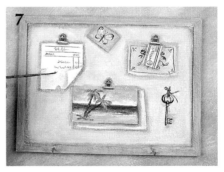

Detailing

7 Mix yellow with white and use the No. 3 brush to paint the butterfly wings and to highlight the string on the key. With the same brush, paint the design on the pale green card in ultramarine. Rinse the brush, dry it on a cloth and add black detail to the butterfly; if necessary, add a touch of water to help the paint flow. Rinse and dry again and add metallic silver midtones to the key; take up a touch of white on the brush and highlight the key. Now take up some black on the brush, and paint the detail on the receipt and pink ticket. Allow to dry, then apply a coat of varnish.

KITCHENS

Left: A large plaque painted as a trompe l'oeil shelf holding traditional kitchen items adds colour and humour, and can easily be hung on the wall.

Right: The panelled double doors of this cupboard have been painted to look as though they have glass fronts that reveal the objects inside. This is a useful idea if the contents of your kitchen cupboards are rather less decorative! To increase the visual trickery, it's fun to match a painted item to a real object in the room.

You can have great fun using trompe l'oeil in the kitchen. Not only is it the heart of the home and often these days quite a large room, but there are also so many surfaces suitable for painting. An individual cupboard, a row of cabinets, a breakfast nook, a pantry door, an archway, even a backsplash behind the counter (especially if it is well lit) – all are tailormade for painting. Culinary themes, such as fruit, vegetables, herbs and kitchen crockery and pots, are traditional and can look very good, but you don't have to restrict yourself to them: an animal theme, for example, will be enjoyed by the entire family.

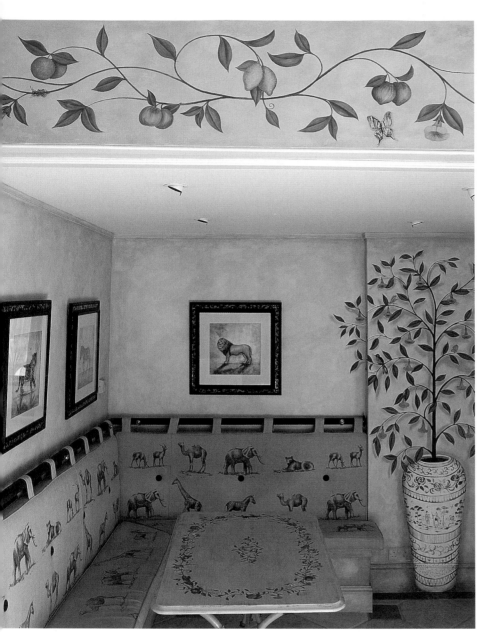

Fruit and Flower Frieze

With its realistic fruit motifs, this frieze is ideal for the kitchen, where it could be used along the wall between the cabinets and the counter, above a long shelf or over a door, window or archway. The technique given here is the standard method for painting trompe l'oeil fruit.

YOU WILL NEED
Pencil

No. 5 artist's brush

Acrylic paints in titanium white, raw umber, cadmium yellow, orange (mixed from red and yellow, if preferred), cadmium red, chromium oxide green and black

Flat latex paints in dark green and pale lime green

Matt varnish and varnishing brush

Preparation
This wall was painted with a colourwash of sand latex paint over a white base coat, but other colours or a flat finish would also be suitable (though colours that are not light would have to be overpainted with white within the outline of the trompe l'oeil frieze).

Draw out in pencil the undulating stems, and then pencil in the leaves, fruits and butterfly.

Blocking in fruit, flowers, branches and leaves

1 The No. 5 brush is used throughout. Paint the fruits and flowers white and leave to dry. Mix raw umber with a little water so it flows well, then paint the branches, making the line thinner at the end of each stem. Slightly vary the amount of water you add to the raw umber, so there is some variation of tone. Paint the leaves dark green, leaving neat outlines.

Shading and highlighting fruit and flowers

2 Outline the fruit in raw umber. With raw umber still on the brush, pick up a little white and use this to fill in the fruits, adding more white as you come to the centre of each fruit. For the oranges and lemons, use a stippling action to create the texture of peel. For the smooth fruits, apply the paint in soft, stroking movements, following their shapes. Do this for the flowers, too, so the brush strokes of white seem to lead out of a dark central semicircle.

Beginning butterfly and completing leaves

3 Paint the butterfly's body, legs and antennae with raw umber, then pick up a little white on the brush and use this to outline the wings. Pick up more white and fill in the wings.

Now mix the dark green and pale lime green together, and use this to paint the midtones of one leaf, leaving a darker central vein. Add more of the pale lime green to the mixture along with a touch of white, and add a few highlights to the leaf with this while the midtones are still wet. Repeat the procedure for the other leaves, completing each one before you start the next.

Glazing fruit, flowers and butterfly's wings

4 Clean the brush, and put a little yellow, white, orange, raw umber, red and chromium oxide green on the palette. Dilute the yellow with water on the palette, and paint this glaze over the lemons. Add a touch of white

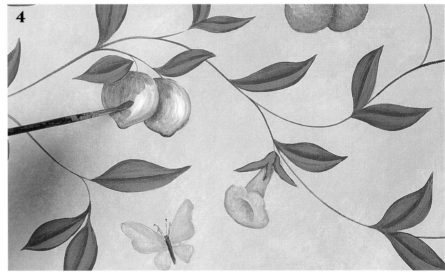

and use this to glaze the flowers and the butterfly's wings. Rinse the brush, dilute the orange and paint this glaze over the oranges. With the orange glaze still on the brush, pick up raw umber and a little red, and use this to glaze the nectarines, also picking up a little chromium oxide green and yellow as you glaze to the centre of each nectarine. For the peaches, start with a raw umber and orange glaze on the edges, and then add a little yellow and white as you work towards the

centre of each fruit. Mix chromium oxide green with yellow, dilute and use this to glaze the apples, picking up a touch of white as you work into the centre. Leave to dry, and then if the colours need strengthening, repeat the process.

TIP Latex paints are too thick and opaque for glazing, so acrylics, which contain finer pigments, have to be used. The amount of water needed for a glaze varies with the paint, so test the colour first on a piece of paper.

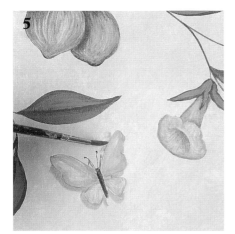

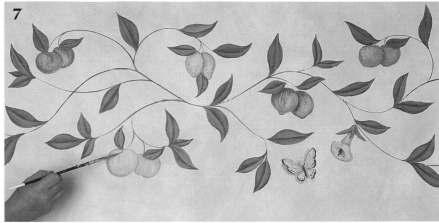

Completing butterfly

5 Thin the raw umber with water on the palette to make a glaze, and use this to add the butterfly's shadow. It is best not to pencil this in, as the lines would show. Keep the edge of the shadow soft, using a cloth if necessary to 'blot' the shadow.

Finishing

7 Add more highlights and glazes to the fruits and flowers if necessary, and then leave to dry completely. Finally, apply one or two coats of varnish, depending on how much wear the surface will receive; two coats are advisable in the kitchen.

TIP Refer to a book on butterflies for the colours and markings of other butterflies, which can be painted using the same techniques.

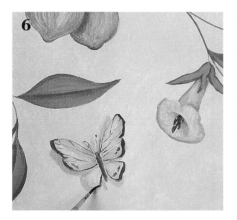

6 Put some black acrylic on the palette, dilute it a little with water so that it will flow easily, and add the butterfly's markings and the stamens on the flowers.

Right: Borders can be used in a variety of ways, not just as friezes. For example, in the kitchen in which the fruit and flower frieze was painted, a similar border was painted on a table in the breakfast nook.

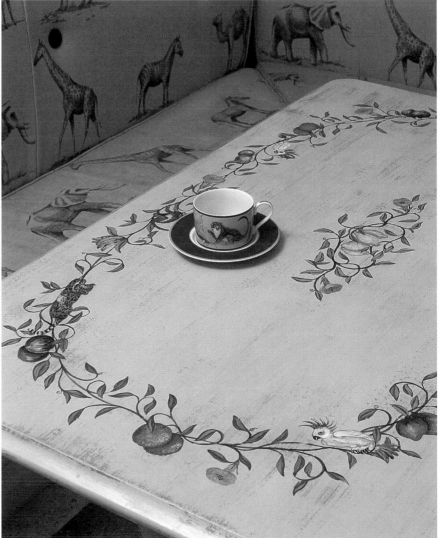

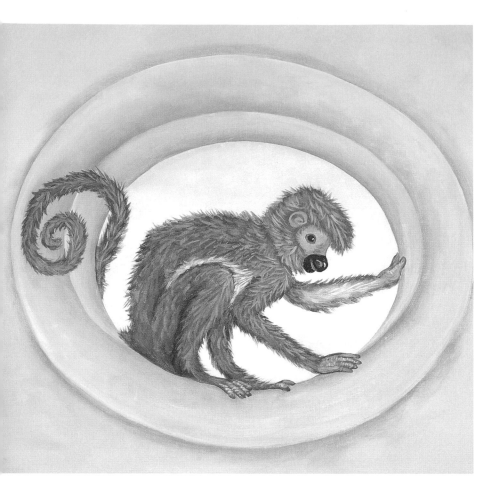

Cheeky Monkey

As a place where the family gathers, today's kitchen can be decorated with all manner of amusing and fanciful illusions. Birds, butterflies, insects and monkeys incorporated with other trompe l'oeil effects like this circular niche are, in fact, fun for any room and can be placed in larger murals as details.

YOU WILL NEED

Template of monkey in a window
(page 137)
Tracing paper and pencils
Flat latex paints in white and
 wall colour
5cm (2in) decorator's brush
2.5cm (1in) fitch
Acrylic paints in cobalt blue, raw
 umber, titanium white and black
No. 5 and No. 8 artist's brushes
Matt varnish and varnishing brush

Preparation

This wall was painted with a colourwash of sand latex paint over a white base coat, but other colours or a flat finish would also be suitable.

Enlarge the template and transfer the outline to the wall using tracing paper and pencils (see page 13). Paint the whole shape in white latex paint using the decorator's brush, and the fitch at the edges. Allow to dry. Now transfer the entire design to the wall.

Background

1 Mix a touch of cobalt blue with the white latex paint and a little water to create a soft sky blue. With the fitch, paint this on the inner oval, behind the monkey, using a loose stippling action. As you work, pick up a little extra white on the brush from time to time, to create a cloudy effect. Keep the stippling action soft.

Surround

2 Mix a little raw umber with the wall colour, and use the fitch to paint in a shadow around the outer oval. Soften the shadow into the wall colour, using a cloth if necessary.

3 Pick up some white paint, raw umber and wall colour on the No. 8 brush without mixing them, and paint from the inner to the outer oval, with the brush strokes following the curves. Keep the inner edge crisp, then change to the fitch to soften the outer edge into the surrounding wall. Keep the edge wet as you work outwards, to make the blending easier. Use extra raw umber for the shadows outside the inner oval and the central oval, and extra white for the highlights around the centre of each oval.

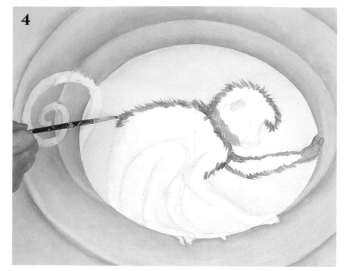

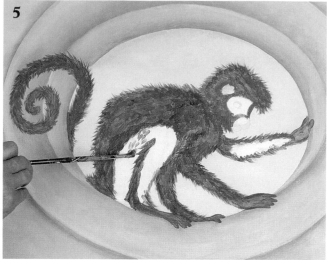

Monkey's dark fur

4 Lightly pencil in more detail on the monkey. Using the No. 8 brush, paint a spiky outline in raw umber, to resemble fur. Add a touch of water to the brush from time to time in order to vary the thickness of the paint for a more realistic look.

5 Fill in the monkey's fur using the No. 8 brush and the same short, spiky brush strokes in raw umber. Take up a little water on the brush to lighten some areas, and overpaint shadows and the edges of the limbs in undiluted raw umber to make these areas darker.

Midtones on monkey

6 On the palette, mix some of the white acrylic (or the wall colour if sand latex paint was used) with raw umber, and using the No. 8 brush, paint the face and inner arm of the monkey. Do not use spiky strokes for this, except to overlap the edges of the darker fur.

Now paint some more spiky strokes in this colour around the outside of the monkey's head. Add a little extra raw umber to the mixture, and use it to define the edges of the face and inner arm, this time using smooth, non-spiky brush strokes.

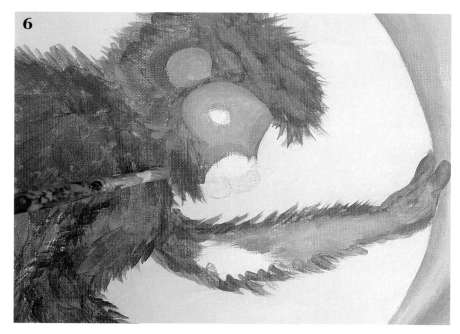

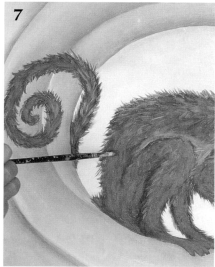

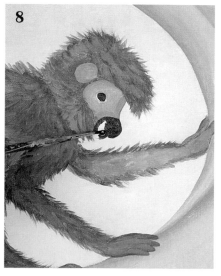

7 With the shade that was used to define the edges of the face in step 6, add midtones to the body and tail, using spiky strokes of the No. 8 brush.

Detailing and highlights

8 With the No. 8 brush and black, paint the eye, leaving a white rim around it, and the nose. Leave to dry.

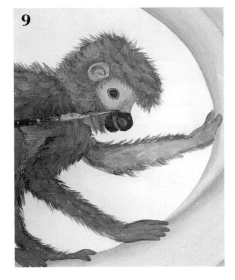

9 Mix raw umber with a touch of white acrylic, and use the No. 5 brush to outline the eye and to add a nostril and mouth. Add more white, and subtly highlight the fur using the No. 5 brush. Pick up more white, and highlight the chest and fingers.

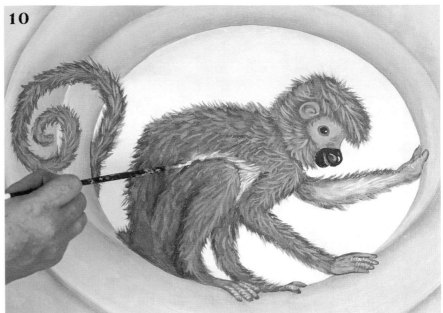

10 Clean the brush, and use it to add a white eye dot, a highlight on the nose and some spiky white brush strokes to the fur above the leg. When dry, apply a coat of varnish.

Below: Here, the monkey has been incorporated into the fruit and flower frieze (page 64), showing how well these projects combine.

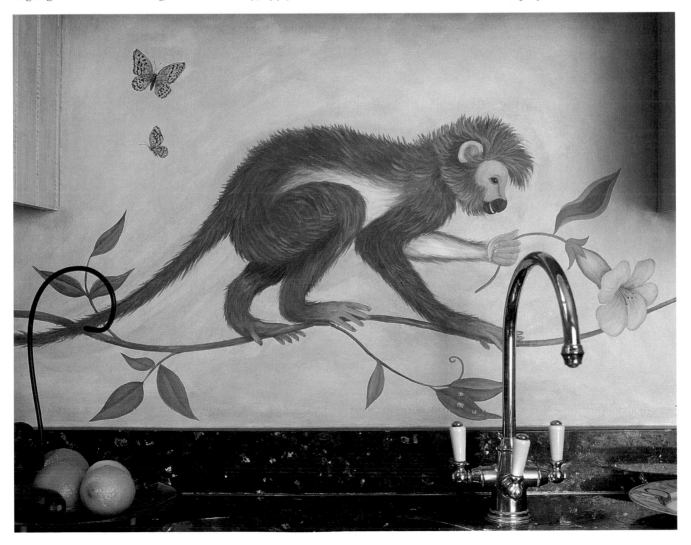

CONSERVATORIES

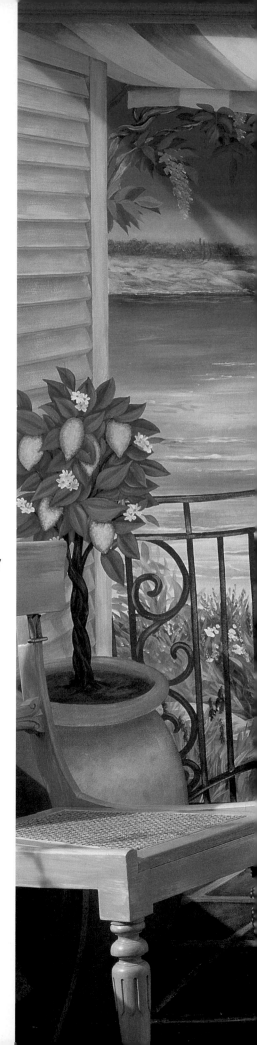

Left: Bring the tropics to a conservatory wall with a potted banana plant. Combined with real plants, it would be hard to tell where reality ends and trompe l'oeil begins.

Right: With its steps leading down to the sea, this mural turns a conservatory into a tropical veranda. The symmetrical arrangement of palm trees, plants and architectural features, combined with the central viewpoint, adds to the dramatic impact.

A conservatory wall offers a wonderful opportunity to create a mural such as a Mediterranean landscape or a Caribbean seascape. Not only will it make the conservatory seem larger, but it will also help the room to merge with the garden, bringing the outdoors (admittedly an idealized version!) inside. You can have great fun combining real and faux pots of plants, architectural elements and flooring. Although a mural like the one shown here seems complex, the individual elements that make it up are not difficult and could be successfully used on their own, right down to the smallest geranium plant.

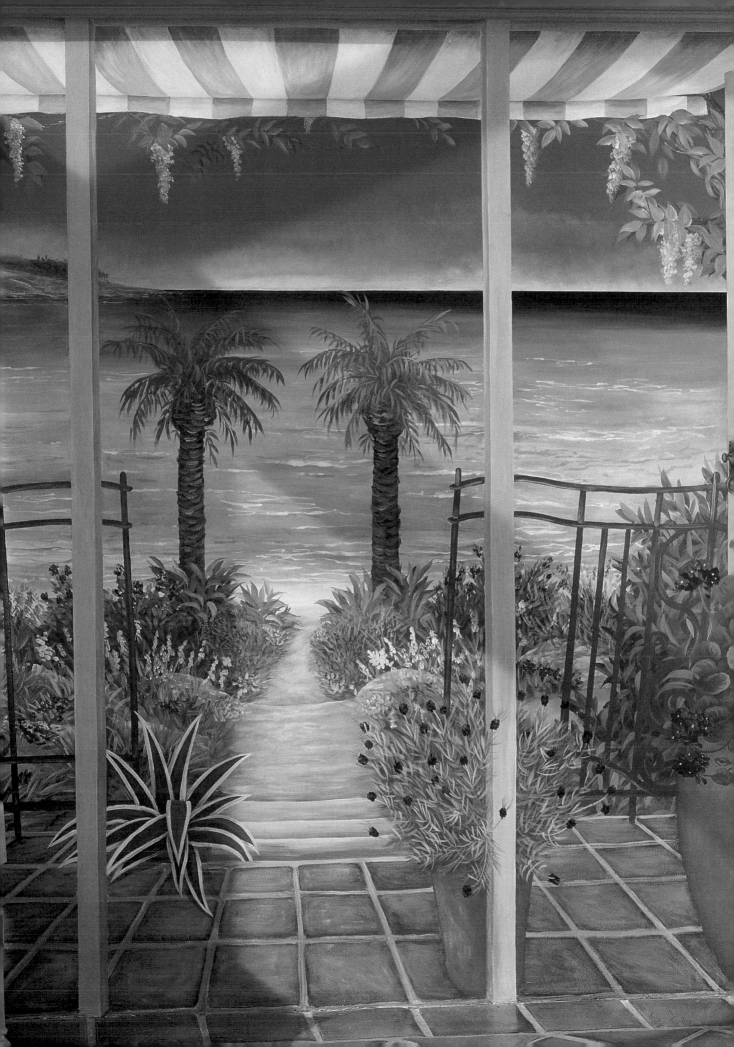

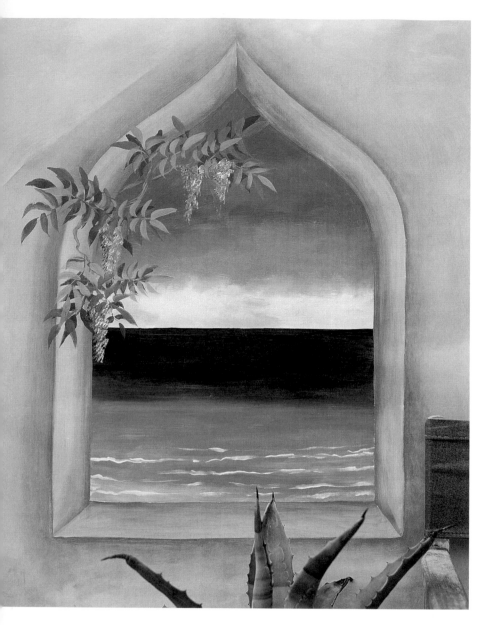

Sea View

Framed in a faux stone archway, this seascape is much simpler than the mural on pages 72–73, but the sea, sky and twining wisteria are painted in exactly the same way. Either paint this just as it is, or use the techniques to make a larger, more ambitious mural incorporating these elements.

YOU WILL NEED

Large piece of paper, pencils and
 tracing paper
Carpenter's level
Flat latex paints in off-white,
 deep sky blue, pale blue, deep
 sea blue, turquoise, wall colour,
 dark green, deep purple and light
 sage green
5cm (2in) decorator's brush
Low-tack masking tape
No. 8 artist's brush
2.5cm (1in) fitch
Acrylic paint in raw umber

Preparation

This wall was painted with a colourwash of sand latex paint over a white base coat, but other colours or a flat finish would also be suitable.

 Make a drawing of the arch on a large piece of paper. Trace this and transfer it to the wall (see page 13), using a carpenter's level to ensure that the lines are exactly horizontal and vertical. Paint within the window shape with off-white paint using the decorator's brush. Allow to dry. With a pencil, draw the inner outline of the window, and apply masking tape beneath the horizon line and along all the inner straight edges.

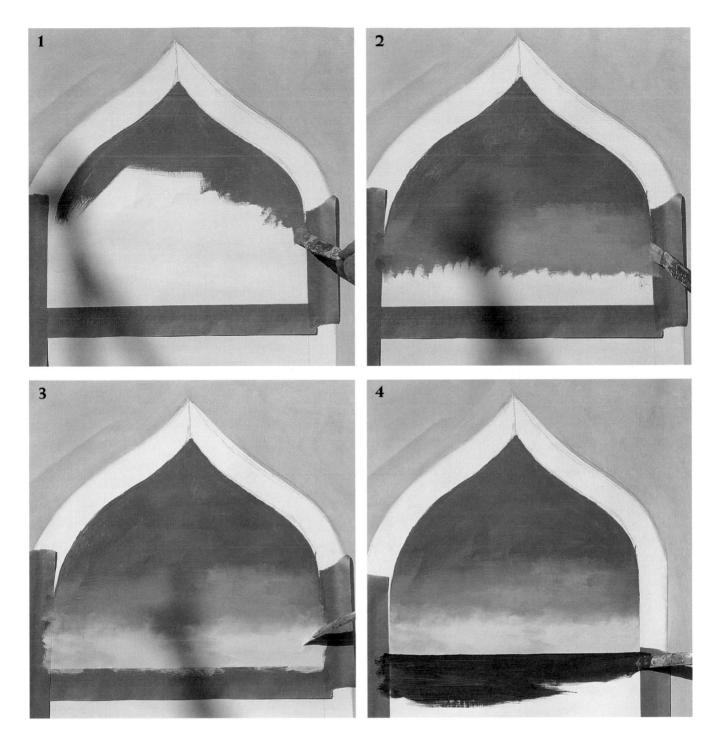

Sky

1 Paint the upper part of the sky in deep sky blue, using the No. 8 brush around the arch and the fitch for the remainder. Add a little water to the brushes before dipping them into the paint, and keep the lower edge of the sky softened and damp.

2 With a little deep sky blue still left on the fitch, begin to pick up pale blue while painting the portion of the sky just beneath the deep blue. Soften the edge into it so the colours blend together and the sky changes colour gradually. Keep the lower edge softened and damp, as in step 1.

3 With a little pale blue remaining on the fitch, begin to pick up off-white on the fitch while painting the lower portion of sky. Again blend the paint into the colour above, this time using a stippling action. Continue right up to the taped horizon line. Carefully remove this tape.

Sea

4 Still using the fitch, paint the upper portion of the sea in deep sea blue, using long horizontal strokes and keeping the lower edge softened and damp. Dipping the fitch in water first makes this easier and also helps create a suitably watery effect.

> **TIP** When you need to keep a wet edge, work on a stretch of no more than about 15cm (6in) at a time, so that it will not dry out before you have finished.

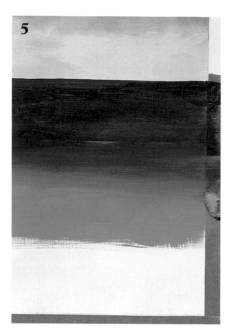

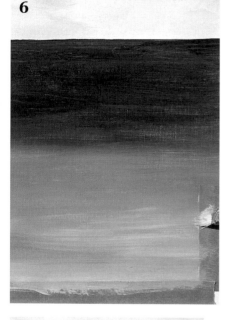

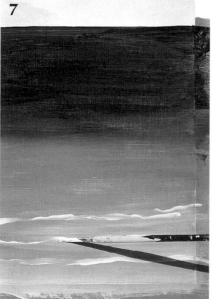

5 Begin to pick up turquoise on the fitch, and paint the portion of sea beneath the deep blue, again using long horizontal strokes and softening it into the previous colour, though it does not have to be quite so gradual this time. Once again, maintain a wet lower edge.

6 Now, still using the fitch, start picking up the pale blue and deep sky blue without mixing them. Paint the lower portion of the sea, softening the colour into the turquoise but allowing the pale and deep sky blue tones to stay streaky. Paint right down to the masking tape.

7 When the sea colours are dry, use the No. 8 brush to paint off-white ragged lines representing waves, then carefully remove all the remaining masking tape.

Arch

8 Mix raw umber with a little of the wall colour. With the fitch, paint the window 'recess' in this colour. The edge next to the view should be sharp, but as you come to the outer edge, start picking up more and more of the wall colour and gradually blend it into the painted wall at that edge. As you are blending, maintain a wet edge.

9 Using the same mixture as you used for the inner edge of the window 'recess' in step 8, paint the wall around the window. Create a sharp edge along the outer edge of the 'recess', then pick up more of the wall colour on the fitch and gradually blend it into the painted wall.

TIP When painting with a wet edge, add water to the brush before picking up the paint colour, otherwise it will be too wet. You can always dab it into a cloth to avoid overloading the brush.

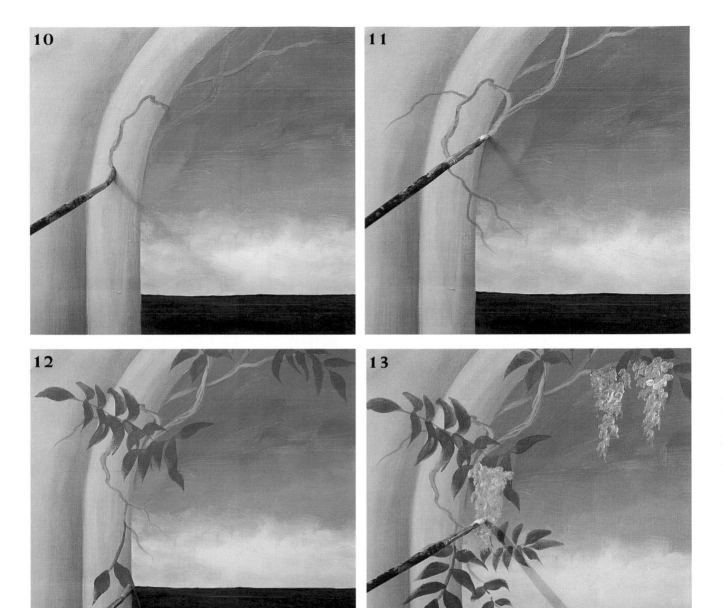

Wisteria

10 On the top half of one side of the window, lightly pencil in some stems of wisteria. Mix a touch of off-white with raw umber, and paint in the stem outlines using the No. 8 brush.

11 Mix more off-white into the stem colour and add a soft line of highlight along the stem, using the same brush.

12 Still using the No. 8 brush, paint dark green leaves. They should overlap in places for a realistic effect. (Until you become confident, you can pencil these in first if you wish.)

13 Unevenly mix off-white with deep purple. Using the No. 8 brush, stipple frothy little flower heads in clumps, almost like bunches of grapes. Pick up more off-white on the brush, and add lighter tones to the cascading flowers. Allowing it to dry before proceeding to the next step is not necessary.

14 Mix light sage green with the dark green, and paint some midtones on the leaves. Add some leaves overlapping the flowers. Pick up some off-white on the brush, too, and paint a few very light smaller leaves.

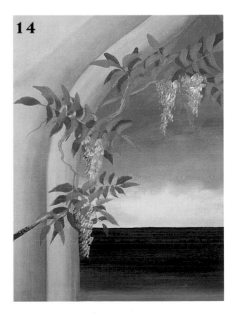

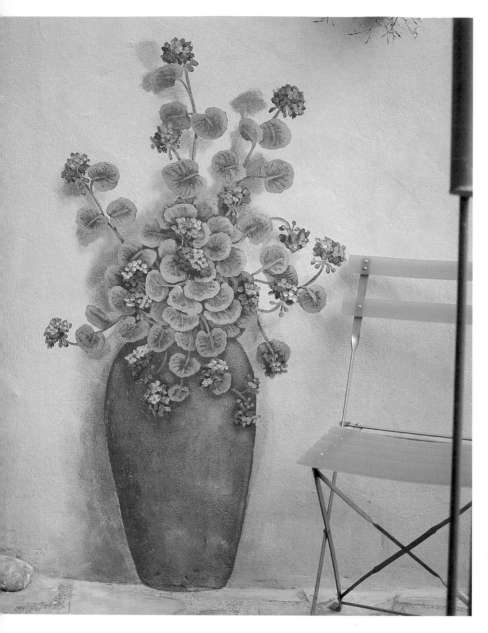

Pot of Geraniums

This design, which can be used either on its own or in a larger project, looks stunning in a conservatory. The terracotta pot could be filled with a variety of plants, and the flowers painted in any colour – just change the deepest shade and follow the steps using the same techniques.

YOU WILL NEED

Tracing paper and pencils

Acrylic paints in raw umber and black

Flat latex paints in wall colour,
 terracotta, dark green, deep pink,
 cream and pale lime green

No. 8 artist's brush

2.5cm (1in) fitch

Preparation

This wall was painted with a colourwash of sand latex paint over a white base coat, but other colours or a flat finish would also be suitable (though colours that are not light would have to be overpainted with white within the outline of the pot of geraniums).

Draw the olive oil pot and transfer it to the wall using tracing paper and pencils (see page 13 for drawing symmetrical shapes). Sketch the shapes of the geranium stems and leaves.

Shadows

1 Take up raw umber acrylic and the wall colour (without mixing them) on the No. 8 brush, and paint in the shadows of the pot and geranium in raw umber, creating crisp inner edges. Now soften the outer edges of the shadows into the background with the fitch, adding a little water to it if desired. To create the effect of light coming from the right, make the shadows on the left slightly heavier.

Outlines and blocking in

2 Mix raw umber with terracotta, and, with the No. 8 brush, paint a neat outline for the pot. Now use the fitch to soften the inner edge, picking up only terracotta with the brush as you work into the centre of the pot.

While this is drying, use the No. 8 brush to outline the plant in dark green, including the stems. With the fitch, fill in the central mass of leaves in this colour, leaving a few small unpainted patches for flowers.

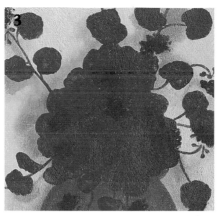

3 With the No. 8 brush, paint deep pink flowers in these white spaces and also at the ends of the stems. Use the shape of the brush to 'print' the outer petal edges, then fill in the centres.

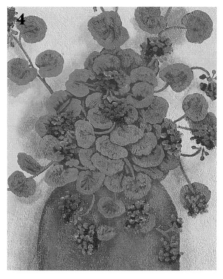

Midtones

4 Mix cream into the terracotta, and add midtones to the pot using the fitch. Start with the area that is to be the lightest – i.e., the right side – and soften towards the edges as the paint is used up on the fitch.

Mix the dark green with pale lime green, and use the No. 8 brush to add midtones to the foliage, so the leaves overlap. Start in the middle and work outward. Add a thin line to each stem.

For the midtones of the flowers, mix cream with deep pink, and use the artist's brush to paint small flower heads on the deep pink areas. Add more cream for extra tonal variation.

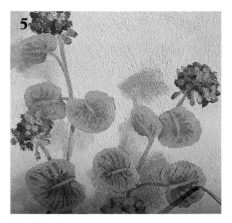

Highlights

5 When the midtones are dry, you can add highlights, concentrating them on the lighter side (the right). Mix a creamy terracotta and use the fitch to add a few small patches to the pot, softening the edges as it runs out of paint. Now mix cream with the midtone green, and with the artist's brush add light details to the edges of the leaves and the veins. Mix a creamy pink and add a few paler petals to the flowers with the artist's brush.

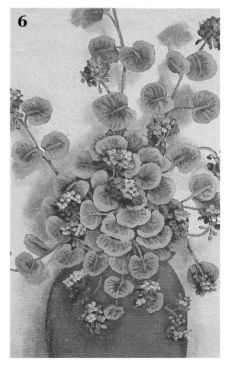

Detailing

6 Pick up a bit of black on the No. 8 brush and dot tiny centres on the flowers. (Don't clean the brush, as any pink left on it will soften the black.)

YOU WILL NEED

Template of lizard (page 138)
Tracing paper and pencils
Acrylic paints in raw umber,
 chromium oxide green, black,
 titanium white, lime green, cobalt
 blue and lemon yellow
2.5cm (1in) fitch
No. 5 and No. 8 artist's brushes

Lazy Lizard

*Although he looks so realistic
that you'd expect him to scurry
off at any moment, this lizard is
quick and easy to paint. Basking
on the wall — above a trompe
l'oeil pot of flowers, perhaps — he
would make an amusing
addition to any conservatory.*

Preparation

This wall was painted with a
colourwash of sand latex paint over a
white base coat, but other colours or a
flat finish would also be suitable
(though colours that are not light
would have to be overpainted with
white within the outline of the lizard).

 Enlarge the template and transfer it
to the wall using tracing paper and
pencils (see page 13).

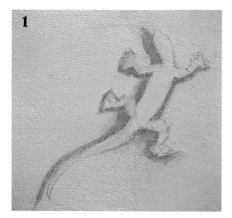

1

Shadow

1 Mix raw umber with a little water, and use the fitch to paint the shadow around the outline of the lizard. Here, the light source appears to come from the right, because the shadow is more pronounced on the left, but if your natural light source comes from the left, you should put the shadow on the right so that it will look more natural. Dip the fitch in water and then in the paint on the palette; take off the excess on a cloth, and lightly smudge the edges of the shadow using a scrubbing action.

> **TIP** If you cannot get a soft enough effect on shadows just with the fitch, try dabbing the edges with a cloth.

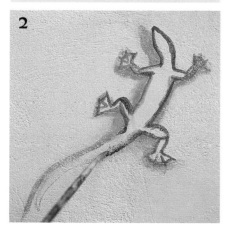

2

Outline

2 Dip the No. 8 brush in water, then pick up raw umber, chromium oxide green and black on the brush without mixing them. Paint the outline of the lizard, then pick up a little more water

on the brush and soften the colour into the body, keeping the outline crisp and neat. Allow to dry.

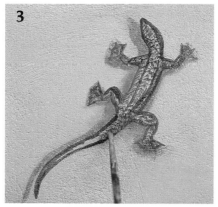

3

Scales

3 Using the No. 8 brush and the same colours (but very little of the black), stipple the body to create the effect of scales, while allowing the base colour to show through. If you find that you have added too much colour, stipple a little white on in the same way. Leave to dry completely (20 minutes or so).

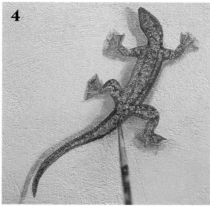

4

Glaze and detailing

4 Clean the No. 8 brush, then dilute lime green with water. Apply this glaze all over the body. Allow to dry.

With the No. 5 brush, add small dots of thick paint, in cobalt blue, chromium oxide green and lemon yellow to the body; apply the colours separately, and clean the brush with a cloth after applying each. For a more vibrant effect, add white to the lemon yellow. Put slightly more dots on the right (unless the light is from the left).

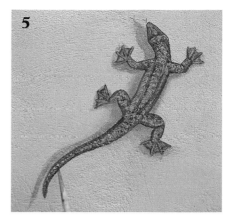

5

Detailing

5 Mix raw umber with a touch of black and some water, and with the No. 5 brush emphasize the outline of the lizard. Define the web detailing on the feet and the lines on the back and around the eyes. Add a forked tongue, and then use raw umber and water to create a shadow of the tongue.

Below: The lizard has been painted on a conservatory wall above a pot of trompe l'oeil geraniums (see pages 78–79).

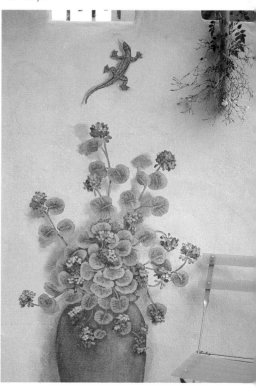

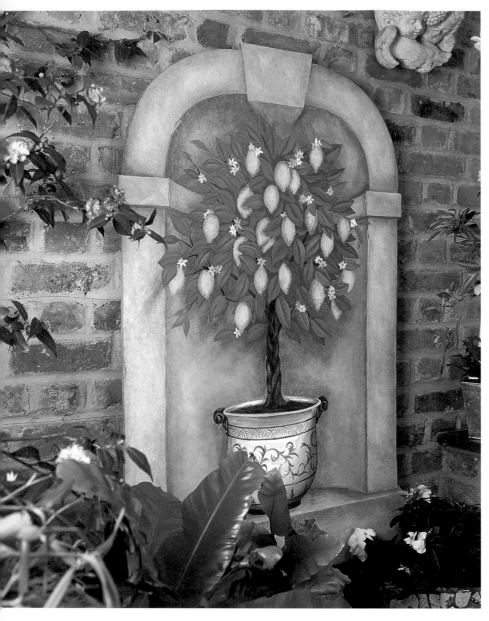

Lemon Tree

The perfect trompe l'oeil for a
conservatory, a lemon tree will,
in fact, cheer up any room.
Paint it on a shaped board, as
here, or right on the wall.
It can be set into a faux stone
niche like this one, incorporated
into a mural, or simply used
in splendid isolation.

YOU WILL NEED

Large sheets of tracing paper and
 cellophane tape
Pencils and straightedge
2.5cm (1in) fitch
Flat latex paints in dark grey-brown,
 sand, cream, pine green and
 light green
Low-tack masking tape
Acrylic paints in raw umber, black,
 ultramarine, titanium white and
 cadmium yellow
No. 5 and No. 8 artist's brushes
Matt varnish and varnishing brush

Preparation

This lemon tree was painted on a
piece of board that had been cut with
an electric jigsaw into the shape of a
niche, using a template (see below).
After being cut out, the board was
primed with acrylic primer and then
painted with white latex paint.

 To make the template, stick large
sheets of tracing paper together with
cellophane tape, and draw half of the
niche and half of the tree and pot on
the paper, using the photograph on
page 83 (step 1) as a guide.

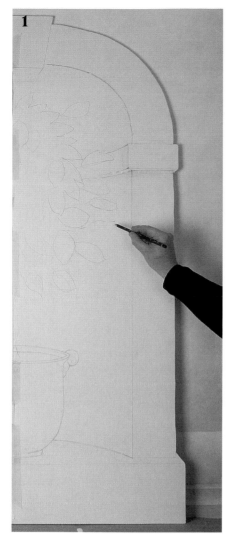

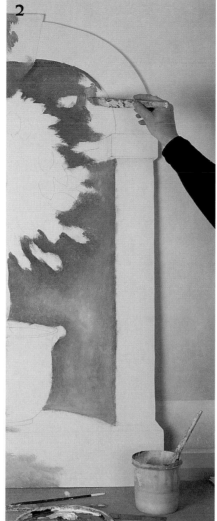

Surround

3 For the surround, mask the straight edges as shown. Using the fitch, apply dark grey-brown along these masked edges and along the outer edge. Work on only a small area at a time, and then pick up sand paint on the fitch and stipple this onto the surround, blending into the dark grey-brown. Pick up cream and highlight the centre. The surround should be lighter than the more shadowy background within it, to add to the three-dimensional effect. Remove the tape as you finish painting alongside it.

> **TIP** When painting the surround, you can mask straight edges as necessary, but try not to overdo it, as slightly wobbly lines look more natural.

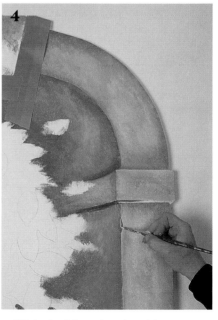

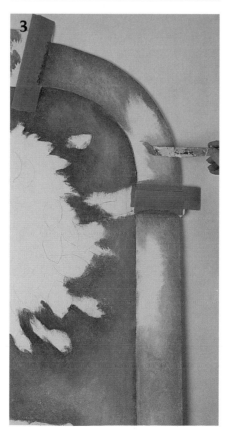

Outline and detailing

1 Transfer the outline and detailing of the niche, tree and pot from the template to the painted board (see page 13) using pencils. Or, if you prefer, lightly draw the tree and lemons freehand on the board.

Niche

2 With the fitch, paint around the outline of the tree in dark grey-brown. Now pick up a touch of sand paint on the fitch along with a bit of water, and stipple the background a little at a time. Pick up some cream on the fitch and stipple it into a few of the most central areas of the background.

> **TIP** When stippling the background, don't overload the brush or over-blend the paint.

4 With the No. 5 brush, add narrow shadows in dark grey-brown around the keystone, the column top and the curved base of the niche. Pick up some cream, and add small irregularities and chips to the edges of the niche. Mask the keystone and stipple it in the same way, keeping it generally quite light, with some dark tones on the top edge. Remove the tape.

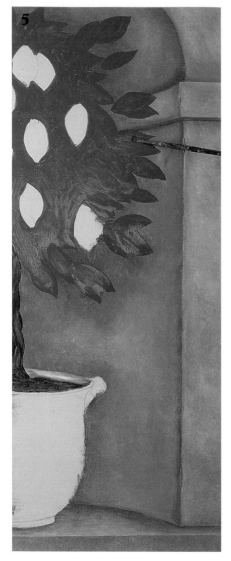

5

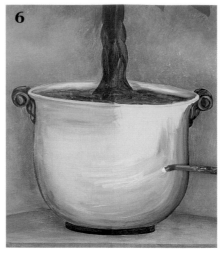

6

Add still more white, and gradually work towards the centre of the pot, using sweeping brush strokes. When you reach the centre, the colour should be nearly white. Allow to dry.

> **TIP** Work on one side at a time, so that the paint will remain wet enough for you to shade subtly from dark at the edges to midtone to light in the centre.

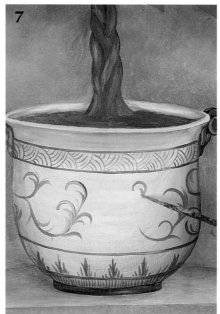

7

7 Lightly pencil the decoration on the pot. Mix ultramarine with black, and use the No. 5 brush to paint the border pattern near the base. Add some white to the mixture, loosen the paint with a little water, and paint the remaining pattern, varying the shades slightly. Use the same colour to add details and highlights to the handles.

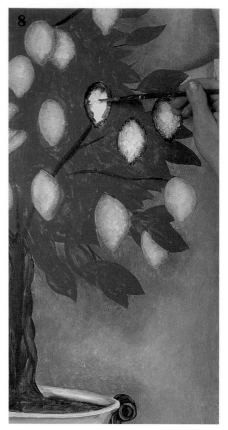

8

Blocking in tree and soil

5 Using the fitch, fill in the tree foliage in pine green, leaving the lemons white. With the No. 8 brush, paint individual leaves coming out of the mass of leaves. Mix raw umber with a touch of black, and loosen a little with water, then use the No. 5 brush to paint the trunk and branches, and also the soil in the pot. Vary the thickness of the paint as you stroke it on the trunk, to create a gnarled look.

Ceramic pot

6 Mix ultramarine, black and a lot of white, then, using the No. 5 brush, paint the handles and dark base rim of the pot. Pick up a little more white on the brush, then paint the midtones of the handles and the outline of the pot.

Lemons

8 With the No. 5 brush, outline the lemons in raw umber. Pick up some white on the brush and work the colour into the centre of the fruit using a stippling action to create the characteristic spongy texture. Do the lemons one at a time.

After you have painted three or four lemons, the first should be dry enough to glaze. To do this, mix cadmium yellow acrylic with a touch of white and dilute it with water. Paint this semi-transparent glaze onto the lemons, then add more white for a highlight in the centre.

Allow to dry, then strengthen the raw umber around the edges, add a few more white highlights and glaze again. Leave to dry.

> **TIP** This is the standard technique for painting fruit, but if you were working on an individual fruit, more layers of glaze would be used.

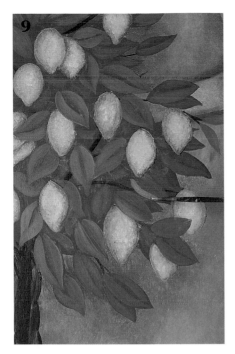

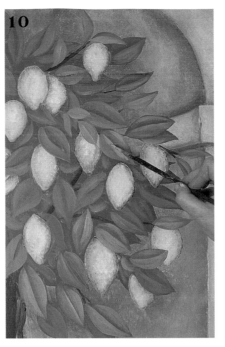

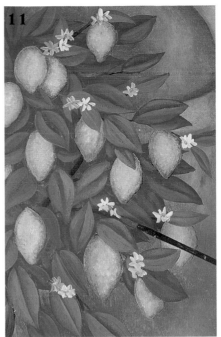

Leaf detail

9 Mix light green with pine green. With the No. 8 brush, paint individual leaves on the mass of foliage, from the centre outwards. Vary these midtones slightly, and sometimes overlap the leaves over the lemons. Paint only a few at a time, then go on to step 10.

10 Mix light green with a touch of white, and use the No. 8 brush to add small highlights to the leaves while the midtones from step 9 are still damp. Now repeat step 9 and this step for another small area. Continue adding midtones, then highlights, until all the leaves are painted.

Flowers

11 Pick up white and a touch of raw umber on a No. 5 brush without mixing them, and paint small flower heads in varying shades of white to off-white. Clean the brush and add deep yellow centres. Leave to dry, then apply a coat of varnish.

Right: Here the lemon tree has been painted directly on the wall that has faux stone panelling, shown in the project on page 32. The terracotta pot is painted in the same manner as the geranium pot on page 78, with handles added.

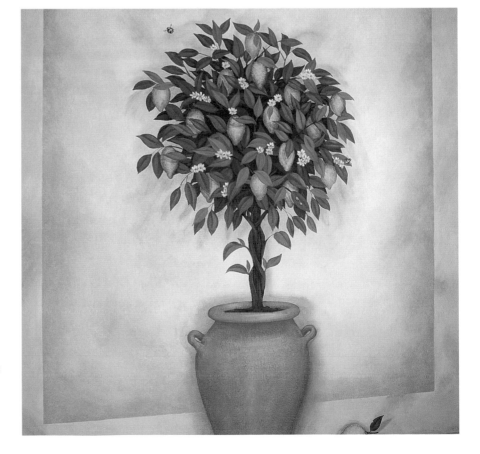

POWDER ROOMS

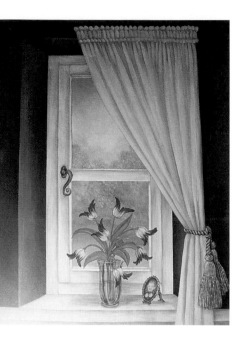

Left: A strong colour scheme and a small trompe l'oeil window add a sense of fun as well as space to this powder room.

Right: With its vista of formal gardens framed by a faux stone archway surrounded by faux stone panelling, this powder room looks infinitely larger and grander than it really is. The mirror enhances the effect.

Because powder rooms are often quite small, they offer an ideal opportunity for all-over transformation, particularly when they have an unusual shape or interesting angles. Faux fabric draped over the walls, and possibly even over the ceiling for a tented effect, can look fabulous. Strong colours look dramatic and fun in a small space, and can be broken up with a trompe l'oeil window. The window is all the more effective if the powder room doesn't have a real window. A mural on one wall, or the top half of a wall, looks stunning even in such a confined space, particularly if it is reflected by a carefully placed mirror.

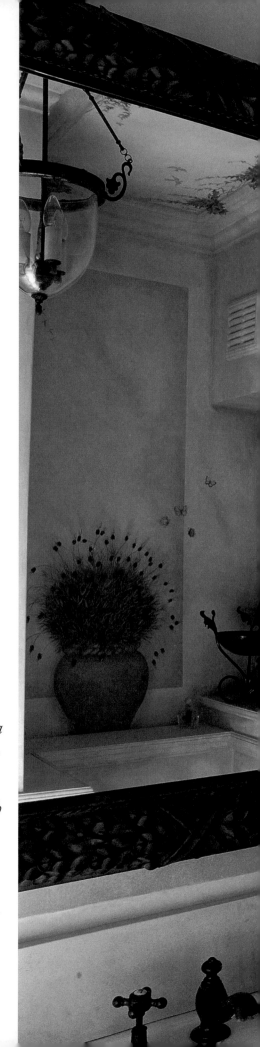

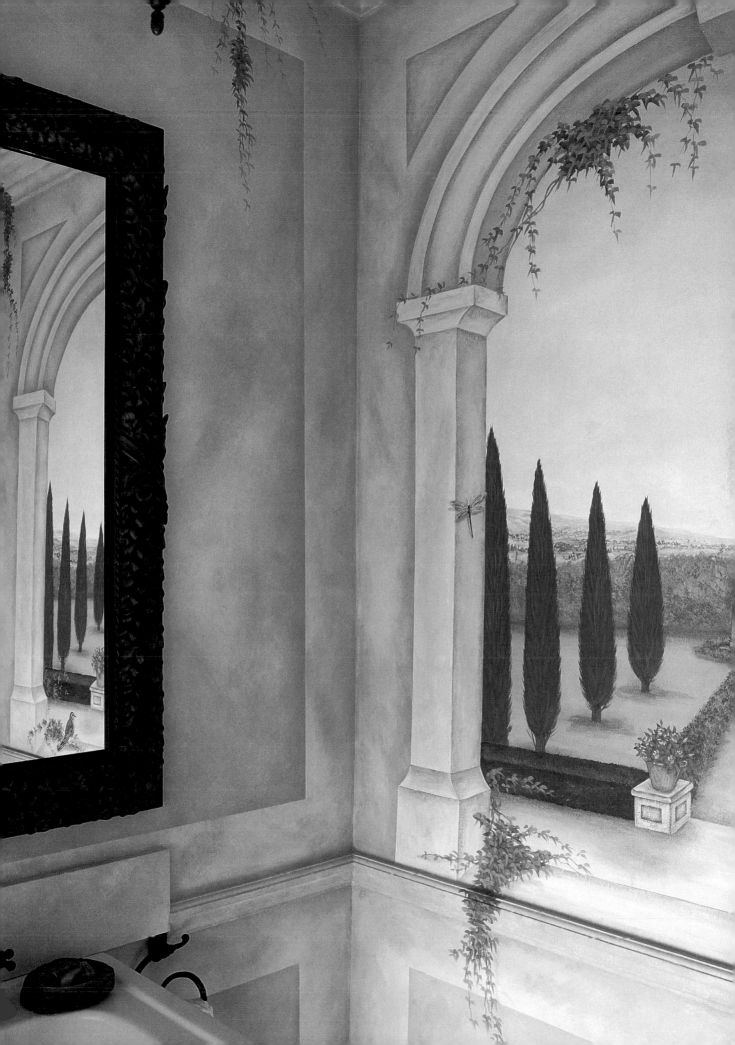

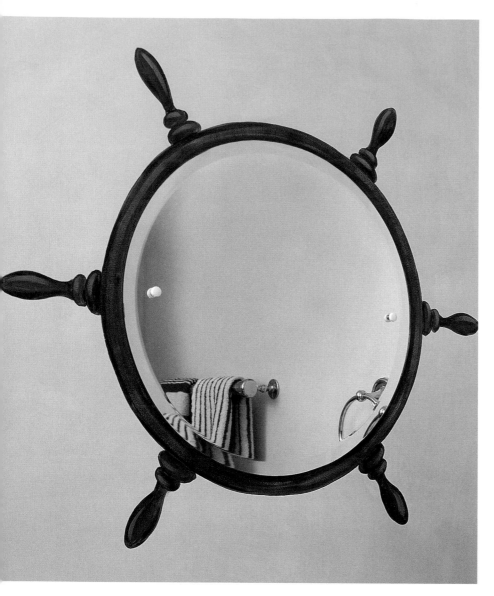

Ship's-Wheel Mirror Frame

A nautical theme works well in a powder room. This trompe l'oeil ship's-wheel border painted around a bevelled mirror that is glued to the wall is simplicity itself to do. It would also look good in a full bath or a child's bedroom.

YOU WILL NEED

Pencils, straightedge and
 tracing paper
Template for handle (page 138)
Acrylic paints in burnt umber, black,
 raw sienna and titanium white
No. 8 artist's brush
Satin varnish and varnishing brush
Super-strong adhesive for mirrors
 (available from glass supply stores)

Preparation

The wall was colourwashed with cream latex paint over a white base coat, but any colour or finish would be suitable.

Put the mirror in position, draw around it with a pencil and then take it down. Divide the circle into six equal segments, using a straightedge and pencil to draw light lines that extend from the centre beyond the outline. Draw a larger circle 5cm (2in) outside the first. Enlarge the handle template so it is about 15cm (6in) long. Trace it using a soft pencil, then centre the tracing (pencil-side down) over one of the six lines, with the base on the outer circle, and transfer it to the wall (see page 13). Repeat for the other five handles.

TIP To draw the second circle, either measure out from the first circle and then join the marks, or make a paper template as follows: Tie one end of a piece of string to a pencil and the other end to a drawing pin placed at the centre of a piece of lining paper, with the length of the string equal to the desired radius of the circle. Use it like a pair of compasses, keeping the string taut and the drawing pin firmly in place at the centre as you draw the circle. Cut out the template and draw around it on the wall.

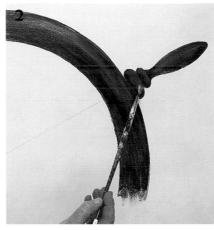

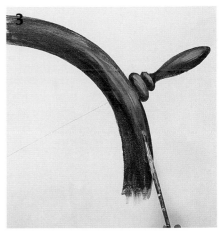

Outlines and blocking in

1 The No. 8 brush is used throughout. Mix burnt umber with a touch of black acrylic, and paint the outlines of the handles and of the inner and outer circles. Add a little water to keep the paint flowing easily. Now pick up burnt umber alone on the brush and fill in the wheel and the handles between the outlines.

Midtones

2 Mix raw sienna with a little burnt umber acrylic, and using long sweeping brush strokes, paint midtones on the wheel edge and on the handles to emphasize the curves.

TIP You can either complete the circle and then do each handle one at a time, or paint the handles as you come to them.

Highlights and finishing

3 Pick up a touch of white along with the raw sienna already on the brush, and paint highlights sparingly on the wheel and handles, again to define the curves. When dry, apply a coat of varnish (or two coats if it is likely to be splashed or need frequent cleaning). Position the mirror, then fix it to the wall with adhesive.

Right: To go with the nautical theme of the ship's-wheel mirror frame, you could combine portholes (see page 112) and other marine motifs. These fish are painted with acrylics using glazes, with details and outlines added with raw umber using a fine artist's brush. The outlines are traced on and then filled in with acrylic washes to build up the colours.

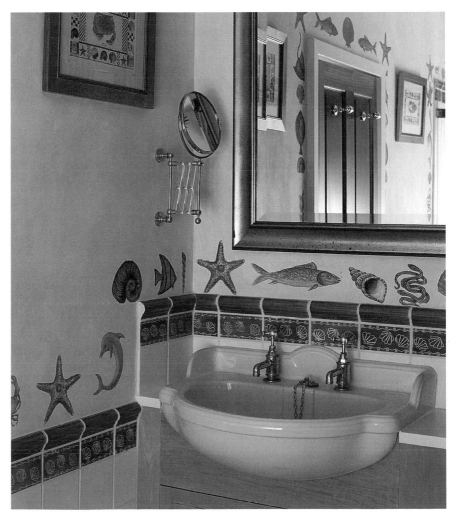

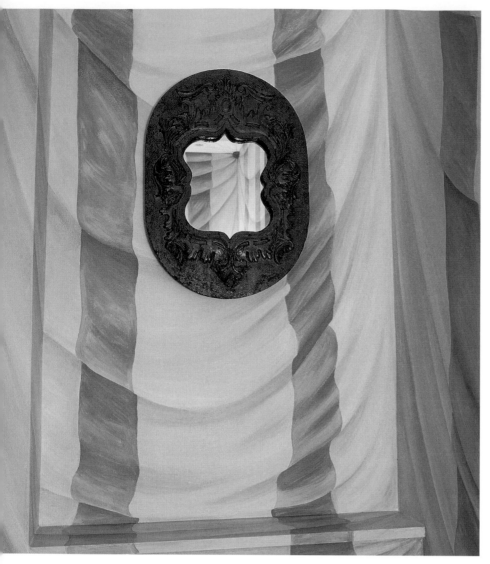

YOU WILL NEED

Pencil

2.5cm (1in) fitch

Flat latex paints in soft grey-
 brown, cream, white and
 dark rose-pink

No. 8 artist's brush

Matt varnish and varnishing brush

Fabric-Draped Walls

Trompe l'oeil draped fabric looks fabulous in small- or medium-sized powder rooms, as well as in entry halls, dressing rooms and full baths. It's easy to customize the faux fabric to match an existing colour scheme or even a fabric, but stripes are the most suitable as they emphasize the realistic-looking folds.

Preparation

The walls were first painted with white latex paint using a roller.

Imagine fabric gathered up at the corners of the room and draped over the walls in graceful folds. Now pencil lines onto the walls to represent the folds, which are smallest and tightest at the top corners and which get larger and looser as they fan out. The lines are therefore close together at the top corners, becoming farther apart and more gently curved, then finally disappearing in the bottom half of the wall at the centre.

Finally, draw the vertical stripes curving over each fold.

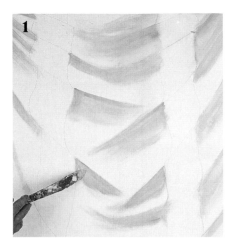

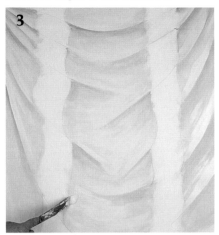

Shadows in background

1 The background (the areas between the stripes) is painted first for the whole wall, then the stripes are painted. Whether painting the background or the stripes, work on no more than a square metre (yard) at a time. Using a fitch and soft grey-brown, paint subtle shadows under the folds in the background. Keep the top edge of each shadow crisp but soften the lower edge by picking up a little water on the brush and washing the colour downwards so it fades away.

> **TIP** If you are painting a large room, you could use a 5cm (2in) brush to fill in the largest central areas.

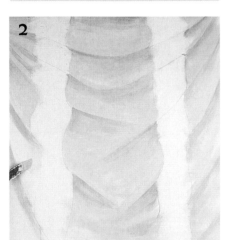

Midtones in background

2 Clean the fitch with water, and without drying it, pick up some cream paint. Paint the midtones under the

shadows, using brush strokes that follow the undulations of the fabric. As the fitch runs out of paint, soften the edges of the midtones onto the softened edges of the shadows.

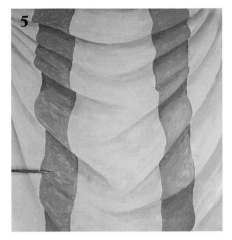

Highlights in background

3 Clean the fitch with water again, and without drying it, pick up some white. Work back over the area painted in step 2, adding highlights to the folds. As the brush runs out of paint, soften the edges of the highlights over the midtones. Repeat steps 1 and 2 and this step for the rest of the wall, still working on only one square metre (yard) at a time.

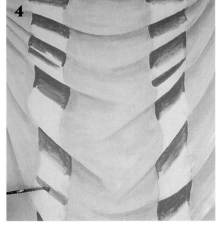

Shadows in stripes

4 Using the No. 8 brush and the dark rose-pink, paint the shadows under the folds in the stripes, relating them to the shadows already painted in the background. Again, work on no more

than a square metre (yard) at once, and soften the lower edges of the shadows as in step 1. Keep the top and side edges sharp.

Midtones in stripes

5 Mix white into the dark rose-pink. Using the No. 8 brush, paint the stripe midtones. Keep the lower edges and sides sharp and soften the top edges into the shadows, dipping the brush into water a little to help the flow.

> **TIP** Make up a quantity of the stripe midtone colour (dark rose-pink mixed with white) and store it in a jam jar so that you can use it while you are working on a room over a few days.

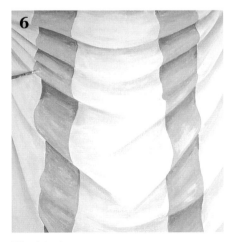

Highlights in stripes

6 Mix more white into the midtone colour, and with the No. 8 brush add highlights on the folds, softening the edges of the highlights over the midtones. When dry, apply varnish.

BEDROOMS

Left: Picking up details from fabrics and enlarging them in a trompe l'oeil design can be both amusing and dramatic. In this bedroom, clocks were taken from the fabric used on the shade and painted on the walls to look surprisingly realistic.

Right: Faux stone walls and a sky ceiling provide a rich though neutral background that will look good with a variety of fabrics and colour schemes, allowing you to change the decor of the bedroom without redecorating.

The bedroom is the traditional site for a sky ceiling, which can look superb combined with subtle faux stone slabs or faux wood panelling for the walls. There are other wide expanses here that are also ideal for trompe l'oeil – the wall above the bed and the doors of wardrobes both lend themselves well to a variety of subjects. Chests of drawers offer a good opportunity for small, witty paintings depicting items of clothing hanging out of the drawers. As soft furnishings are used a lot in this room, faux fabric always looks good here, too, particularly if it echoes an existing fabric such as the curtains or bed cover.

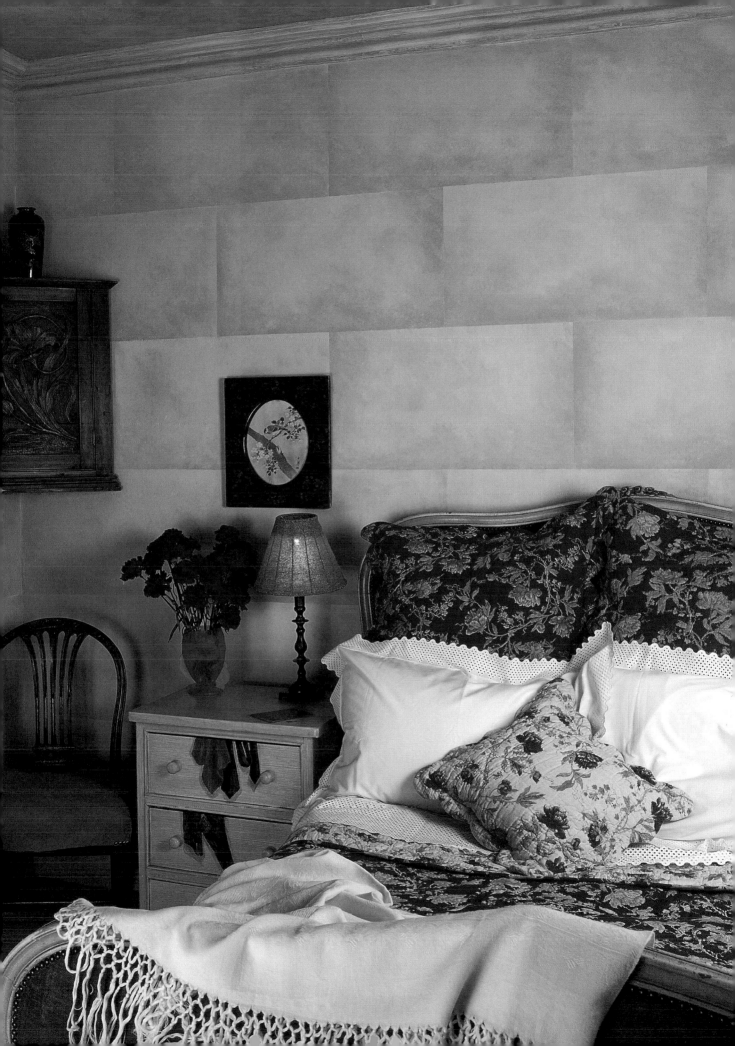

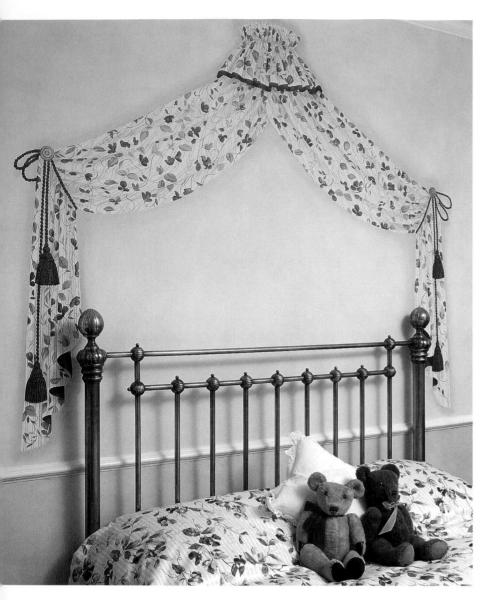

Bed Canopy

Faux fabric looks wonderful in the bedroom and is more practical than the real thing. For this trompe l'oeil canopy above a headboard, the colours and pattern are loosely based on those of the real fabric on the bed, without being an exact copy, which would lose the flowing, painterly look.

YOU WILL NEED

Pencil

Flat latex paints in white, wall colour and sand

5cm (2in) decorator's brush

2.5cm (1in) fitch

Acrylic paints in raw umber, black, crimson, cadmium yellow, chromium oxide green, ultramarine and metallic gold

No. 5 and No. 8 artist's brushes

Pair of compasses or a small jam jar

Matt varnish and varnishing brush

Preparation

The wall was painted with a colourwash of sand latex paint over a white base coat, but other colours or a flat finish would also be suitable.

Draw the outline freehand in pencil on the wall, and fill in the whole area with white latex paint using the decorator's brush, and the fitch at the edges. Allow to dry.

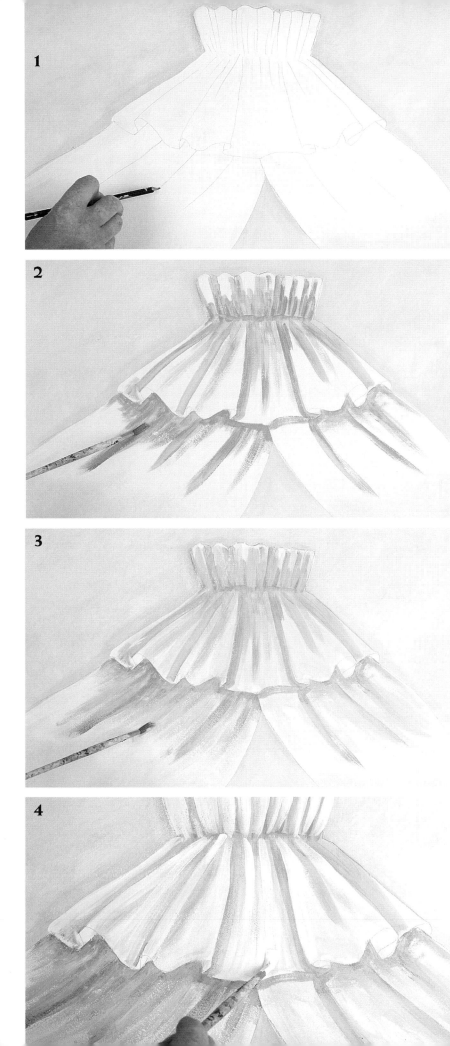

Background shadow and sketching

1 For the very light shadow around the canopy, mix some of the wall colour with a little raw umber acrylic, to deepen the wall colour just a little. With the fitch, apply this around the outside of the outline of the whole canopy, softening and blending the outer edge of the shadow into the existing wall colour surrounding it in order to make it as subtle as possible. Leave to dry.

Lightly sketch the coronet (i.e., the top portion of the canopy), and all the lines and creases in the coronet and swags (i.e., the curtains that are draped at each side). Note that the folds fan out from the top, a little bit on the canopy and more so on the swags.

Shadows within canopy

2 Mix some raw umber acrylic with white latex paint, and using the No. 8 artist's brush, paint shadows along these pencilled lines. Keep the edges of the shadows soft by taking up a touch of water on the brush. Don't work on too large an area at a time, because the edges need to be wet for the softening that will be done in the next step.

Midtones

3 Add a little sand latex paint to the raw umber and white mixture, and use the No. 8 brush to paint midtones between the shadows. Using a long, sweeping brush stroke along each fold, soften the edges into the darker shadows.

Highlights

4 Clean the brush, then use it to highlight the folds in the fabric and to define the undulations in the coronet with white paint.

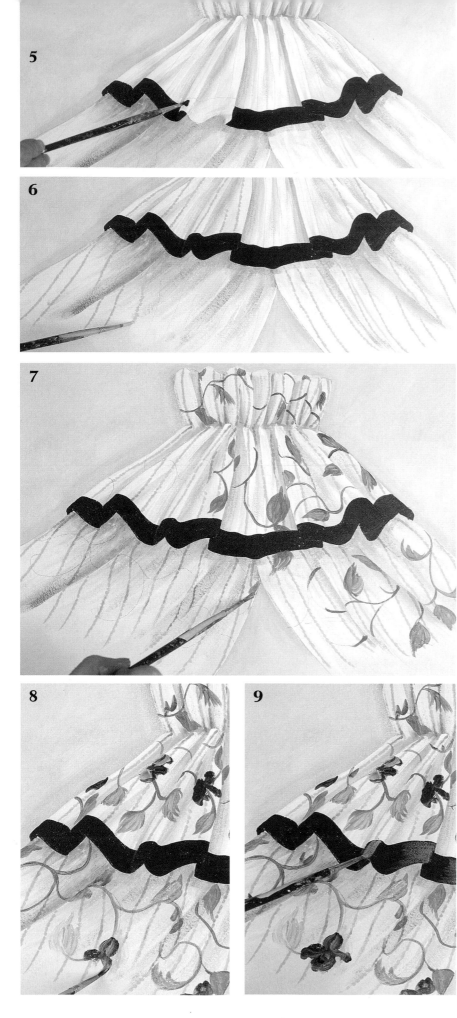

Ribbon trim

5 If you wish, lightly pencil in the inner edge of the ribbon trim on the coronet. Mix a little black with the crimson, and paint the ribbon using a No. 5 brush. Add extra black to some of it for the shadows, and complete each undulation, including the shadows, before starting the next. This will enable you to keep a wet edge for subtle blending.

Stripes

6 Lightly pencil in narrow stripes along the fabric. Mix yellow and raw umber to form a golden tone, and with the No. 5 brush paint each stripe as a line of dots that just touch, rather like a chain. On the areas where the fabric is in shadow, mix extra raw umber into the paint; for the highlights, add more yellow to the mixture.

Foliage and flowers

7 Lightly pencil in leaves and stems on the fabric. Mix green with a touch of white, and paint the leaves and stems using the No. 5 brush. Vary the proportions to create a variety of tones, and use the darkest greens in the fabric shadows.

8 Mix crimson and ultramarine to create purple, and also put a little crimson and a little white on the palette. With the No. 5 brush, pick up some purple along with varying amounts of crimson and white (without mixing the three colours), and paint the flowers and buds on the fabric. The darkest purples should be used for the fabric shadows and the palest ones for the highlights.

9 Mix some white and crimson and use this with the No. 5 brush to highlight some of the petals and at the same time the folds of the ribbon on the coronet.

Shadows behind tieback

10 Use compasses or draw around the base of a jam jar to pencil in the roundel for the tieback. Sketch the cord and tassel. Repeat the procedure set out in step 1 for creating shadows on the wall, this time for shadows from the roundel and cord. Paint in shadows on the fabric around the outline of the tassel. Paint the rest of the canopy as in steps 2–4 and 6–9.

> **TIP** Although the instructions here are for one tieback, the other can be done either at the same time or after you've finished painting the first tieback.

Tassel and cord

11 Mix crimson with a touch of ultramarine, and with the No. 8 brush, block in the tassel. Block in the cord, too, using shallow S-shaped brush strokes to create each segment of the cord.

12 Add some white to this colour and use the No. 5 brush to paint midtones on the tassel and cord, using dots for the top of the tassel, linked dots similar to a chain for the tassel fringing, and small, shallow S-strokes for the cord. Make sure you retain the dark outline.

13 Add some more white and paint the same brush strokes, but smaller, over the midtones, to highlight the tassel and cord.

Roundel

14 Mix a touch of black with raw umber and a little water. Using the No. 8 brush, paint the concentric circles of the metal roundel. Now pick up a little gold on the brush and fill in the spaces between the circles.

15 Add more gold to the mixture and use this to highlight the roundel. Allow the canopy to dry, and then apply a coat of varnish.

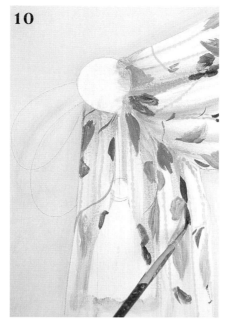

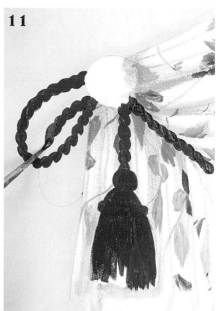

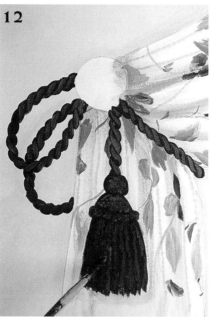

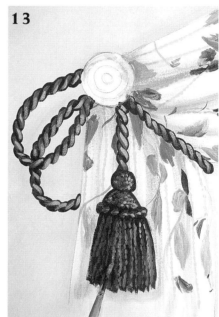

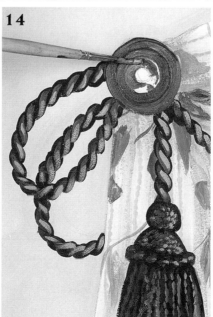

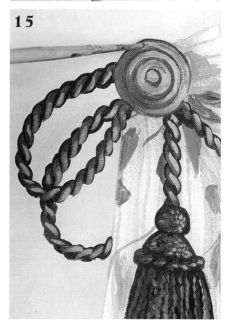

Sky Ceiling

Bedrooms are the best setting for
dramatic sky ceilings like this
one, while more subtle tones look
better in rooms used mostly in
daylight. Recessed downlighters
work better than uplighters
with sky ceilings — whereas
uplighting tends to flatten the
effect, downlighting adds depth.

YOU WILL NEED

Three 5cm (2in) decorator's brushes
Low-tack masking tape
Flat latex paints in deep indigo, sky
blue, sand and cream

Preparation

The ceiling was painted with a white
base coat. This is essential even for
quite dark sky ceilings.

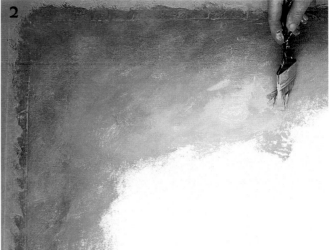

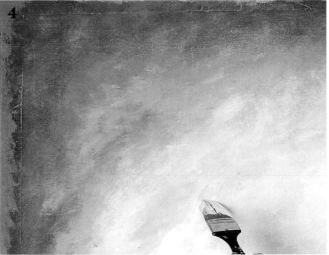

Deep indigo

1 Mask the wall edge (or cornice edge if you have one) where it meets the ceiling. Use one brush for the deep indigo, another for the sky blue and a third for the sand and cream. The overall working plan is to start at the edges and work around the room in ever-decreasing circles into the centre. However, you should work on an area of no more than about 45cm (18in) square before completing steps 2 and 3, so that each colour stays damp enough to blend into the others.

The darkest colour – the deep indigo – is clouded around the edge of the ceiling, with the inner edge softened about 7.5–20cm (3–8in) from the ceiling edge, and about 45cm

(18in) from the corners. Apply the deep indigo using a loose stipple action (letting the brush slip as you stipple) to create semicircular 'cloud' shapes. The edges will dry as you do this, so leave ragged edges, picking up a little water to thin the paint.

> **TIP** Do the masking of the ceiling edge as you work your way around the room.

Sky blue

2 With a second brush, work sky blue into the softened deep indigo edge, using the same arching shapes and blending back into the denser blue. Add water to the brush as necessary, and bring the sky blue out 15–20cm (6–8in) from the deep indigo, once again softening the edges.

Sand

3 With a third brush, work a little sand colour next to the sky blue in the same way, again softening back into the area you have already painted, using water as necessary. This portion of the painting should be about 15–60cm (6–24in) wide.

Sky blue with cream

4 As you approach the centre of the ceiling, use just the sky blue and cream paints, with their respective brushes. Pick up the colours in varying amounts to alter the tones, and always blend back into the previously painted areas, softening with water as before if needed. Occasionally work in a little of the sand and extra sky blue to create a few deeper-coloured areas.

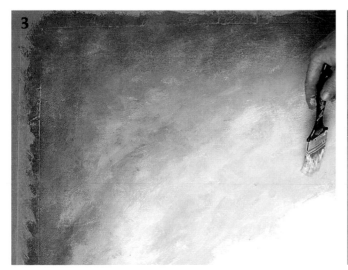

CHILDREN'S ROOMS

Left: A trompe l'oeil straw hat makes a fun addition to a wardrobe door in a child's room. The door is part of a large wardrobe painted to look like beach huts, but the picture proves that simple trompe l'oeil ideas often have as much impact as larger-scale, more complex projects.

Right: In this small attic bedroom, a fantasy world of flowers, friendly animals and fairies extends all the way around the walls. It would be possible to either frame the scene within an archway or to use any of the elements individually.

Children of all ages love trompe l'oeil, and it is so versatile that it can be used in any child's room, from a baby's nursery to a teenager's den. Walls, ceilings, floors, wardrobes, chests of drawers, trunks, headboards and bunk beds are all suitable, and in a child's room you can let your imagination run riot! Whether you paint a full-scale mural or just decorate a door or piece of furniture with a small motif, the child will be delighted — especially if humour plays a large part in the subject matter.

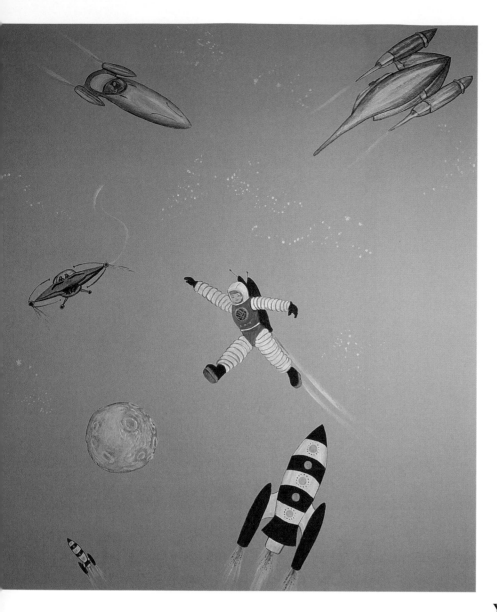

Space Scene

What better way to decorate the bedroom of a young Star Wars fan than with a space scene on the wall? The great thing about it is that objects floating in space can be any size. Also, you can trace star ships, astronauts' suits and other items from favourite books, comics or posters, making the process even simpler.

YOU WILL NEED

Tracing paper (optional) and pencils
No. 3, No. 5 and No. 8 artist's
 brushes
Acrylic paints in titanium white,
 cadmium red, cadmium yellow,
 deep turquoise, black, raw umber
 and metallic silver

Preparation

The walls of the bedroom were painted deep sky blue and the ceiling was 'clouded' using some of the blue from the walls.

Enlarge the images and transfer them to the wall using tracing paper and pencils (see page 13), or draw them out freehand using a pencil.

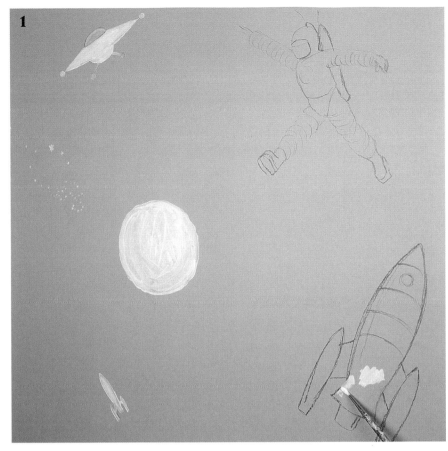

1

Coloured detail

3 Put some red on the palette, loosen it with a little water, and use the No. 5 brush to paint the astronaut's gloves, rocket pack, boots (except the soles) and chest emblem. Also paint the details of the rocket, curving the lines of the stripes to make it look more three-dimensional. Allow to dry.

4

Filling in with white

1 Using a No. 8 brush, fill in the images with white, apart from the astronaut. (If the pencil shows through the paint, it will create an effective subtle shading.) As you do the brush strokes, vary the thickness of the paint with a little water to produce a more three-dimensional look, since these don't use conventional shading.

> **TIP** If you make any mistakes pencilling the images on the wall, erase them with a clean damp cloth.

2 Fill in the astronaut with the No. 5 brush and white paint, using C-shaped brush strokes on the arms and legs of his suit to create a Michelin Man effect. Vary the thickness of the paint as in step 1. Using the No. 8 brush and very little white paint, add the vapour trails from the astronaut's rocket pack, trailing them off with long brush strokes. Allow to dry.

2

3

4 Mix a touch of red with white and a tiny bit of yellow to create a flesh tint, and paint the astronaut's face using the No. 3 brush. Clean the No. 5 brush and paint yellow circles on the rocket, yellow dots surrounding the red circle on the astronaut's chest and a yellow lattice pattern over it. Clean the brush and paint turquoise dots around the yellow circles on the rocket. Paint the astronaut's turquoise tunic (leaving a white belt), and turquoise lines on the arms and legs of the suit and around the helmet. With red and yellow on the No. 3 brush, add three tiny dots above the astronaut's belt and some flames coming from the rocket pack. Also paint the astronaut's red-orange hair. Mix the turquoise with a bit of black, and paint the soles of the boots. Pick up a little white on the brush to highlight the edges of the soles.

Raw umber detailing

5 With the No. 3 brush, outline in raw umber the rocket and the astronaut's boots, gloves, belt, rocket pack, helmet and face, as well as adding the antennae and facial features. When painting the mouth, pick up a little red on the brush too.

Rocket vapour trails

6 The rocket vapour trails are now added. With the No. 8 brush, paint the white trails, using large brush strokes that gradually fade away. With yellow and red on the brush, add fiery streaks coming from the base of each vapour trail, fading into the white. Pick up more red, and dot this orange colour on top.

Planet

7 Paint the planet with a yellow wash, then create shadows at the edge with the No. 8 brush and raw umber. Still using raw umber, add circles of varying sizes to suggest craters and hills. Allow to dry.

8 Mix a thicker yellow with a touch of white, and paint midtones onto the rims of the craters and the peaks of the hills. Continue adding white to the mixture, and paint small highlights over the midtones, adding extra highlights on one side to make the planet look more spherical.

Starship

9 Mix black and metallic silver, and paint the starship with this pewter shade using the No. 5 brush. Start with a sharp outline, then pick up water on the brush and soften the inner edge so it fades into the body of the starship. Allow to dry.

10 With the No. 5 brush, paint yellow details on the starship, adding a touch of raw umber for the darker tones. Add silver midtones, softening the edges by picking up water on the brush and blending the colour into the pewter shade. Allow to dry.

11 Mix a little more black into the pewter shade on the palette, and outline the starship using the No. 3 brush.

TIP Since the images are high on the wall, there is no need to varnish the work, as acrylic paints are durable and varnish would dull the metallic paint used on the starships. If you do wish to varnish it, however, you could apply matt varnish to the whole mural and then paint gloss varnish on the starships to put back the shine.

Bunny Box

This toy box decorated with friendly bunnies will motivate young children to put away their toys. The box looks good either on its own or as part of a larger scheme; for example, it could be used with the mural on pages 100–101. Alternatively, you could stand the box at the edge of the room and continue the tree and grass onto the wall.

YOU WILL NEED

Pencil and tracing paper

Templates of rabbits (page 139)

5cm (2in) decorator's brush

Matt acrylic varnish (to dilute paint)

Flat latex paints in grass green, dark
 brown, tan, black and cream

2.5cm (1in) fitch

Acrylic paints in raw umber, titanium
 white, crimson, chromium oxide
 green and ultramarine

No. 5 and No. 8 artist's brushes

Satin acrylic varnish and varnishing
 brush (to seal)

TIP Here, the paints are thinned with matt acrylic varnish instead of water, for a more durable finish, with less chipping. On unfinished, new wood it also prevents the wood from swelling and becoming rough and the grain from lifting, all of which could happen if water were used.

Preparation

An unfinished pine box, which did not require any preparation (thereby allowing the grain to show through the paint), was used. However, a painted or varnished box could be sanded down, primed with acrylic primer and then given a base coat of cream latex paint to resemble the colour of an unfinished box.

Draw the outline of the tree. Enlarge the rabbit templates and transfer them, including the entrance to the rabbit hollow, to the box, using tracing paper and pencils (see page 13).

Beginning grass and tree

1 Dip the decorator's brush in matt varnish and then into grass green. Paint the grass on the front, back, sides and lid, using brush strokes that follow the wood grain.

Clean the brush with water and dry it on a cloth. Dip it into varnish and then into dark brown latex paint; the mix should be fairly thick. Paint the shadows and outline of the tree, working on small areas at a time and leaving the rabbit shapes unpainted.

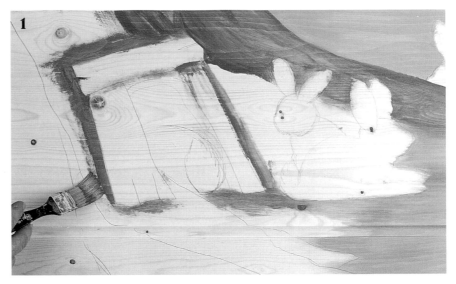

Add more varnish to the brush, and soften the edges of the shadows. Now pick up still more varnish and some tan paint on the brush, and cover the rest of the tree trunk, occasionally dipping into the dark brown and varnish to vary the tones.

> **TIP** When painting the grass, make sure the whole area is covered, but don't apply the paint too heavily. Don't try to prevent the colour from varying in depth, as the variation actually adds to the realism.

2 Dip the fitch into varnish, then into black latex paint, and paint the rabbit holes at the bottom of the tree,

starting at the centre of each hole and working outwards. As you come away from the centre, pick up more varnish and also a little dark brown, and soften the edges over the tree trunk. Leave to dry (about 30 minutes). Clean the fitch.

3 Dip the decorator's brush into varnish, then into grass green, and strengthen the grass colour in places, softening it back onto the base of the tree trunk. Pick up a little cream on the brush, and blend it in by painting over the green, to create paler areas of grass. Allow to dry.

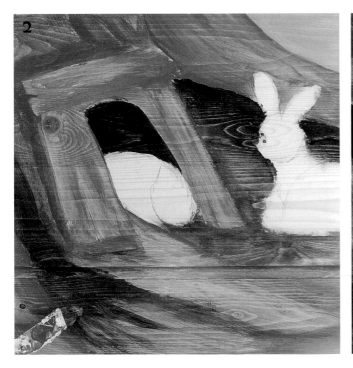

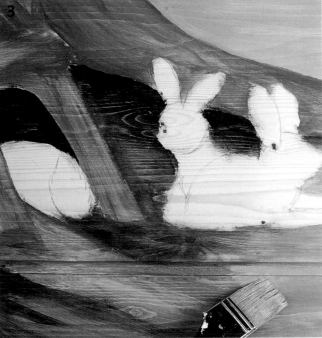

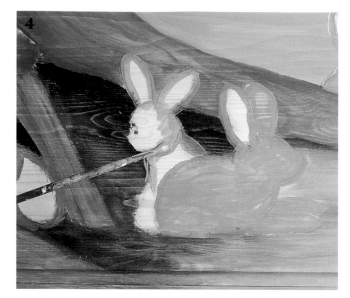

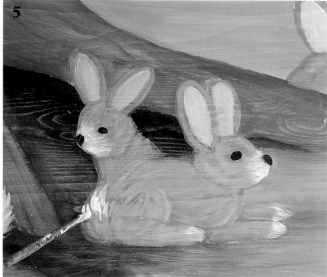

Rabbits

4 Mix raw umber with white to make a mid-brown tint, and use the No. 8 brush to fill in the rabbits' bodies, leaving the tails and the insides of the ears unpainted. Dilute the paint with a touch of varnish if necessary.

5 Add a little more white, and paint this pale brown tint onto the rabbits with the No. 8 brush, using the direction of the brush strokes to define the shapes of each rabbit's head and legs. Add a touch of crimson and more white to the brush, and paint the

ears. With the No. 5 brush, paint black eyes and noses. Now clean the No. 8 brush, and dip it into varnish, then into white. Paint each rabbit's tail, paws and fur on the nose, using short fluffy strokes resembling fur. Allow to dry.

6 To strengthen the white, go over it with more white, using short strokes of the No. 5 brush. Also add some white chest fur using the same brush. Pick up a little of the pale brown tint (from step 5) while there is still white on the brush, and highlight

the rabbits' fur with this, using short brush strokes.

7 Mix varnish with raw umber on the palette, and use the No. 5 brush to outline each rabbits' body and face, add a little mouth, outline the eyes and add whiskers. By the time you have done this for all the rabbits, the ones that you started with should be dry enough for you to proceed with the final touches. With a No. 5 brush, add some white whiskers and white dots on the eyes and noses. Allow to dry.

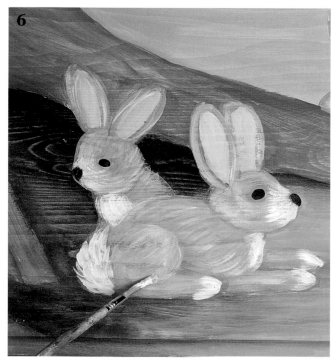

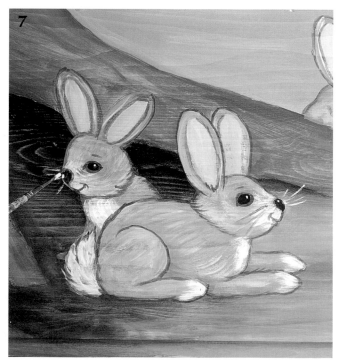

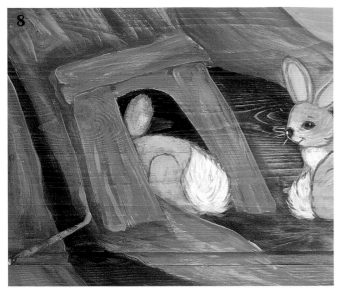

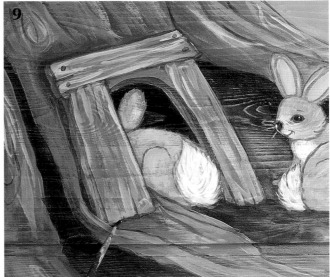

Completing tree

8 Paint long, undulating midtones on the tree trunk and roots using the No. 8 brush and tan latex paint. Strengthen the shape of the entrance to the rabbit hollow. Allow to dry.

9 Using long strokes of the No. 8 brush, add cream highlights to the tree trunk and entrance to the rabbit hollow. Paint circles on the trunk to look like bark lines. With the No. 5 brush and raw umber, outline where necessary to define the detail on the tree trunk and the entrance to the hollow. Paint the nails on the top part of the entrance.

Completing grass and flowers

10 Mix chromium oxide green with a little varnish, and with the No. 5 brush, paint dark grass around the tree base, and tulip leaves. Pick up white on the brush, and paint more grass using this midtone, overlapping the other grass; also add the midtones on the tulip leaves. Continue picking up white to paint paler and paler grass.

Rinse the brush and dry it on a cloth, then mix a little white with crimson and paint the tulip heads. Mix in some more white to add a few midtones to the tulips.

Clean the brush again with a cloth, and paint some white daisy heads. Mix ultramarine with white, and add blue forget-me-nots. Add tan centres to the daisies and white centres to the forget-me-nots.

Clean the brush with a cloth. Mix white and chromium oxide green and use this to add pale green highlights to the leaves and grass. Allow to dry overnight, then seal with satin varnish.

BATHROOMS

Left: A subtle trompe l'oeil tented effect decorates the walls of this bathroom, with faux braid, cord and tassels elegantly picking out the colours of the panelling and window blind.

Right: An underwater scene was the perfect subject for this untiled tub alcove. Although the mural was painted right on the wall, it could be painted onto MDF and then fixed to the wall. Whichever method is used, thorough varnishing is essential.

An underwater theme, such as a large mural set into a tub alcove, looks wonderful in a bathroom. If you don't have the space or the confidence to tackle a mural, you could start out with a sea view framed within a porthole. Marine motifs work well individually in a frieze, too. If the walls are fully tiled, the ceiling would be a good place for the underwater scene. Tented effects also look dramatic in bathrooms, or you could simply pick up motifs in the flooring and add trompe l'oeil tiles to match. Another idea is to add classical features to turn your bathroom into a bath house from ancient Rome.

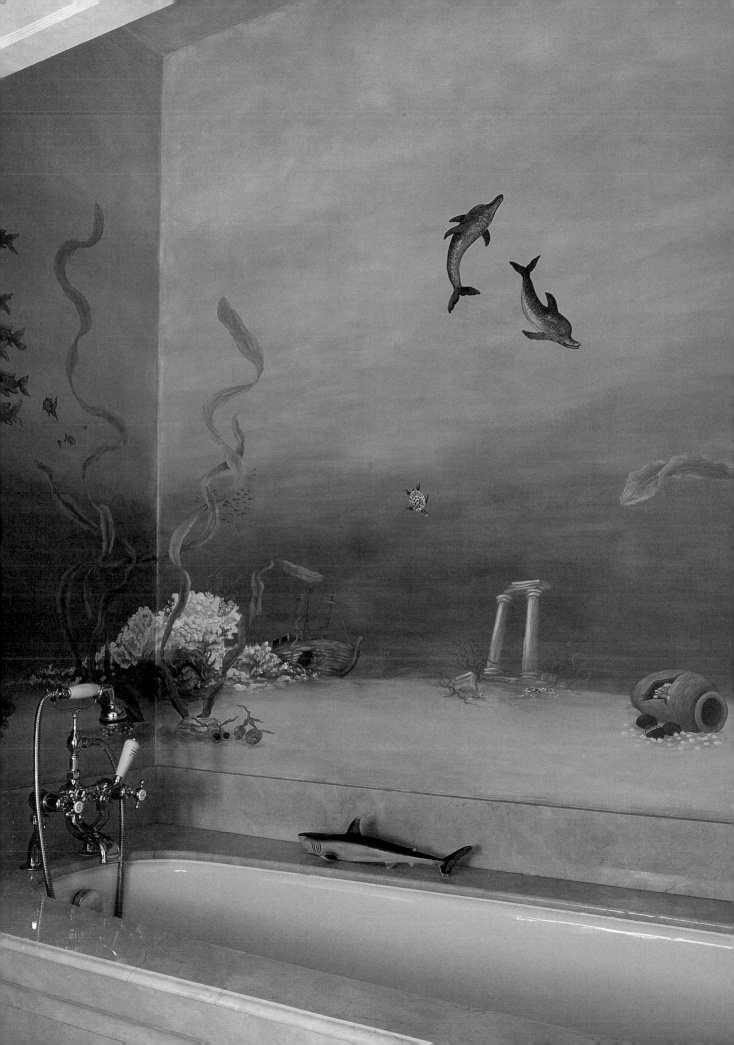

Ship's Portholes

This project is well suited to a full bath or powder room, as both of the trompe l'oeil portholes included in the project are marine in theme. In fact, they would be suitable for anywhere in the home. Either one — the sailboat or the underwater scene (illustrated on page 115) — could be used on its own, or they could be used as a pair. In a child's room, for example, they could be hung next to bunk beds, with the sea-view porthole by the top bunk and the underwater-scene porthole next to the bottom bunk.

YOU WILL NEED

Pencils and tracing paper

Flat latex paints in white, dark olive green and pale lime green

5cm (2in) decorator's brush

Template of sailboat, island and porthole catch (page 140)

Acrylic paints in titanium white, cobalt blue, ultramarine, black, turquoise, metallic silver, cadmium yellow, raw umber, cadmium red and orange

2.5cm (1in) fitch

No. 5 and No. 8 artist's brushes

Matt varnish and varnishing brush

Preparation

This can be painted onto a board cut in a circular shape, as here, and mounted on the wall when completed, or it can be painted onto a circle pencilled on the wall. Paint the board (which should first have been given an acrylic undercoat) or the circle with white latex paint using the decorator's brush; leave to dry. Pencil in the horizon line and the inner edge of the porthole frame. Now pencil in the other four concentric circles on the frame, using the photograph above as a guide. Also pencil in the small circles representing bolts at regular intervals around the frame.

Enlarge the template and transfer it to the board or wall using tracing paper and pencils (see page 13).

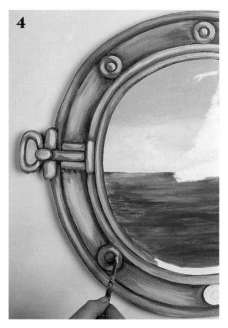

Sky and sea

1 The background, which extends as far as the inner circle, is painted first (with the shape of the boat left unpainted for the time being). Mix titanium white and cobalt blue acrylic to make a sky blue shade, and begin painting the sky using horizontal strokes of the fitch. You can dip the fitch in water if necessary, to make the paint flow better.

About halfway down the sky, start picking up titanium white on the fitch – just a touch at first and then more and more so that the blue gradually lightens as you approach the horizon. Use swirly brush strokes for this lower portion of the sky, to create a slightly hazy effect.

For the sea, mix ultramarine with a touch of black acrylic; dilute it with a little water and apply this with horizontal strokes of a No. 8 brush. Thin some of the paint with a bit more water to create a streaky effect.

For the shallow water at the left, where the island will be, use the more diluted paint, and pick up a little turquoise on the brush, softening this into the rest of the sea. Leave to dry.

Porthole frame

2 Mix black and just a touch of silver on the palette, and use the No. 8 brush to paint the shadows of the porthole frame (i.e., the outer edge and the next three circles, but not the inner edge adjacent to the background). Work on only a small section of the frame at a time, completing this step and the next one before moving on to the adjoining portion, so that you keep a wet edge for blending. When you come to the catch, paint its outlines in this same dark shade.

3 Add more silver to the black to make a shade resembling pewter, and with the No. 8 brush fill in the midtones between the dark shadows, blending into the dark lines to make them look soft and shadowy. Your brush strokes should follow the curve of the frame. Add still more silver, and go over some of the midtones with this.

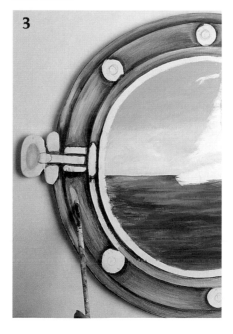

4 Paint the catch at the left side in the same way as the midtones of the rest of the frame (see step 3).

The inner rim of the frame (for which you need a sharp, neat edge next to the sea and sky) and the bolts can be painted either as you work your way around the frame, or at the end after you have finished the rest of the frame, but the technique is the same as in steps 2–3.

When the shadows and midtones are dry, highlight the frame very sparingly with a mixture of silver and titanium white, using the No. 5 brush.

TIP If you find you have applied too much of the silver and titanium white highlighting, lightly wipe some off with a damp cloth before the paint has dried.

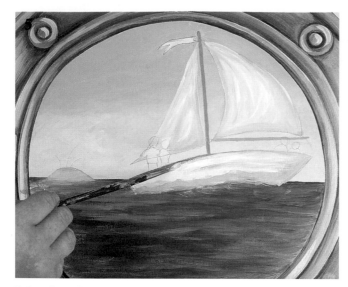

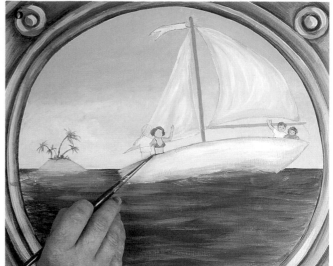

Island and sailboat

5 Pencil in the shapes for the island (including several curving lines for palm trees), the boat with its flag, and the family on the boat.

Combine yellow, raw umber and white and, with the No. 8 brush, paint the island on the horizon at the left. Pick up a little more raw umber on the brush and make some of the sand deeper in tone.

Use this same colour to paint the shadows on the hull of the boat and the outline of the sail, then pick up still more raw umber and paint the mast and the boom. Without cleaning the brush, pick up some white, and paint in the midtones on the hull and sails; the brush strokes should follow the curve of these shapes, and the edge between the hull and water should be quite rough. Continue picking up white, and use this to highlight the hull and sails.

Palm trees and people

6 With the No. 5 brush and raw umber, paint the trunks of the palm trees on the island. Mix dark olive green with pale lime green, and paint the palm fronds and ground foliage. Add more pale lime green and a little white, and highlight with this.

Clean the brush, and mix a touch of raw umber with red, yellow and a lot of white to produce a flesh tone. Paint the people's faces and bodies. Paint the hair with raw umber, the mother's bikini and girl's T-shirt with red, the boy's T-shirt and father's trousers with white, and the father's shirt with blue. Leave to dry, then paint the features and subtle body outlines in raw umber.

Detailing of sailboat and sea

7 With the No. 5 brush and raw umber, paint the rudder and outline the boom. Then, with the same brush and red paint loosened with a little water, paint the flag and add a red stripe near the top of the hull.

8 Clean the No. 5 brush, and apply thick white paint for the foam on the waves, using jerky movements and varying the brush pressure and the thickness of the paint. Add small, thin lines around the edge of the island.

9 Mix raw umber with a little water to a flowing consistency, and with the No. 5 brush paint the rigging as a line of linked dots, like a chain. Also use it to define the rudder and outline the sails. When the paint is dry, varnish the 'view' but not the porthole frame, as varnish would dull the sheen of the silver paint.

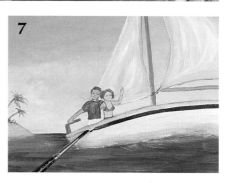

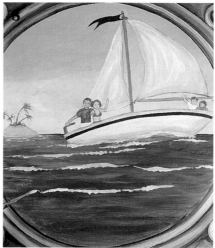

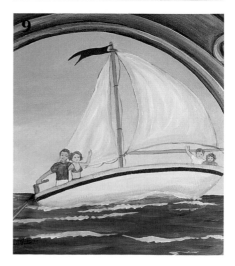

Underwater scene

10 For the porthole with the underwater scene, prepare it in the same way (see Preparation), but instead of a boat, sketch exotic fish and seaweed shapes in the sea.

To paint the sea, mix turquoise with white and apply it with the fitch in uneven horizontal strokes, loosening the paint with a little water. Gradually pick up more and more ultramarine on the brush to deepen the colour subtly; leave the fish and seaweed shapes unpainted for now. Paint the porthole frame as before (steps 2–4).

When the sea is dry, pencil in the fish and seaweed outlines again, then block in the colours with the No. 8 brush. For the orange fish, use orange with a touch of raw umber and red. For the seaweed, clean the brush and fill in with dark olive green. For the pair of striped fish, clean the brush and use titanium white.

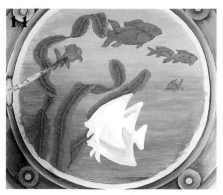

11 Mix pale lime green with dark olive green and a touch of white. With the No. 8 brush, add midtones to the outer edges of the seaweed, leaving the centres dark. Now add the central veins, and lightly stroke out some side veins. Notice that the edges are feathery and the seaweed is twisted like a ribbon, so be sure to leave shadows at each point where it twists. Add a soft shadow behind the front striped fish using raw umber. Mix white and orange, and use the No. 5 brush to add scales, fins and a head to each orange fish. Allow to dry.

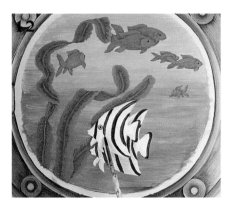

12 Using the No. 5 brush, add black eye dots to the orange fish. For the two striped fish, paint the black stripes and the black eye on the front fish.

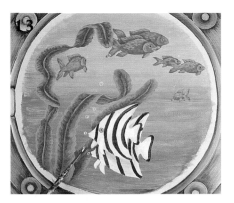

13 Add white to the pale lime green, and with the No. 5 brush, highlight the edges of the seaweed and parts of the central vein. Add a little yellow detail to the striped fish's eye. Mix white with orange and outline the orange fishes' eyes, and highlight their scales. Clean the brush and add a white highlight to each eye and bubbles coming from the mouths. When dry, varnish the 'view' (see step 9).

Below: This scene could be adapted to create a series of underwater views.

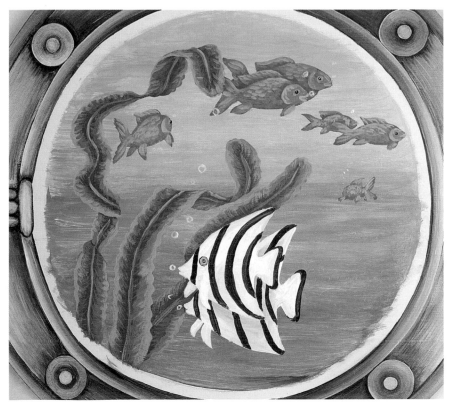

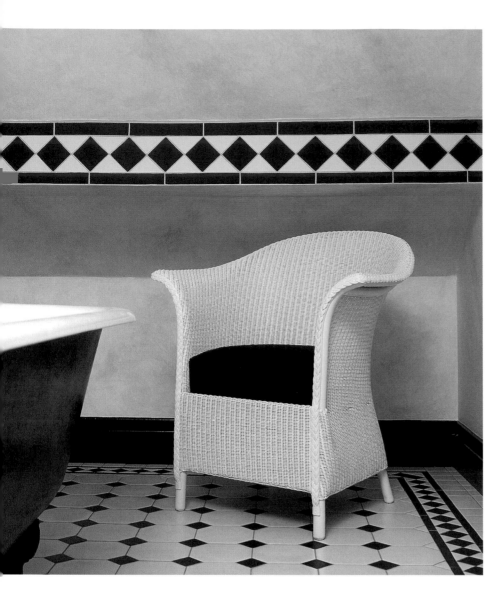

Tile Border

These trompe l'oeil tiles were designed to echo the floor tiles and colour scheme of this bathroom, but the idea could easily be adapted for other designs. In a bathroom (or kitchen) without tiled walls, a line of faux tiles can be just what is needed to enliven the scheme, and they are very easy to paint.

YOU WILL NEED

Tape measure, pencils, carpenter's level and straightedge

Low-tack masking tape

Flat latex paints in dark grey-brown, cream and black

Template of tile pattern (page 141)

Roll of tracing paper

No. 5 artist's brush

2.5cm (1in) fitch

Satin varnish and varnishing brush

Preparation

This wall was painted with a white base coat. The walls surrounding the tiled strip were colourwashed with peach and pale coral latex paint, but other colours or a flat finish would also be suitable (though colours that are not light would have to be overpainted with white within the tile area). However, if you don't want to paint all the walls, you could simply paint the tile strip white.

With a tape measure and pencil, mark out the upper and lower edges of the tile border. Check the marked lines with a carpenter's level, adjusting as necessary, then draw the lines using a straightedge and a pencil.

Mask along the inside of the lines – i.e., below the top line and above the lower line.

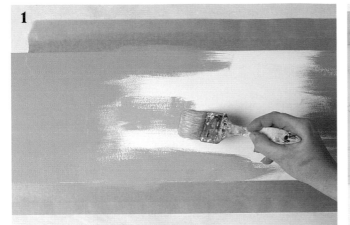

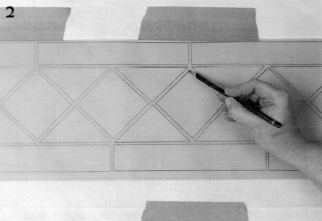

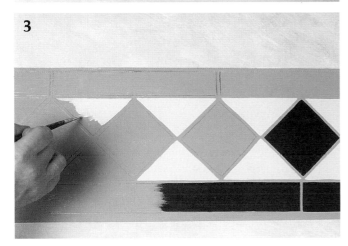

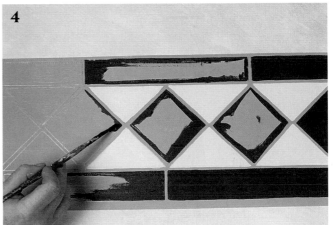

Painting grey background

1 Mask along the outside of the white strip of wall. Paint the area between the strips of tape in dark grey-brown using the decorator's brush. Remove the tape as you go. Allow to dry.

Creating tile pattern

2 Enlarge the template and use it to draw a repeat tile pattern on about a metre (yard) of tracing paper. Transfer to the wall (see page 13).

Painting tiles

3 Paint the triangular tiles in cream using the No. 5 brush for the edges and a fitch to fill in. After you have painted about a metre (yard), the first ones you painted should be dry enough to do the black tiles (see next step). The process is repeated as you work your way along the wall.

> **TIP** To turn a corner, you may need to stretch or shrink the design slightly.

4 Paint the square and rectangular tiles in black, again using the No. 5 brush to outline them and the fitch to fill in. When the first black tiles you paint are dry, you can repeat the previous step on the next stretch of tiles.

Finishing

5 With the dark grey-brown and the No. 5 brush, touch up the grout lines as necessary. Leave to dry completely and then apply two coats of varnish, allowing it to dry between coats.

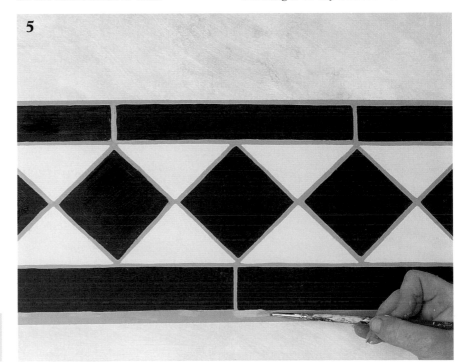

GARDENS

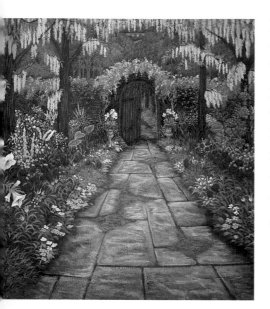

Left: This trompe l'oeil walkway provides colourful blooms to a patio garden permanently shaded by trees that prevent sun-loving plants from flourishing. The visual trickery makes it difficult to resist trying to walk straight into the wall.

Right: Instead of a large mural, landscape scenes have been painted in two existing niches in this wall. The two scenes have been designed to appear as parts of one vast landscape beyond the wall.

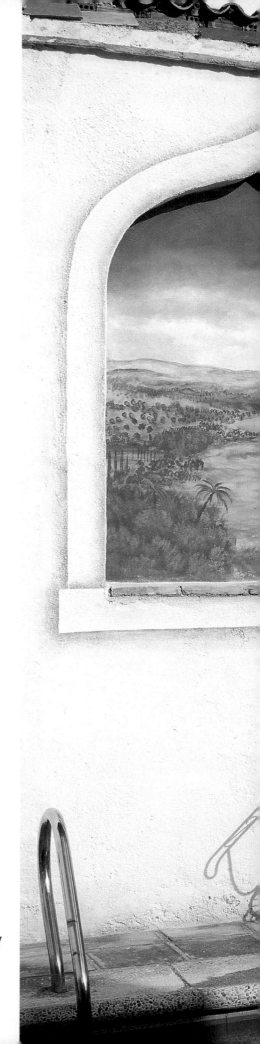

Most people never think of painting trompe l'oeil outdoors, but with good-quality paints and adequate varnishing, it is perfectly feasible. Amazing effects are possible with relatively little detail. Rolling countryside, tranquil seascapes, sun-drenched beaches, and exotic potted plants can all look fantastic on garden walls (or the walls of buildings). Trompe l'oeil is particularly effective adjacent to a patio, pool area, courtyard or roof terrace but also looks great in a small garden. Not only will it add year-round colour but it will make a small space feel much bigger.

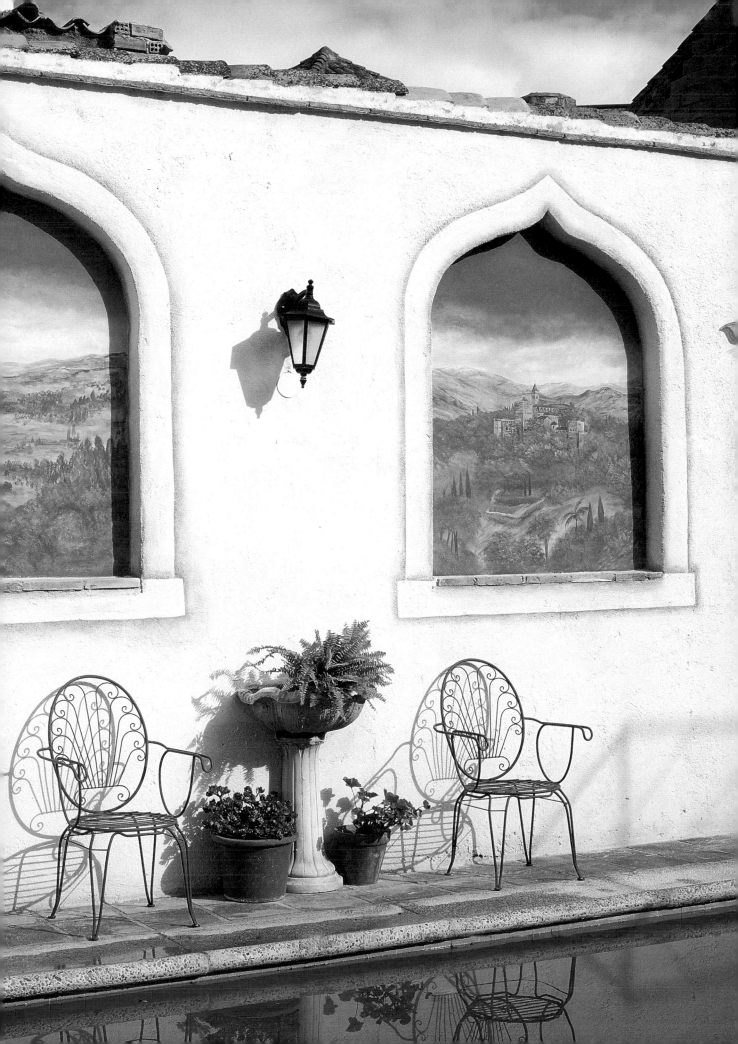

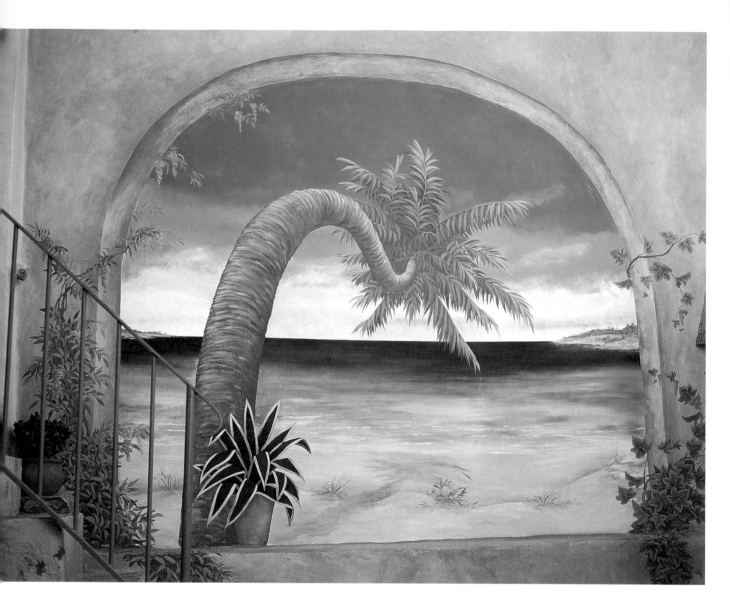

Palm Beach

Painted on the wall of a small courtyard, this dramatic mural makes the area seem much bigger and less closed-in. Although quite large, it would still look good scaled down to fit in, say, a bathroom, hallway or conservatory. In addition, individual elements such as the potted plant or the vine could be used on their own.

YOU WILL NEED

Pencil and carpenter's level

Flat latex paint in white, dark brown, dark olive green, deep sky blue, deep sea blue, turquoise, sand, tan, dark grey-brown, pale lime green, pine green, terracotta, deep purple, black and cream

5cm (2in) decorator's brush

2.5cm (1in) fitch

Low-tack masking tape

No. 5 and No. 8 artist's brushes

Matt varnish and varnishing brush

Preparation

The wall around the archway was painted using exterior latex paint in sand and tan colourwashed over a base coat of exterior latex paint in cream, then varnished.

Pencil the archway on the wall, then paint it in white paint using the decorator's brush. Leave to dry. Using a carpenter's level, lightly draw the horizon line, just over halfway down the archway. Lightly draw the line between the sea and beach freehand, about halfway down from the horizon line. Also draw the palm tree trunk and foliage freehand.

It's a good idea to roughly block in the tree trunk in dark brown, and the central mass of foliage in dark olive green, using the fitch; this helps to give you a sense of the scale of the composition right from the beginning.

Sky, sea and sand

1 With the decorator's brush, start painting the sky using deep sky blue, working from the top downwards. About two-thirds of the way down the sky, start picking up white on the brush, and gradually pick up more and more white. Near the horizon use the fitch and white paint to stipple a bank of clouds, blending it into the wet sky. Allow to dry.

2 Mask above the horizon line, and outside both side edges from the horizon line down. Using the decorator's brush, paint horizontal strokes of deep sea blue across the whole archway, gradually working your way down the wall for about 15–23cm (6–9in). Keep the bottom edge soft and wet by adding a little water to the brush. Remove the tape next to the painted area.

Pick up a little deep sky blue along with the deep sea blue already on the brush, and start blending it across the archway into the wet edge of the deep sea blue, keeping the brush strokes horizontal. Also pick up some turquoise on the brush and blend it into the blues. Pick up small amounts of white, too.

3 Still with the decorator's brush, paint the beach, again using horizontal brush strokes and adding water to the brush to keep the edge soft and wet. Start painting it at the top using sand paint, then pick up small amounts of dark brown and tan to define the dunes and create shadows cast by the palm tree and the tufts of grass. (The palm tree and tufts of grass themselves are not completed until a later stage.) Remove the masking tape.

Headlands and waves

4 Lightly outline the headlands in pencil. Using a No. 8 brush, paint in the headland on one side, starting at the top with dark brown. As you work down to the sea, pick up some sand and a touch of white on the brush, blending the colours together. Add a little water to the brush to slightly soften where the shore meets the sea. Add a little dark grey-brown, and paint subtle rocks in the sand; pick up more white, and highlight the rocks.

5 Still with the No. 8 brush, paint the forest and palm tree tops on the headland in dark olive green, making the trees that are nearer a bit larger.

6 With the No. 5 brush, paint the palm tree trunks on the headland dark brown. Mix pale lime green with a little pine green, and paint midtones on the palm trees and forest. Mix this colour with some white, and highlight the palm trees and forest.

7 Clean the No. 5 brush, and paint tiny, jagged white waves around the shore of the headland, getting smaller as they get farther away from the shore. Also add some white waves to the shoreline in the foreground.

8 Repeat steps 4–7 for the other headland.

Palm tree

9 Using the No. 8 brush, paint dark olive green palm fronds extending from the central mass of foliage. With the fitch, paint the tree trunk dark

brown, using large C-shaped brush strokes to help create the illusion that the tree is sweeping away from the viewer.

10 Mix dark olive green with pale lime green. With the No. 8 brush, use this midtone shade to paint individual leaves within the mass of green foliage and on the fronds at the edge. Once you have generally mapped out the leaves, lengthen the fronds a little by painting some slightly paler ones extending out from the ends of the fronds, and overlapping them on the central mass.

11 Mix some white into the pale green midtone shade, and add highlights to the ends of the fronds and to the top leaves that would catch the sunlight.

> **TIP** Don't overdo the highlights on the palm fronds – more can always be added later if necessary.

12 Mix sand and white with dark brown, and apply this midtone shade to the trunk using C-shaped strokes with the fitch and the No. 8 brush. The size of the strokes should diminish as you work towards the crown of the palm.

13 Mix a touch of terracotta with dark brown and white, and use the No. 8 brush to add dried palm fronds where the trunk and green palm fronds join. Add some white to this mixture, and use it to highlight the dried fronds and the trunk.

14 Add some more white to the highlighting shade mixed in step 11, and use this with the No. 8 brush to paint some very pale highlights on the trunk and leaves, to emphasize where the light is coming from (in this instance, the light comes from slightly to the right).

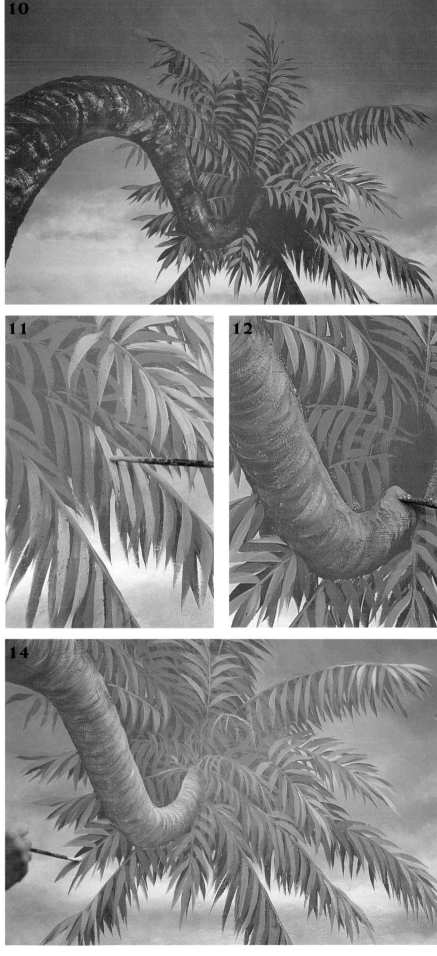

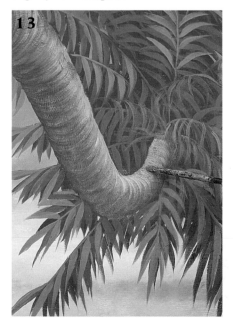

15

TIP When painting the archway reveal, work on only about 45–60cm (18–24in) at a time, so that you keep a wet edge for subtle blending and softening.

Grasses on beach

15 Roughly mix dark olive green and pale lime green with a touch of dark brown and tan and a little water, to make an uneven, streaky watercolour. With the No. 5 brush, paint tufts of grasses in the sand next to where you created their shadows in step 3.

16

Archway

16 Loosen some dark brown with a little water, and use the No. 8 brush to paint the outer edge (next to the wall) on the curved part of the archway reveal. Keep the outside edge hard, and soften the other side. With the tan paint, paint the inner edge (next to the sky), softening these midtones into the shadows just painted. Pick up a little sand on the brush, and blend it along the centre as a highlight. Now paint the straight sides of the archway reveal, making the outer edge pale,

and the inner edge darker with a blend of tan and dark brown. Once again, the tones should be softened into each other.

Vine and wisteria

17 Fill in the dense area of vine foliage with dark olive green paint, using the decorator's brush. With a pencil, lightly sketch the stems and individual vine leaves at the edge. Now, using the No. 8 brush, paint the stems dark brown and the individual vine leaves dark olive green.

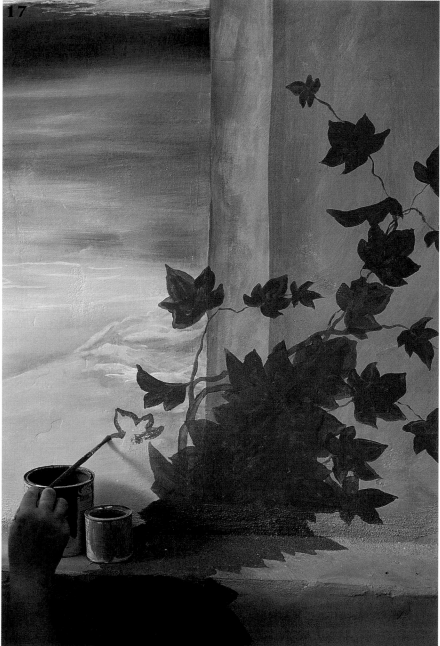

17

18

18 For the midtones, mix pale lime green with dark olive. With the No. 8 brush, paint individual leaves in the central mass, starting in the middle and working out to the edges. Outline the individual leaves, softening the outline into the centre of each. Add a vein down the middle of each leaf.

19

19 Mix pale lime green with varying amounts of white, and use these light tones and the No. 5 brush to add small clusters of baby grapes and then to highlight the leaves sparingly. Add still more white to the mix, and highlight the grapes. Paint the wisteria as in Sea View, steps 10–14 (page 77), using deep purple but substituting white, dark brown, dark olive green and pale lime green for the off-white, raw umber, dark green and light sage green.

20

Potted plant

20 Lightly sketch in pencil the outline of the pot and leaves. With the No. 8 brush, outline the plant in pine green mixed with a little black. Fill in the leaves with the same colour using the fitch. Clean the brushes, outline the pot with the No. 8 brush and then fill it in with the fitch, using terracotta and dark brown in varying amounts. Leave to dry.

21 Mix a little white with the pine green. Using the No. 8 brush, add midtones to define the shape of the leaves, starting with the central leaves and working outwards. Pick up some white on the brush, and highlight the

leaves. Mix white with terracotta and add midtones to the pot using the fitch, softening the edges in order to leave the leaf edges and the shadows under the leaves dark.

21

22

22 Put white, sand and cream on the palette. Mix some of the white with a little dark brown, and paint the light edging of the leaves with the No. 5 brush. As you work on each leaf, pick up a little cream on the brush to add subtle midtones, and then some white to highlight the edging. Allow to dry, then varnish as in Secret Garden, step 8 (page 129).

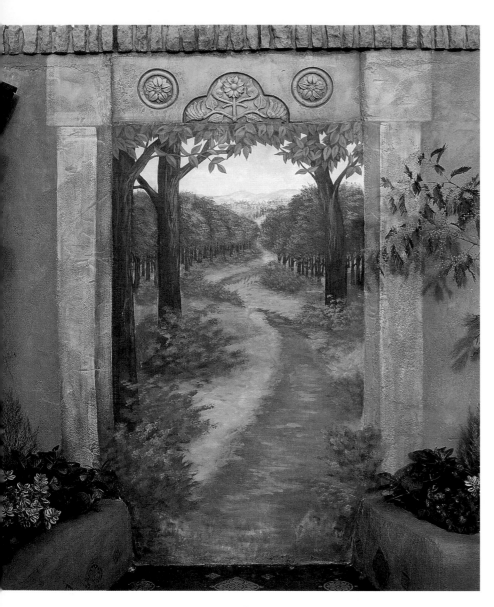

YOU WILL NEED

Pencil

2.5cm (1in) fitch

Flat latex paints in sky blue, white,
 deep purple, dark brown, pale lime
 green, dark olive green, cream,
 pine green and black

No. 5 and No. 8 artist's brushes

5cm (2in) decorator's brush

Matt varnish and varnishing brush

Secret Garden

*This mural is relatively small,
but it has a huge visual impact.
Many town gardens offer the
opportunity to create wonderful
illusions, and the project would
also suit a patio or roof terrace
that has no view or visual escape.
Ideally, try to arrange the
composition to tie in with existing
features such as a garden path.*

Preparation

The garden wall was painted with
exterior latex paint in a mixture of
terracotta, sand and grey-brown. The
portion of the wall where the mural
would be was filled with epoxy filler,
to provide a smooth enough surface
for the mural, and then painted with
exterior latex paint in white. The faux
stone surround to the archway was
given a grey-brown base coat, with
black added to the brush in varying
amounts, and then it was scuffed with
exterior latex paint in cream as it dried.

Lightly sketch the design on the
wall in pencil.

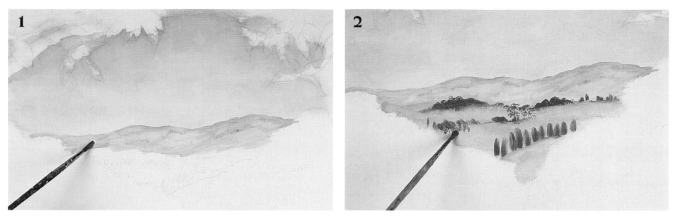

Sky and mountains

1 Using the fitch and sky blue paint, start painting the sky from the top, working from side to side. Pick up a little white on the brush, then gradually more and more, as you work downwards. Mix deep purple and dark brown and dilute to a watercolour consistency, then paint the mountains using the No. 8 brush.

Distant grass and trees

2 Thin the pale lime green to the same consistency as for the sky and mountains, and paint the grass in the distance using the fitch. Occasionally pick up a little white on the fitch to lighten some of the grass, and at other times a little extra pale lime green to strengthen patches of grass. With the No. 5 brush and dark olive green paint, paint the distant trees and forests.

Middle distance

3 Use the fitch and the pale lime green to continue painting the grass, working your way down and painting between the pencilled-in tree trunks in the middle distance and near the more distant part of the path.

Mix the dark brown with some water and, using the No. 8 brush, paint the edges of the path, and the tree trunks (except for the very large ones at the sides). Now pick up undiluted dark brown on the brush and use this to deepen the tone here and there. Pick up some cream on the same brush, and fill in the path between the dark edges.

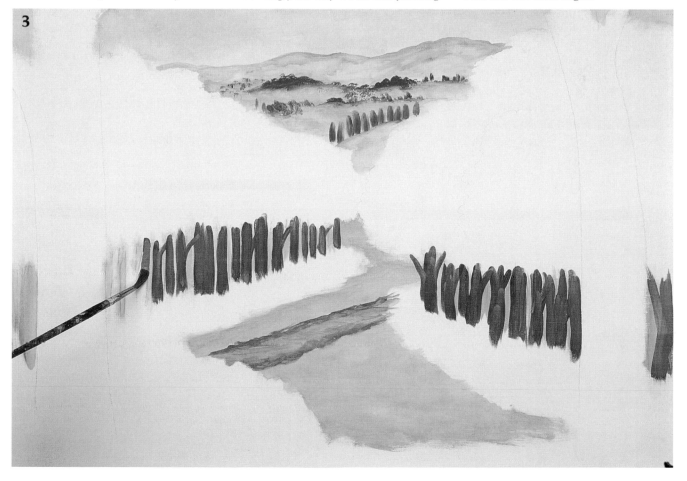

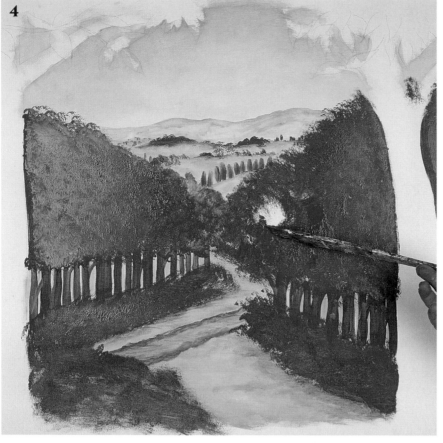

4 With the fitch, stipple dark olive green foliage at the tops of the tree trunks, and bushes at the base of the trees and in front of the part of the path already painted. Add a little water to the brush as necessary, but keep the paint quite thick and opaque now. The stippled edges of the foliage should look 'frothy'.

5 Mix a little pale lime green with the dark olive green and use the fitch to stipple it over the tree tops and the tops of the bushes – the closer the foliage, the heavier the stippling should be. Add more pale lime green to the mixture, and, while the foliage is damp, rather than wet, stipple on some midtones. Now add a touch of white to the mixture and highlight the foliage at the tops of the trees and bushes with this.

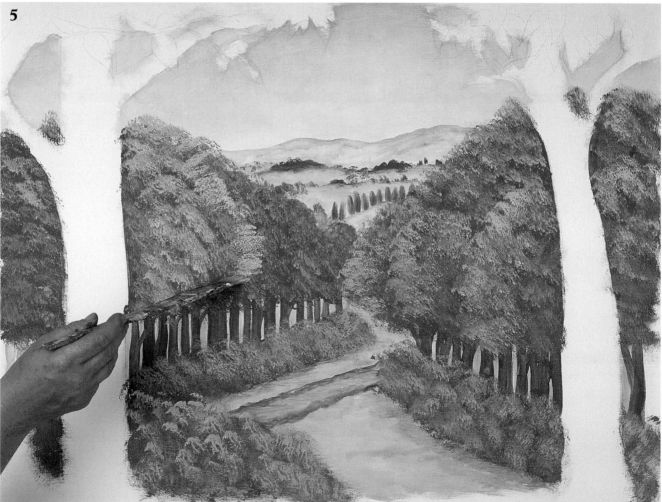

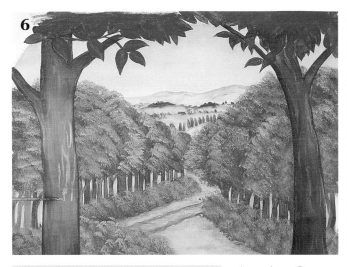

TIP If necessary you can add a tiny bit of water to the green shades used for the foliage, but at this stage the paint should be quite thick.

Large trees at sides

6 With the No. 8 brush and pine green, fill in the foliage of the large trees at the sides. With the fitch and dark brown, fill in their trunks and branches. Occasionally pick up a bit of black on the brush, too, to create texture. Now mix a little white with the dark brown, and use the No. 8 brush to add midtones to the trunks and branches with this shade, creating the effect of bark. Add more white to the mixture, and highlight the trunks a little with this.

7 Mix pale lime green with pine green, and use the No. 8 brush to paint midtones on the foliage of these large trees, defining each leaf with a crisp outline and leaving the middle dark for the central vein. Mix more pale lime green with pine green, and use this to highlight the leaves.

Foreground

8 Complete the foreground in the same way, using the decorator's brush to fill in the base colour of larger areas. At this point you can work back over the whole mural, softening, shading and highlighting, and adding additional trees or foliage as necessary.

For the path in the foreground, pick up dark brown on the fitch and use this to outline, then pick up cream on the fitch to fill in. Pick up more cream to add midtones, and still more for highlights, using irregular horizontal strokes for dappled sunlight.

Leave the paint to dry thoroughly, preferably for 24 hours. Varnish with three coats of matt varnish (one or two coats if not outside), allowing the varnish to dry between coats.

TIP When you are leaving the completed mural to dry, if there is a chance of rain, protect it with plastic sheeting. Then, before varnishing, allow the mural to dry in the air for a couple more hours.

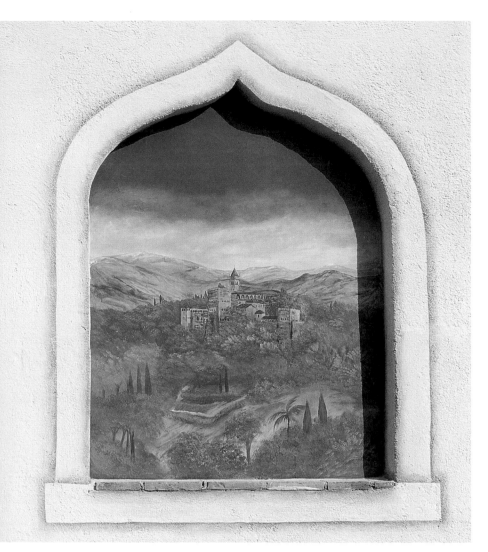

Moorish Niche

This mural, depicting a view of Spain's Alhambra Palace, has been painted in a real niche set into a wall, but a trompe l'oeil niche, complete with Moorish arch like this, could be painted around it instead. This is also an ideal treatment for a blocked-in window. With its feeling of distance, the project works well in cramped spaces such as courtyards and hallways.

YOU WILL NEED

Pencil

5cm (2in) decorator's brush

Flat latex paints in deep sky blue, pale blue, white, deep purple, dark brown, tan, cream, terracotta, dark olive green, light sage green, pine green and sand

2.5cm (1in) fitch

No. 5 and No. 8 artist's brushes

Matt varnish and varnishing brush

Preparation

The surrounding wall was painted with exterior latex paint in white. The niche was smoothed with exterior filler and then painted with exterior latex paint in cream over a white base coat. If you are not using a real niche, you could paint a trompe l'oeil version – see pages 74 and 76.

Divide the archway roughly into three sections, pencilling in the mountain outline and then drawing a line between the foreground and the middle distance. Also sketch the rough outline of the castle.

Sky, mountains and landscape

1 Using the decorator's brush with the deep sky blue, pale blue and white, paint the sky as in Palm Beach, step 1 (page 121). Soften the lower edge over the pencilled mountain line.

Paint the mountains as in Balcony View, step 1 (page 49), using deep purple, dark brown, tan and cream, and substituting a fitch for the No. 8 brush, and substituting a No. 8 brush for the No. 5 brush. Keep the lower edge very soft.

Now, with the mountain colours still on the fitch, pick up a touch of terracotta and dark olive green, and subtly soften back into the mountains. Dip the decorator's brush into water, and blend light sage green and terracotta into the landscape, softening back into the painted areas. Random amounts of these colours are picked up on the brush and applied as a watery wash for the entire ground.

The trees are painted as in Balcony View, steps 2–5 (pages 49–50), using dark olive and pine green, with light sage green and cream for midtones and highlights respectively. Use the fitch for the larger trees, and the No. 8 brush for distant details. The brush should be wet for the distant trees, and dry for those in the foreground. For the tree trunks, mix dark brown with a little water, then add some cream to the brown for the highlights.

For the stone wall, use the No. 8 brush with dark brown, adding sand and cream for the midtones and highlights respectively.

> **TIP** When painting the distant trees (but not the others), keep the paint wet and then use a clean, dry fitch to soften the trees before the paint completely dries.

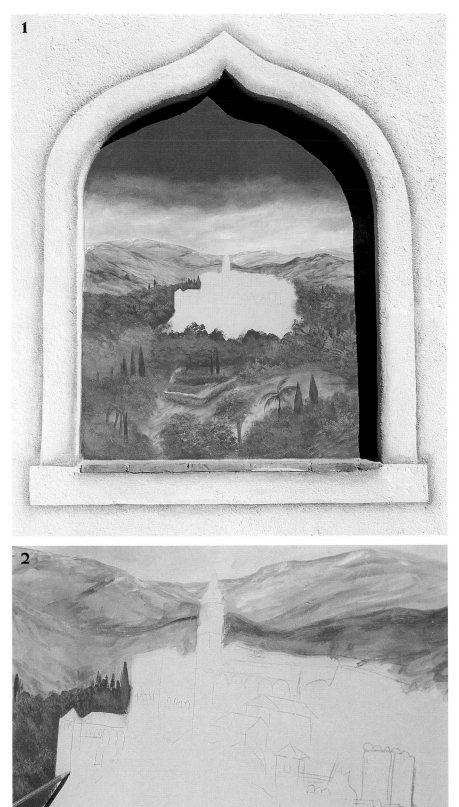

Drawing castle

2 You can add more detail to the sketch of the castle now, using a pencil. Don't worry about adding a great deal of detail, however, because the style of painting that is used here is a watercolour technique, in which 'less is more'.

3

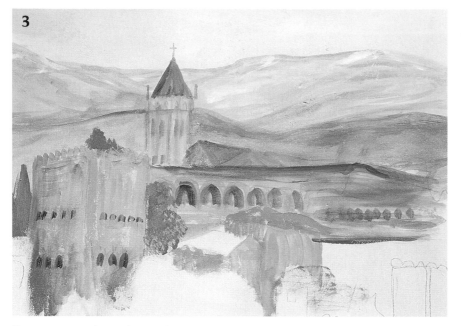

4 Add water to the No. 8 brush and, using the dark grey from step 3, soften the edges of the shadows. Pick up sand on the brush, and strengthen the walls not in shadow. Pick up terracotta, and strengthen the colour of the roofs in places. Mix dark grey-brown with the sand/cream wall colour, and paint the trees' shadows on the walls with the fitch. Now mix dark olive green with light sage green, and paint the trees themselves, using a stippling action of the fitch. Start picking up extra light sage green on the brush to define shapes in the foliage.

Painting castle and nearby trees

3 Mix the dark brown and deep purple with water to form a very dark grey wash. With the No. 8 brush, paint the windows, archways and roofs, adding terracotta for other roofs. Add cream to the brown/purple mix, and paint the walls that are in shadow. Clean the brush, mix sand with cream and some water, and paint the remaining walls.

> **TIP** When painting with a loose, free, watercolour technique as used here, try not to overwork the detail at all. Build up features on the whole castle without concentrating on a small area.

4

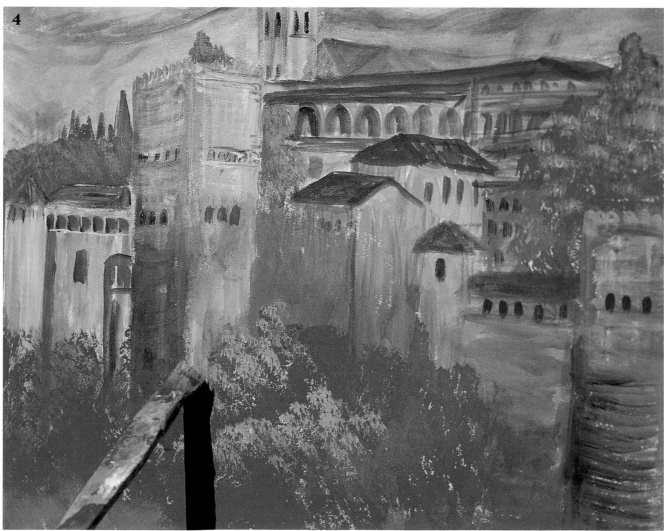

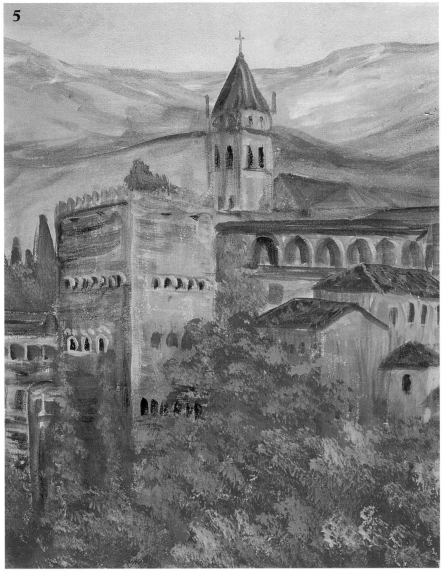

5

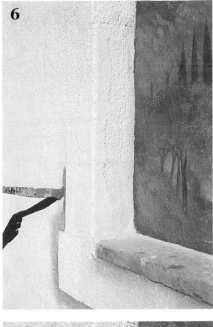

6

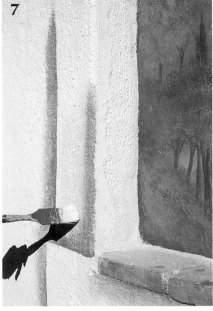

7

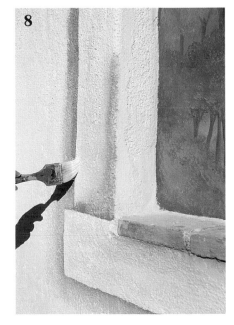

8

5 Mix cream and white, and using the No. 5 brush, paint details around the windows and in the brickwork, and highlight the roofs.

Mix light sage green and cream with dark olive green, and mix the light sage green and cream separately with pine green, and use these two shades to stipple highlights with the fitch on the trees around the base of the castle and in the landscape.

Niche surround

6 Draw the outline of the trompe l'oeil surround lightly in pencil then use the fitch to paint in dark brown shadows outside the edge of the surround, above the sill, and along the inside edge of the surround. Work on stretches of no more than 30–45cm (12–18in) at a time. Soften the colour onto the surrounding wall, adding a little water to the paint as necessary to make the blending easier.

7 With the decorator's brush, pick up cream paint and blend it with the dark brown shadows before they dry, softening the colour onto the surrounding wall.

8 Pick up white on the decorator's brush and continue softening the shadow into the surrounding wall. Now, with the brush fairly dry, dust the white over the almost dry shadows to soften the effect. Allow to dry, then varnish as in Secret Garden, step 8 (page 129).

Templates

Hall table p24

Hall table p24

Baluster p48

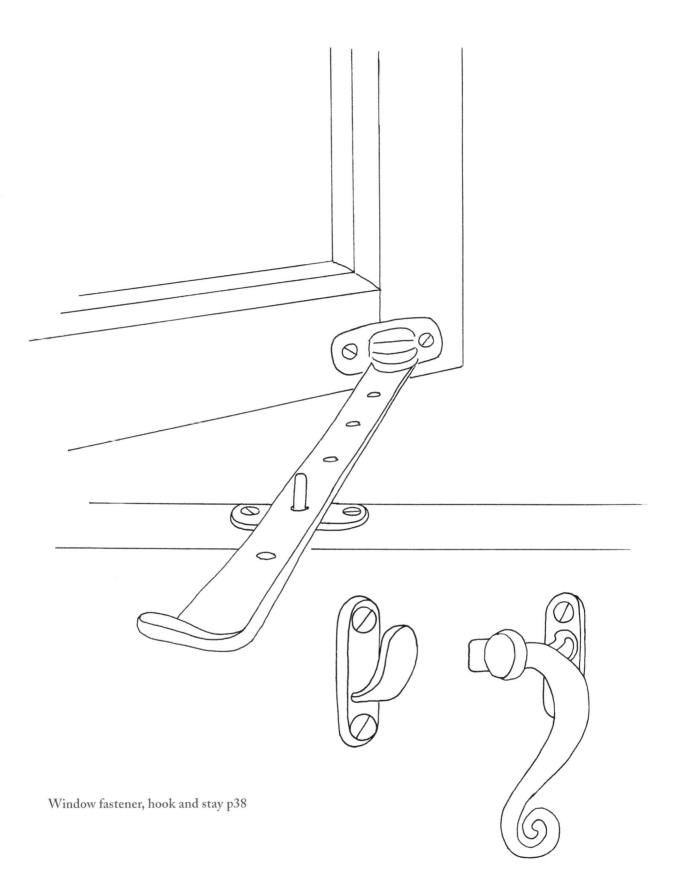

Window fastener, hook and stay p38

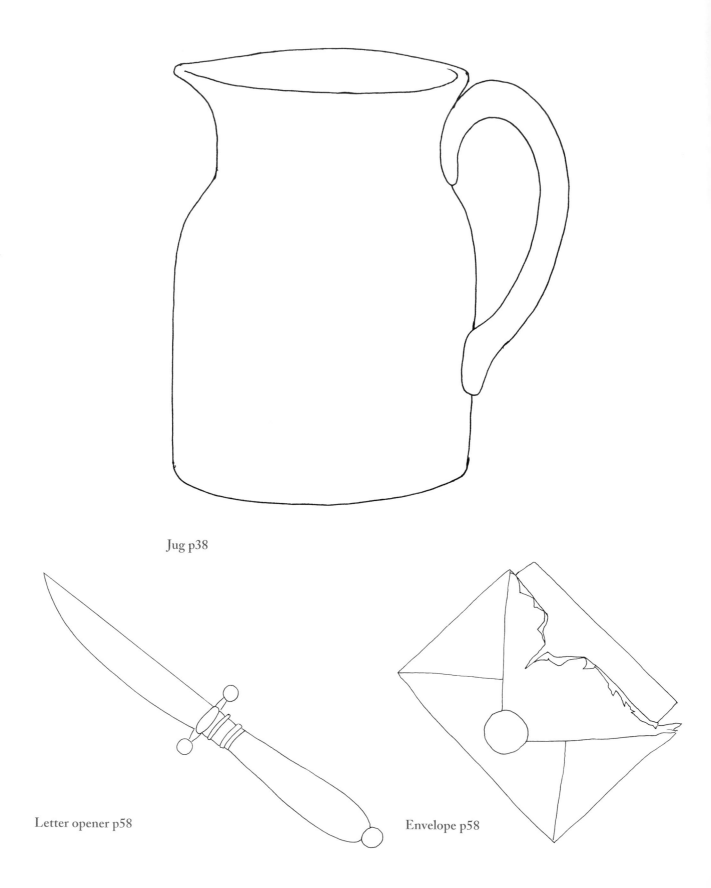

Jug p38

Letter opener p58

Envelope p58

Monkey in window p68

Lizard p80

Handle for ship's wheel p88

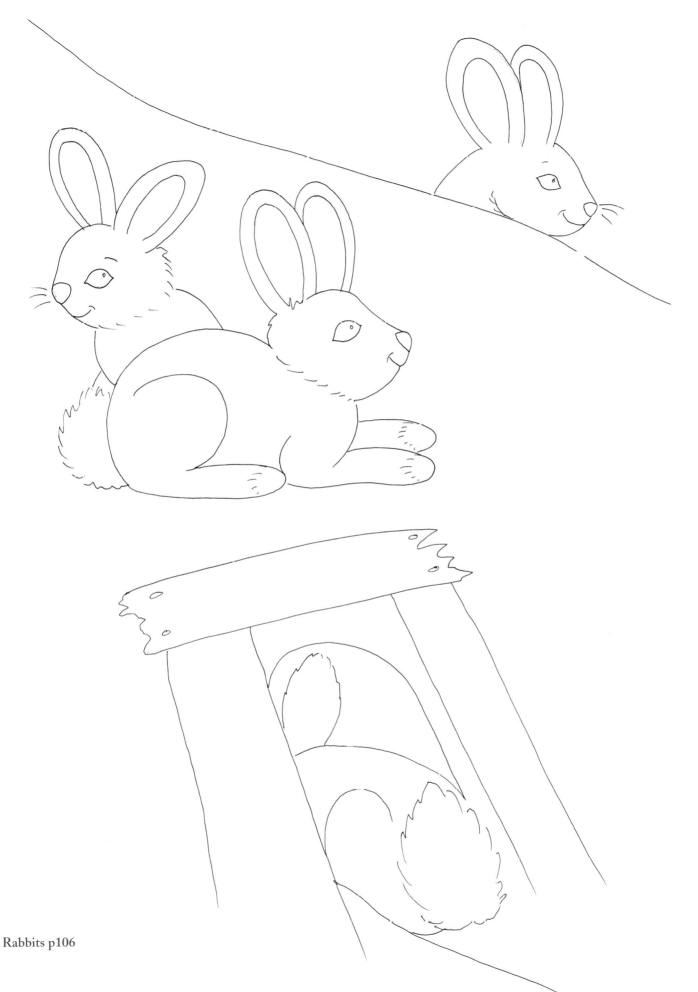

Rabbits p106

Tile Pattern p116

Suppliers

Listed below are manufacturers of and retail sources for the materials used in this book. Because space limitations prohibit a comprehensive listing, readers should not restrict their choices of products and retailers to those listed in this directory, and should investigate local sources, including paint, hardware, art supply, hobby, and craft stores, as well as regionally manufactured and distributed products.

Manufacturers

The following companies generally sell their products exclusively through retail outlets, which are a consumer's most dependable source for painting materials and supplies. Your local retailer's knowledgeable personnel can advise you on your purchases, and if you need something that they don't have in stock they will usually order it for you. If you can't find a store in your area that carries a particular item or will accept a request for an order, or if you need special technical assistance, a manufacturer will gladly direct you to the retailer nearest you that carries their products, and will try to answer any other questions you might have.

Artist-quality acrylic paints
Golden Artist Colors, Inc.
188 Bell Road
New Berlin, New York 13411
(607) 847-6154
http://www.goldenpaints.com/

Winsor & Newton
11 Constitution Avenue
Piscataway, New Jersey 08855-1396
(908) 562-0770
http://www.winsornewton.com/

Latex paints, acrylic varnishes and related materials
Benjamin Moore & Co.
51 Chestnut Ridge Road
Montvale, New Jersey 07645
(800) 334-0400
http://www.benjaminmoore.com/

Pratt & Lambert, Inc.
P.O. Box 22
Buffalo, New York 14240
(716) 873-6000
http://www.prattandlambert.com/

The Sherwin-Williams Company
101 Prospect Avenue N.W.
Cleveland, Ohio 44115
(216) 566-2000
http://www.sherwin-williams.com/

Tapes and adhesives
3M Company
3M Product Information Center
Building 304-1-01
St. Paul, Minnesota 55144-1000
(800) 364-3577
FAX (800) 713-6329
http://www.3M.com/

Retailers/Mail Order Sources

The retailers listed here offer complete selections of artist- and/or professional-quality painting products and supplies. Call or write for a catalog or the location nearest you.

Dick Blick Fine Art Co.
P.O. Box 1267
Galesburg, Illinois 61401
(800) 447-8192
http://www.dickblick.com/

Janovic Plaza
30-35 Thomson Avenue
Long Island City, New York 11101
(718) 392-3999
http://www.janovic.com/

Mann Brothers
757 North La Brea Avenue
Hollywood, California 90038
(213) 936-5168
(800) 245-MANN

New York Central Art Supply
62 Third Avenue
New York, New York 10003
(212) 477-0400
(800) 950-6111
http://www.nycentralart.com/

The Home Depot
2455 Paces Ferry Road
Atlanta, Georgia 30339
(770) 433-8211
http://www.homedepot.com/

For information on painting workshops in London or Spain with Roberta Gordon-Smith, call or fax 011 44 20 7381 0601, email info@artyfacts.demon.co.uk or visit Roberta Gordon-Smith's website at http://www.artyfactsuk.com

Index

Italics indicate illustrations

Acknowledgements

First of all, thank you to my husband, Barry, and daughter, Georgina, for putting up with chaos while I wrote this book! A special thank you to my patrons who allowed us to photograph their commissions, particularly to Leo for the space scene in his room and to Evie for the fairy landscape in hers. Thanks are also due to Jennifer Taylor of Sophistocat, 192 Wandsworth Bridge Road, London SW6 2UF (tel: 020 7731 2221; fax: 020 7731 0802) for supplying the bunny toy box (she supplies all types of furniture ready for painting); and to Damask at 3–4 Broxholme House, New Kings Road, London SW6 4AA; (tel: 020 7731 3553; e-mail: enquiries@damask.co.uk; website: www.damask.co.uk) for supplying the bedlinen and other bedroom soft furnishings.